€10 —

# EXPLORING DUBLIN
## WILDLIFE, PARKS, WATERWAYS

CHRISTOPHER MORIARTY is a naturalist and fisheries expert. He is author of *Down the Dodder, Byways rather than Highways* and *On Foot in Dublin and Wicklow: Exploring the Wilderness.* He is co-author with Elizabeth Healy and Gerard O'Flaherty of *The Book of the Liffey: from source to the sea.* His love for places where people are free to wander has led him to collect a treasure-trove of information on what there is to see, and why it is there. His work as a fishery scientist, together with his qualifications in geology and botany, gives him a special expertise on river flora and fauna.

*To the members of the*
*Dublin Naturalists' Field Club,*
*past, present and to come*

# Exploring Dublin

## Wildlife, Parks, Waterways

### Christopher Moriarty

**Photographs by the author**

WOLFHOUND PRESS

First published in 1997 by
Wolfhound Press Ltd
68 Mountjoy Square
Dublin 1, Ireland

British Library Cataloguing in Publication Data
A catalogue record for this book is available from the British Library.

ISBN 0-86327-590-7

Photographs: Christopher Moriarty
Line Drawings: Ruairi Moriarty, with the exception of:
    Kingfisher, p. 140: Brendon Deacy
    Heron (p. 31), Swift (p. 69), Swallow (p. 141), Wren (p. 145)
    and Bat (p. 198): Jeanette Dunne
Map of Dublin: Eilis Young
Cover Design: Slick Fish Design
Typesetting: Wolfhound Press
Printed in the Republic of Ireland by Colour Books, Dublin.

# Contents

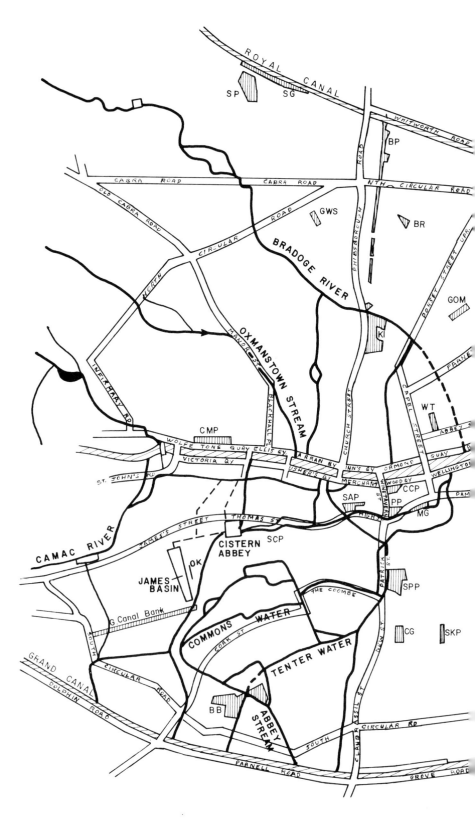

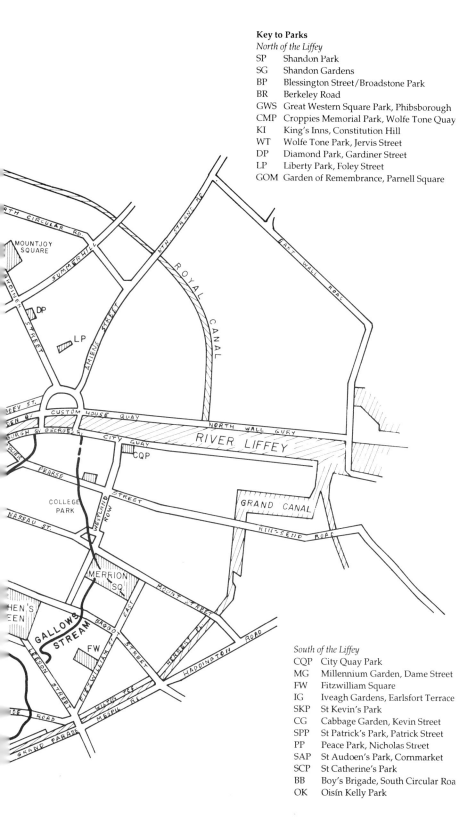

**Key to Parks**

*North of the Liffey*

| | |
|---|---|
| SP | Shandon Park |
| SG | Shandon Gardens |
| BP | Blessington Street/Broadstone Park |
| BR | Berkeley Road |
| GWS | Great Western Square Park, Phibsborough |
| CMP | Croppies Memorial Park, Wolfe Tone Quay |
| KI | King's Inns, Constitution Hill |
| WT | Wolfe Tone Park, Jervis Street |
| DP | Diamond Park, Gardiner Street |
| LP | Liberty Park, Foley Street |
| GOM | Garden of Remembrance, Parnell Square |

*South of the Liffey*

| | |
|---|---|
| CQP | City Quay Park |
| MG | Millennium Garden, Dame Street |
| FW | Fitzwilliam Square |
| IG | Iveagh Gardens, Earlsfort Terrace |
| SKP | St Kevin's Park |
| CG | Cabbage Garden, Kevin Street |
| SPP | St Patrick's Park, Patrick Street |
| PP | Peace Park, Nicholas Street |
| SAP | St Audoen's Park, Cornmarket |
| SCP | St Catherine's Park |
| BB | Boy's Brigade, South Circular Roa |
| OK | Oisín Kelly Park |

# Acknowledgements

This book is based primarily on notes made in the course of wandering the streets of Dublin between 1991 and 1996. These are supplemented by casual observations from when I first fed the ducks in Stephen's Green in the 1940s, attended Trinity College in the 1950s and worked in an office in Cathal Brugha Street until the end of 1975.

Published sources are listed in the References. Hearty thanks to friends and acquaintances who have kindly replied to my phone calls or letters seeking further information and generously shared their knowledge. To any I have omitted from the following list I offer my apologies and beg them to blame the computer: Dominic Berridge, Alan Craig, Jerry Crowley, Geoffrey Dean, James Fenwick, Eoghan Ganly, Joe Henry, Mary Holohan, Brian Keeley, David Lockhart, Patrick Lynch, Muriel McCarthy, Peter McDermott, Alan McGurdy, Oscar Merne, Paul O'Brien, John Rochford, Michael Solomons, David Wall, William Warren, Declan White, Ray Wills, Karen Woodlock.

The following experts very kindly read chapters or provided extensive literature and information on the subject matter. Their help, advice and corrections were invaluable, rescuing me from many pitfalls: Gerry Barry, Christy Boylan, Tom Cooney, Margaret Gormley, Bridget Johnston, Brian Madden, Lynn Mitchell, Jim O'Connor, Sylvia Reynolds, Micheline Sheehy Skeffington, Patrick Wyse Jackson.

# 1
# Introduction

Cities are developed and built by people for people. The preservation of wild nature is not a priority of builders and planners, and even the open spaces are regulated by gardeners who work with nature — but seek, with entirely delightful effects, to control the growth of their plants.

The very existence of the city of Dublin depends on the forces of nature. Liffey and Poddle carved their valleys in the glacial till to create the Dark Pool which lured the Vikings to settle. Even before their time, the Ford of the Hurdles provided a crossing place for Celtic wayfarers. Drinking water was available from rivers and wells, and the rivers also served the essential purpose of removing the waste. With their support, the city grew, gradually invading the open spaces and transforming the tidal flats to dry land. The raw materials for the first buildings were wild plants, willow and alder. Later the local bedrock — calp limestone — was quarried for dwellings and defences. As time went by, the city grew, becoming more sophisticated and less dependent on its immediate surroundings, as building materials were imported and more and more of the original land surface was covered by roads and buildings.

In spite of the best efforts of gardeners, developers and vandals, wild plants and animals thrive in Dublin and all the other cities of the world. Some are conspicuous at all times. Seagulls are constantly on the wing in the sky above the city, scanning the ground below for scraps of food. The ducks in Stephen's Green have provided generations of children with their first close encounter with birds and the joy of feeding wild creatures. Birds sing even in the smallest parks throughout the year, with more birds and more song in early summer in the bigger open spaces. Pied wagtails roost, and rooks, magpies and pigeons nest incongruously in the innermost inner city, in the trees of O'Connell Street. The butterfly tree, buddleia, grows everywhere, from gutters and crevices in walls to wasteland and

well-kept parks. Luxuriant ferns thrive outside dank basement windows.

Other species are known to few but active observers. Foxes roam the streets, and otters and seals hunt in the Liffey. Falcons occasionally swoop for their prey from the parapets of Georgian buildings. These are some of the large creatures, totally outnumbered by the smaller ones from bumble bees to butterflies and fleas, to say nothing of crabs invading respectable basements and rare flies captured in pubs frequented by entomologists. The list is endless.

Thomas Molyneux is credited with being the earliest observer of Dublin's plant life, having made a note of a very small plant, pearlwort, growing in St Mary's Churchyard in 1699 or 1700. Caleb Threlkeld in 1726 was the first to publish a flora with references to the city and its surroundings. In the succeeding three centuries, many naturalists made more or less casual references to Dublin's plants and animals.

The outstanding contributors to knowledge of the natural history of Dublin are Peter Wyse Jackson and Micheline Sheehy Skeffington who, with fellow members of the Dublin Naturalists' Field Club, organised a meticulous survey of the plant life. Their *Flora of Inner Dublin* was published by the Royal Dublin Society in 1984 and includes a catalogue of no fewer than 345 species.

Other books devoted to inner-city nature are Patrick Wyse Jackson's *The Building Stones of Dublin* and two small works on the birds and the trees of Trinity College. All have been of the greatest value as source material.

The boundaries of the inner city set by the authors of the *Flora* were the two canals, the old railway line which runs southwards through Cabra and, south of the Liffey, the infilled canal. Phoenix Park was deliberately excluded. This book follows their lead in using the canals as the main boundary but stretches it a little to include Liffey Junction and the 7th Lock of the Royal Canal to the north-west, and the Toll Bridge over the Liffey to the east. The approach has been first to describe a number of separate areas such as the two canals, the Liffey and the parks. The chapters following these cover species rather than places. Chapter 10 makes the first ever attempt to compile a complete list of the birds of the inner city. No attempt is made

to repeat the work of the *Flora of Inner Dublin*, but Chapter 11, on wild flowers, treats a selection of species that are especially interesting for various reasons such as abundance, rarity, beauty or history — or all four and more.

A comprehensive work on the animals of the inner city would be of great scientific interest but limited appeal. The majority of the animals are small and can be recognised only by specialists. A selection of these creatures has been included in Chapter 13, based largely on the observations of Jim O'Connor of the Natural History Museum.

My aim in this book has been to provide, for observant citizens rather than the experts, a description of the natural history of the city. I have allowed myself a fair degree of latitude in considering such topics as the building of the canals and the quays to fall within the bounds of nature.

Survival of wild nature in a city takes place largely in spite of, rather than because of, the work of citizens and the authorities. As late as the seventeenth and even into the eighteenth century, nature was seen as something to be curbed rather than fostered. Enlightenment dawned in the eighteenth century when the promoters of the Circular Branch of the Grand Canal planned trees and a footpath for the enjoyment of the population, the Wide Streets Commissioners planted trees and the Corporation required the lessees around Stephen's Green to do likewise. Public parks and open spaces developed to a greater extent in the nineteenth century and proliferated in the last third of the twentieth.

As recently as the 1950s, people in high places gave serious consideration to the destruction of the canals and the Liffey by covering them over to add to the extent of the road system. Wiser counsel prevailed and, it is hoped, vandalism of this order will never again be contemplated. Thanks to quiet pressure from individuals within such organisations as the Dublin Naturalists' Field Club, to a more public stance by An Taisce and to the efforts of groups of residents such as the saviours of the Blessington Street Basin, there is a much greater awareness of the value to the inhabitants of the city of trees, water and open spaces. Public pressure of this kind has led the powers that be in the City Council to pay much greater attention to those of their own officials who, over many years, have worked

to maintain and enhance the greenery of Dublin.

Most of the books about Dublin tell of people and buildings — and so they should. Cities are human creations. But the natural history is an integral part of the same city, part of its history and part of its indefinable atmosphere. This book is the attempt of one devoted Dub to add a dimension to the growing awareness of the charms of the fair city.

# 2
# The Grand Canal

The Grand Canal was constructed by order of wealthy investors for purely commercial reasons at a time when overland transport was neither rapid nor comfortable. Work had begun in 1756 on the main line running from near the City Basin at James's Street to the River Shannon. Although the line of the canal had been agreed on at an early stage, the actual construction took place in isolated sections, because of problems arising in the acquisition of land. In 1763, the City Assembly of Dublin noted that the canal could also be used as a source of water, and the Commissioners of Navigation were asked to extend the canal to the City Basin itself.

Three years later, the authorities had realised that the Grand Canal was something more than a commercial utility. The Assembly's Pipe-water Committee observed that:

> the canal would be a pleasing recreation as well as a salutary walk to the inhabitants of Dublin, if trees were planted on the banks of the canal, for that purpose, your committee contracted with Mr Patrick Edgar to supply 400 trees, thirty feet high, matched fair and straight, at 3s 3d a tree, including all expenses of planting.

Early plans for the canal aimed to complete its passage to the Liffey by a series of locks directly from the harbour at James's Street. But a more inspired, if more expensive, view prevailed to the eternal benefit of the citizens. In 1785, a canal engineer, William Chapman, published a pamphlet entitled *Observations on the Advantages of bringing the Grand Canal round by the Circular Road into the River Liffey*. This route would provide an amenity for the people and add to the beauty of the city. The South Circular Road had begun in 1763 as part of the grand plan for the modernisation of Dublin, and marked the southern boundary of the city.

The last commercial barge to use the canal departed, laden with Guinness, on 27 May 1960, and the original main line from

Suir Road Bridge to St James's Harbour was filled in in 1974 and transformed to a linear park, so displacing a large herd of swans which used to inhabit it. Jackdaws forage there now and, in spite of the lack of water, black-headed gulls still visit, looking for worms in the lawn. The harbour itself was built over, but the warehouses at its north end survived, forming a pleasant curved façade and commemorated by the street name Grand Canal Place and a house that has firmly held to its name of Canal View.

The 'Circular Line' survived, although threatened in the 1960s with a grim utilitarian scheme to cover it over to provide a road or car park. Higher ideals won the day and the canal was maintained by CIE until directly vested in State care under the control of the Office of Public Works. This had the vital effect of changing ownership from the transport company, which regarded it as a liability, to a public body entitled and expected to spend money on the maintenance and development of an amenity.

The history of the canal has been well documented and the main source of information is Ruth Delaney's *The Grand Canal of Ireland*, first published in 1973. The very survival of both canals as open watercourses owes a great deal to her enthusiasm, aided and abetted by fellow members of the Inland Waterways Association.

The water is beautifully clear, evidence of a remarkable freedom from pollution and of some more subtle factors of the physics and chemistry of open water. The only drawback to this condition is that the clarity makes discarded supermarket trolleys, highway cones and other abandoned artefacts unpleasantly conspicuous. The clarity is explained partly by the very slow speed of the water. Most of the silt particles it contains have plenty of time to sink to the bottom so that they are not carried along as they would be in a river. The speed of flow increases considerably when a lock is opened, but this seldom happens in the absence of regular traffic on the waterway. In any case, the acceleration is not sufficient to stir up the silt to any marked degree.

Another factor is the high content of lime in solution. The main feeder stream is a tributary of the Liffey, the Morrell, which joins the canal between Sallins and Newcastle. This

stream flows for most of its length through limestone gravel, dissolving the calcium carbonate as it goes. One of the effects of the resulting chemical 'hardness' is to cause colloidal material from the soil to flocculate so that it, in common with the silt, sinks to the bottom, making the water not only free from particles but virtually colourless.

## The Grand Canal Basin and its Locks

The opening of the basin in 1796 was a splendid occasion. The Lord Lieutenant, the Earl of Camden, performed the ceremony in the presence of 1,000 guests, who were provided with a lavish breakfast in tents. Besides them, an estimated 150,000 other citizens came to see the fun. The basin was constructed, partly excavated and partly built up, on the level ground reclaimed from the estuary by the building of the great South Wall which had reached Ringsend by 1728. The purpose of the basin was to allow sea-going vessels to enter the canal for easy transfer of their cargoes to the barges.

In spite of the glorious inauguration of the junction between canal and Liffey — effectively completing a waterway extending across the country from the Irish Sea to the Atlantic — the basin never fulfilled its promise. Nature played a part in creating problems for the navigation. This had been foreseen by a consultant engineer, William Jessop, in 1790, and stemmed from the silt brought down by the neighbouring River Dodder and deposited in front of the locks to form a bar. Attempts by the canal company to have the mud dredged by the Ballast Board, responsible for the Liffey navigation, usually failed. The growth of the sand bar frequently prevented all but the smallest sailing ships from entering through the locks. When steam took over, the beautiful locks were found to be too small for the paddle boats. They might have been rebuilt on a larger scale, but the railways by that time had begun and the canal's importance was so greatly reduced that the locks were left in their eighteenth-century state.

The walls of the locks are built of granite, quarried from Dalkey Hill and probably brought across the bay by barge, using the system developed for the building of the South Wall. The supports for the lock gates, however, are of limestone, chosen because its finer texture allows very exact cutting and a

minimum of leakage of water at the hinges. The supports have been carved with concave outer edges to accommodate the movement of the gates. Behind the granite coping, the paving separating the locks is of limestone, grey and smooth. It was quarried 18 km away beside the canal at Gollierstown, a little way west of Lucan, the source of all the limestone used in the construction.

At the north-east end of Buckingham Lock, a broad streak of white in the grey stone is the mineral calcite. Between Buckingham and Camden Locks there is a green sward, the dominant plant being white clover. Buckingham Lock lay derelict for many years, but in 1994 the Office of Public Works replaced the old wooden gates with steel structures. They are proudly embossed with 'OPW 1994' in large letters, following a great tradition of the engineers who, from the earliest times of the canal, made sure that the dates of their achievements would remain clearly written. The locks themselves bear their names and date (1790) boldly carved in the stonework. The lock gates were opened and closed by hand, necessitating the use of long, stout beams of wood to give the required leverage. The timber, originally oak, needs to be replaced from time to time, and a number of new beams were installed in 1994. The wood is ekki, a tropical hardwood. The Office of Public Works applies a regulation that imported timber must come from 'sustained yield' forests and not from uncontrolled logging in the country of origin.

The basin is L-shaped and lined on all sides with limestone masonry. Besides the ferns which grow in its crevices, the commonest plant on the stonework of the basin is pellitory-of-the-wall, which is something of a rarity farther along the canal. At the time of building, the basin lay in a level, open space on the land reclaimed from the Liffey and Dodder estuaries by the building, first of the South Wall and later of the Dodder quay. The storehouses lining the quays were built soon after the docks were completed, encouraged by the canal directors who offered free stone from Gollierstown and a year free of tolls for the first twenty to be built.

After many years of increasing dereliction, with no activity besides the work of the ship repairers on the south quay, the basin has taken on a new life with increasing use by wind

surfers and canoeists who approach from the east quay. The north quay remains a lonely place, a habitat largely of artists and occasional exercisers of dogs. The old warehouses on the north side of Hanover Quay are constructed mainly of a dark red brick but their lower walls are of alternating courses of limestone and granite.

Buddleia grows at intervals along the quayside and attracts butterflies and bumble bees in late summer. The plants of the crevices on the quay wall include bracken and hart's tongue ferns. Gorse grows in places around the Basin, one of only two sites for the species in the inner city. The water in the basin is clear and looks pure but is, in fact, mildly polluted. Water from the Greater Dublin Drainage Scheme flows in at the southern end of the basin. It is relatively rich in phosphorous, which, although not toxic, enhances the growth of microscopic algae and of a variety of rooted water weeds. Hornwort is abundant and its presence actually reduces the growth of the algae and helps to keep the water clean. Fish, in spite of the pollution, thrive in the basin, and shoals of young roach can be seen in summer.

Hundreds of seagulls use the Basin as a resting place, particularly at high tide when they can't feed on the seashore. The majority are black-headed, outnumbering the herring gulls by about ten to one. On the rare occasions when the surface of the basin is frozen, the gulls use the thin ice as a resting place. Pied wagtails are the commonest resident birds, but one or two blackbirds live amongst the shrubs in patches of wasteland.

Buddleia on the quayside of the Grand Canal Basin.

A walk along the canal, from the three tidal locks, is inter-rupted briefly by the warehouses, but you come to the quays again after crossing Pearse Street, which, as Great Brunswick Street, was there before the time of the canals. It cut the original basin in two and necessitated the building of the drawbridge which gives such a fine view of the open water. The inner basin, so deeply shaded by the tall warehouses, was brightened in 1993 by the construction of the Waterways Visitor Centre de-signed by the architects of the Office of Public Works.

The granite railway bridge has an unusual structure: the railway crosses the road at an angle. The stones of the bridge are set at right angles to the railway line and therefore do not lie parallel to the road. For many years this bridge opened on to a dismal stretch of the canal. The basin formerly extended as far as Maquay Bridge at Grand Canal Street but was filled in and the canal reduced to a culvert between concrete banks. A decay-ing slaughterhouse added to the sense of gloom. Improvements came in the 1990s in the shape of a row of bright new offices with a little patch of lawn and flower beds. An interesting feature of the railway wall is the presence of black veins of chert in the grey limestone. To the north of the bridge, a little piece of wasteland tucked into a corner between road and canal has been colonised by Japanese knotweed and sycamore. In the spring of 1996 the abattoir was finally demolished and hopes were raised for a little landscaping.

## From Mount Street to Baggot Street

Maquay Bridge is of granite and bears the date 1790. Upstream begins the wonderful ribbon of green grass and wild flowers, which distinguishes the canal all the way through the city of Dublin. Partly by default and partly by design, it forms one of the finest of the oases in the urban desert. The banks of the canal, whether excavated or built up above the ground level, were earth-lined. Before long, grasses and clovers cover bare soil, but they need either to be grazed or mown if they are to survive since first thorn scrub and, later, trees establish themselves.

It is likely that goats cropped the grasses in days gone by, but urban sanitation requires the banishment of such livestock. First the scythe and then the lawn mower have replaced them. Fre-quent mowing allows few plants other than grasses, clovers and

daisies to grow. Where trimming takes place only once or twice a year, a host of wild flowers can thrive — and they do.

Between Grand Canal Street and Lower Mount Street, the canal is narrow, with steep banks. A modern office block and some town houses face it on the right bank. To their right, a road separates the next houses from the waterside, which is the usual pattern for the remainder of the Grand Canal's passage through the city. The only water bird that lives there is the moorhen. A curious feature of the inner-city canal is that the birds increase in number and variety as you move upstream, reaching a peak at Wilton Place, and then decreasing again as you go farther west. Winter heliotrope is one of the common flowering plants and provides little splashes of pink and white in January when few other flowers are blooming. There are also several clumps of rushes, indicating a patch of badly drained soil, too wet for grasses to grow. This stretch is seldom disturbed by boats and has a very healthy population of water weeds, including the submerged Canadian pondweed and blunt-leaved pondweed, whose narrow leaves bend over where they meet the surface.

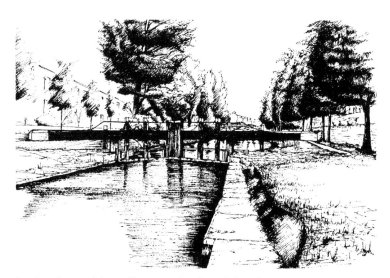

Lock at Lower Mount Street on the Grand Canal.

Lower Mount Street crosses the canal by an unprepossessing structure of concrete which replaced the stone bridge when the street was widened. The second lock lies immediately upstream. Its gates are unusual, being operated by pulleys where the widened bridge left no room for the balance beams.

In Warrington Place the spacious ideas of the planners begin to be seen. The houses are set well back from the water and there are broad banks on either side with room for some trees. The most interesting feature of the Warrington Place reach of canal is Huband Bridge at its northern end, almost in the shadow of St Stephen's Church with its pepper-canister tower. Joseph Huband was a barrister and director of the company whose commemoration at this point is of uncertain merit. He had been in favour of completing the canal at its southern and western extremes rather than pressing for early work on the beautiful Circular Line. However, in spite of being overruled by his fellow directors, he evidently came to be satisfied with the Dublin city scheme and had the bridge decorated at his own expense. He does deserve credit for thus creating one of the most pleasing crossings of the canal.

The water level at Huband Bridge is so high that it usually floods the limestone paving underneath it on the left bank. This spot is a favourite haunt of the grey wagtail, a bird that seems to adopt particular sections of the canal, in contrast to the pied wagtail, which is more plentiful and can be seen at any point. And just upstream lies the territory of the tufted duck. They are newcomers to the canal and I never saw them there before the summer of 1992. They are not permanent residents and some-times move away for weeks at a time, perhaps to Stephen's Green where several pairs breed. Two or three pairs inhabit the reach immediately downstream of Baggot Street Bridge and seldom visit other parts. In the autumn of 1994 there was a family party of five which may have nested there.

The lock just upstream of the bridge has one of the most splendid masses of the tiny flower, mother of thousands. Countless individual plants grow together on the walls, forming a curved fringe of green, the curve following the extent of the splashing of the water falling over the sill of the lock. The wall beyond the curve is too dry for the plant; closer to the lock gate it is too wet.

## Wilton Place and Mespil Road

Swans regularly build their nests on the canal bank within the city. They often attempt to choose places that are slightly inaccessible to the populace. But in 1994 a pair established their residence almost on the roadside near Baggot Street Bridge. They received generous media coverage, to such a degree that nobody dared to disturb them and they reared their family safely. Swan families need spacious territories so that, while one or two pairs nearly always occupy the Grand Canal and stay there throughout the year, the numbers are never large. Young, unpaired swans often gather in herds and used to be plentiful on the main line of the canal at Suir Road, until it was filled in.

The canal below Baggot Street Bridge is deeply excavated, making for a shady place under the railings on the left bank where hawthorn and birch are likely to be self-sown bushes. Across the water, the rears of various business premises testify to the wretched tradition in Ireland of turning one's back to the river. In the days before sewerage systems developed properly, this was perhaps a legitimate position, since many of the rivers were used for all kinds of waste disposal. In the case of the Grand Canal this form of abuse would not have taken place, partly because the canals were built in a more enlightened age and partly because they were used as a supply of pure water.

Close to the canal, the doorway of 73 Lower Baggot Street is decorated with a beautiful relief medallion entitled 'The Turnstone'. Turnstones live close to the inner city but have yet to be officially noticed within our boundary. They hunt for shrimps and other small creatures by turning over small stones and pieces of seaweed at the edge of the tide. The turnstone was proposed as an emblem for the former Medico-Social Health Board by its Secretary, Seán Trant, inspired by the idea that turning over stones to find out what was underneath symbolised the ideals of the Board's duties of looking at the major medico-social problems of Ireland. The medallion was designed by Gerrit van Gelderen and executed by the Office of Public Works.

Between Baggot Street Bridge and the Fourth Lock the canal makes a dark pool in a cutting. The right bank continues to be bordered by buildings, although a small ledge has been exposed and provided with flower pots. Pedestrians on the left bank are protected from the perils of the water by a wall of limestone

with granite coping, surmounted by iron railings. Winter heliotrope grows all the way along the waterside and there is a young sycamore. On the right bank, opposite to the lock, the embankment is held in by an unusual wall, made of unshaped granite rather than cut limestone. The coping is of neatly worked granite and there are three gateways, now redundant.

The Fourth Lock gives way to the most attractive reach of the canal, between the affluent dwellings and prestigious office blocks of Mespil Road and Wilton Terrace. The level at this point is maintained by an embankment running as far upstream as Burlington Road. What distinguishes the canal here is that it has ample space on either side. The stately houses were built facing the water, but set back at a dignified distance. Between the roads, the canal banks themselves are broad, allowing comfortable space for fine trees. The right bank has room for a wide green sward on each side of the tarmac footpath. The outer one is trimmed frequently, making it pleasant to walk on in dry weather. But the inner green is left to itself for long periods so that a variety of wild plants can grow and bear flowers.

By the water's edge some of the finest of the canal's reed beds grow. Until the 1980s, there were two species, *Phalaris arundinacea* and *Glyceria maxima*, both attaining well over one metre in height. A third one, the magnificent *Phragmites communis* is not mentioned in the *Flora of Inner Dublin* and it is hard to believe that the authors could have overlooked it. *Phragmites* now forms a fine fringing reed bed just upstream of the lock and there are smaller clumps of it farther upstream.

The dense growth of the reeds provides excellent cover for moorhen and mallard and the moorhens build their nests amongst the stems. The bankside vegetation is something of a problem in canal management. On the one hand, the boat owners would like to be free to tie up anywhere. But that would necessitate clearing the plants and seriously disturbing the wildlife habitats. In the last days of the barges there was a marked contrast between Grand and Royal Canals. The movement of the boats, combined with frequent weed clearance, made the Grand Canal a dull place from the point of view of wildlife. The Royal on the other hand was left free from disturbance and sustained a much richer flora and fauna. At present, traffic on the Grand is minimal and it is possible to keep the

centre of the waterway clear enough for the few boats, and at the same time to allow the reeds and other plants to grow. If boating returns on a greater scale, an element of zoning will have to be introduced so that naturalists and boat people alike may be satisfied.

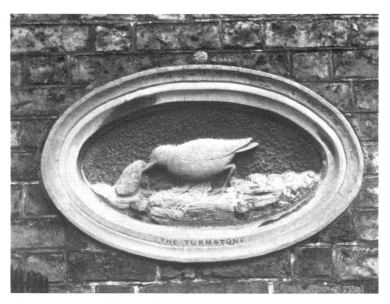

The turnstone at 73 Lower Baggot Street.

The Mespil reach is the place with the greatest concentration of water birds. Mallard and black-headed gull flock there, most of them opposite to the little garden of Wilton Place. Office workers and residents feed them, but the numbers seem to be high whether a crumb-dispensing citizen is present or not. In midwinter, sixty or more black-headed gulls rest on the water or sometimes on the bank, and mallard number forty or so in roughly equal numbers of ducks and drakes. Mallard nest amongst the reeds and grasses beside the banks, as do moorhens, but the breeding black-headed gull migrate to lakes in the midlands in spring. Herring gull fly overhead and occasionally rest on the water, but the canals are not their favourite place.

Small birds are scarce along the canal, though chaffinch and

sparrow sometimes feed on the ground and blue tit visit the trees. From May to August swifts hunt above the water which is a source of small insects. They regularly fly long distances in search of food so that their presence on the canal is no indication that they are breeding nearby. Swallows, on the other hand, are rare at this point because there are no suitable nesting places and they prefer to feed close to their homes. Swallows do live just outside our limit, at Dolphin's Barn. Pied wagtails patrol the entire canal, endlessly hunting for small insects on the ground or sometimes at the water's edge.

A few of the larger species of land bird are regular visitors to Wilton Terrace. The ubiquitous magpies nest in the trees, as do wood pigeon. Pigeons fly overhead and come to the ground for sandwich crusts and other morsels. One or two hooded crows perch in the treetops and small numbers of rooks occasionally appear. Blackbirds from the gardens of the houses across Mespil Road forage for worms in the cut grass of the canal bank.

The trees on the right bank are some of the best and oldest of the canal, but there are gaps between them, now planted with younger specimens. Elms were plentiful once, but the Dutch elm disease began to kill them in the 1960s and the only remnants are small and bushy. They may have developed some immunity to the disease and it is to be hoped that they will grow up again. The elms are able to grow to a shrubby stage because until a thick bark has developed they are not attacked by the beetles which carry the disease. Meanwhile, poplars and London planes are the dominant planted species, while sycamores have established themselves naturally.

## Leeson Street to Portobello

Eustace Bridge carries Leeson Street across the canal. Its most interesting feature is man-made, but almost qualifies as part of the natural history since it carries water from the Vartry river in Co. Wicklow into the city. Each of the two black pipes is topped with a valve bearing the maker's name: 'Park Reville & Co. Engineer'. New granite paving was laid near the bridge in the 1990s and provides an interesting contrast to the stone of the bridge itself, quarried more than 200 years earlier. The paving is smooth, while the coping of the bridge is very rough. Two of the three main constituents of granite — mica and feldspar — are

weathered relatively quickly. The third — quartz — is much more resistant. In the course of time, the feldspar and mica are dissolved away, while the quartz crystals are left standing out. Ultimately even the quartz is released and the stone effectively carried away — but that takes a great deal longer and the bridges will be good for a thousand years or more.

Just downstream of the bridge, yellow lilies grow — sometimes. The lily roots grow in the bed and produce submerged leaves which persist through the winter. The floating leaves and big yellow flowers appear in summer. The lily's problem in the canal is that maintenance dredging uproots it and therefore it goes through alternating periods of abundance and near extinction. Sufficient roots remain close to the edges to be able to recolonise the mid stream when conditions are suitable. The writers of the *Flora*, however, point out that the dredging and weed-killing which take place in the canal actually enhance the underwater vegetation in the sense of quality rather than quantity. Five species of aquatic plant grow there that are absent from the much less disturbed Royal Canal. The reason for the greater diversity is that in the Royal Canal a few vigorous species came to dominate the habitat and suppress the growth of the weaker ones.

The canal banks remain broad and open along the Grand Parade/Charlemont Place reach, though the buildings are less impressive. The old houses at Leeson Street Bridge face Adelaide Road rather than the canal, as do the office blocks. There is, however, plenty of space for trees. One of the finest of the canal-side flowers — the yellow flag — grows just downstream of Charlemont Bridge. Charlemont Place has wide grassy verges at its western end with a pleasant little grove of trees including birch, poplars and plane. To the east, where the road turns off and is replaced by a footpath, an undisturbed piece of canal embankment remains. In the little valley between it and the rear of the buildings of Adelaide Road, self-sown sycamore thrives, and ivy and red valerian grow on the walls.

Opposite to Mount Pleasant Avenue there are two little clumps of bulrush. They are the only ones on either canal and are newcomers, having appeared since 1980. A gas control building on Canal Road interrupts the tow path and a gently sloping bank has developed which is rich in wild flowers.

## From Portobello to the City Limits

One of the rarest grasses of inner Dublin grows to the west of Portobello Bridge. It is the meadow fescue, common enough in real meadows but recorded only from this one site in the city. Red fescue, on the other hand, is one of the commonest of the city grasses.

The stately building overlooking Portobello Lock was built as a hotel for canal passengers in 1805 to the design of an engineer, Thomas Colbourne. Stone for the walls came from Tullamore and the roof slates were quarried in Killaloe — both accessible by water.

Westwards of Portobello, the canal is more restricted between roads, houses, back-gardens and small industries. Trees and lawns have less space. Mallard, moorhen and black-headed gull all use the water and, from February till autumn one or two lesser black-backed gulls are often present. They are summer migrants, always outnumbered by other gulls in Ireland and generally scarce in the city.

Beyond the lawns of Portobello and the allotments of Dolphin's Barn, the left bank becomes more unkempt, and bushes of many varieties have grown up — species which would take over the banks at all points if the lawns were not cut regularly. Hawthorn, elder and willow are plentiful. Alders grow in places and the sycamore is well established. One little geological feature may be seen in the stone of Camac Bridge, which has a particularly fine display of fossil brachiopods. Beyond the city limits, the canal surprisingly becomes less interesting as a wildlife refuge. The five locks, the stone walls, bridges and grassy banks within the city all contribute to its richness and variety.

# 3

# The Royal Canal

Proposals for a canal to cross Ireland from Dublin, presented to Parliament in the 1750s, included both a southern and a northern route. The southern won the day on easily demonstrable grounds of economy, and the Grand Canal was built before long. There the matter might have ended but for the intractable nature of a director of the Grand Canal Company, who had a serious difference of opinion with his colleagues. A description of the incident by Samuel Smiles in his *Lives of the Engineers* has been quoted in most of the canal books even though its subject, whose identity is not known for certain, may not have been a shoemaker. One theory suggests the name of John Binns, another that of his business associate William Cope. Neither they nor any other Royal Canal director made shoes.

> Vowing revenge, the shoemaker threw up his seat at the board, and, on parting with his colleagues, said to them: 'You may think me a very insignificant person, but I will soon show you the contrary. I will set out forthwith, start a rival canal, and carry all the traffic.'

Start a rival he did indeed, in 1790. The problem was that it failed to carry the anticipated traffic. Completed in 1817, it enjoyed about thirty years of busy trading, shipping both freight and passengers. Within the city the canal had a branch line, heading south-westwards from opposite Glasnevin cemetery and ending in a substantial harbour at the Broadstone. In 1844 the Midland Great Western Railway Company purchased the canal, mainly to use the level ground beside it for its undertaking. A condition of the purchase, however, was that the canal would be maintained.

In spite of that, the harbour at Broadstone was filled in in 1877. By 1906 reports of neglect of the branch line had begun to be made and in 1927 it was abandoned, to be replaced by a park. Commercial traffic on the main line of the canal soldiered on, with a small rise in its fortunes during the Second World

War, but the last boat of the old tradition passed in 1951 and the canal was closed in 1966. A new life began in 1986 when owner-ship passed from CIE, a transport authority which had no use for it, to the Office of Public Works, committed to the develop-ment of inland waterways. Over the years, the Royal Canal has been transformed from a near-derelict waterway to a pleasant park — with wide open spaces about it. The banks support the finest variety of wild flowers to be found in the inner city. No fewer than 172 species are listed in *The Flora of Inner Dublin.* This may be far from the original scheme of the mythical shoe-maker, but the people of Dublin owe him a debt of gratitude for the unwitting creation of a corridor bringing wildlife and un-troubled water to the centre of the city.

## The North Lotts

The lowest reaches of the canal were excavated in the level ground of the North Lotts. Reclaimed from the sea after the building of the North Wall Quay in the eighteenth century, this land was sold or rented in 'lotts' and, as the new streets did not have to follow the boundaries of older properties, they were long, straight and level. Rocque's map of 1756 shows them in their pristine form. But the building of the canal and, subse-quently, the railway lines, broke up the pattern and led to the creation of embankments to carry the roads over the tracks.

Perhaps, in view of the rancour at the outset and the many bitter disputes that followed, it is only fitting that the waterway ends its journey from west to east in a singularly unprepossess-ing accumulation of tidal mud. Construction of a railway siding nearby confined the canal to a culvert and effectively ended its days as a connection between Liffey and Shannon. Only the most determined of urban naturalists would explore this region. Nevertheless, one morning in August 1994, my determination was rewarded by the sight of a kingfisher, a brilliant flash of colour against the grey background. It had been perched on a bush beside Spencer Dock.

The Royal Canal, even in its heyday, entered the Liffey dis-creetly, with nothing so flamboyant as the three magnificent locks of the Grand Canal Basin across the river. The entrance is narrow, but well built with big blocks of cut granite for the kerbs and neat limestone masonry beneath them. Two granite

bollards are set in the quay close to the Liffey and there is a depth gauge on the upstream corner. The rolling lift bridge was built in 1912 — a lovely piece of engineering that is no longer functional.

The neglect of the lower canal is to be reversed, with rebuilding of the lifting bridges and restoration of the final lock gate. Proposals for 1997 included construction of a lift-bridge to open the railway spur so that boats can travel from canal to Liffey. This will require careful co-ordination with the tides: low water to pass under the bridge on Custom House Quay and half tide to navigate the next reach.

Below high-tide mark, between the lift bridge and the Liffey, the stones are encrusted with acorn barnacles. Each individual has a conical shell, two or three millimetres in height, cemented at its base to the rock. Barnacles are crustaceans, distant relatives of shrimps and woodlice. Unlike most of their tribe, the barnacles spend the greater part of their lives as sedentary animals, unable to move away from their point of anchorage. The young are free-living and, after a few weeks of drifting with the tidal currents, they attach themselves to the rock surface and spend the rest of their lives in the same spot. Their presence at the canal opening is a little puzzling, since they are scarce elsewhere in the inner city.

A little piece of wasteland, where the towpath used to run, is fenced off on the north side of North Wall Quay and provides a small haven for wild flowers and shrubs. The ubiquitous buddleia is a dominant member of the group. Mallow, Oxford ragwort, ivy, nettle and dandelion abound and there are clumps of pellitory-on-the-wall.

The next point where the canal can be seen at close quarters is at Sheriff Street. Here the Midland Great Western Railway Company was responsible, in 1870, for one major positive construction on the canal, Spencer Dock, built to allow a railway siding to run alongside cargo vessels. It was partly filled in in the 1970s, making it much narrower than originally planned.

The pillars of the bridge that carries Sheriff Street across the dock are encaged in wire mesh, which nearly conceals the handsome nameplate and insignia carved in limestone. Between the railway lines and on the banks of the canal Oxford ragwort and willow herb manage to survive, buddleia is plentiful and a

beautiful elder bush grows on the bridge itself.

The water in this lowest reach is tidal and, in the absence of any traffic or need to keep it navigable, has silted up to a considerable degree. The sea lock is derelict and half-filled with grey mud. But even this spot is brightened by the small bindweed which grows luxuriantly on the lock gates and by Japanese knot grass. White butterflies, too, are plentiful.

The canal bank upstream is hemmed in by railway lines and a walk along the canal has to be postponed until Newcomen Bridge on the North Strand Road. A very much improved situation obtains onwards and upwards from Newcomen Bridge and the First Lock where the North Strand Road crosses. The name of the road pre-dates the construction of the North Wall Quay in 1750 when the road really did run along the northern edge of the tide of Dublin Bay. The rising ground, to the north, shows the line of the left bank of the Liffey in prehistoric times. Before settling into its historical bed farther to the south, it entered Dublin Bay close to Annesley Bridge where the North Strand Road crosses the Tolka.

## Locks and Excavations

Deep excavations had to be made into this bank for the canal. Charleville Avenue runs on the right bank, beside the towpath, opposite to the railway line, and leads as far as Clarke Bridge at Summerhill. There is a substantial grassy bank beside the railway line and the canal, and a jungle thrives there of interesting weeds including ragwort, bindweed, willow herb and splendid thistles. Rowan trees have been planted on the left bank.

Reeds fringe the water's edge and amphibious bistort makes patches of pink flowers amongst its floating leaves. Moorhen and mallard are plentiful, though the Grand Canal supports very much larger numbers of mallard than the Royal. They may benefit from the greater population of humans amongst the office blocks and flats along the Grand who visit the canal and contribute a liberal supply of bread. Royal Canal residents who feed the birds are, however, rewarded by flocks of pigeons and black-headed gulls which gather as soon as any of their regular benefactors appear.

The towpath opposite to Croke Park runs along a deeply excavated stretch of canal as the ground rises steadily. The 25-foot

(7.6 m) contour meets the canal at Corduff Bridge and the 50-foot (15.2 m) crosses it about half a mile farther on at Binns Bridge on Drumcondra Road, just downstream of the second lock. Small gardens extend down to the path, some of them immaculately kept, others with interesting assemblages of dandelion and dock.

Whitworth Road follows the natural rise of the land, while deep excavation and the third and fourth locks are required to regulate the canal. Redundant chimneys within Mountjoy Jail provide nesting places for jackdaws and, as a result, they are much more plentiful on the Royal Canal than on the Grand. The limestone walls of the railway cutting are richly festooned with wild flowers — red valerian is abundant, interspersed with big bunches of ivy-leaved toadflax. The towpath has been covered with tarmac and the grass verges immaculately mown. An elderly willow leans over the water at the fourth lock.

Under the grim grey limestone wall of the jail, the towpath on the right bank makes a pleasant green walk. In May 1995 a pair of swans nested there and successfully hatched a family of four. They were perfectly tame, belying the tradition of danger-ously aggressive swans, and allowed passers by to come close to the brood as they rested on the bank. Mallard and moor-hen breed there regularly. From time to time, tufted duck visit the Royal Canal, flying over from their home in the Blessington Street Basin. The heron is a frequent visitor.

Heron.

At the fourth lock, a shrubbery with cotoneaster, laurel, sycamore and willow is fenced off from the path. This provides good cover for blackbirds which like to hunt for worms on the cut grass but need bushes for refuge from cats. A factory prop-erty, extending to the edge of the water, blocks further progress along the towpath and a short diversion by road must be made to continue the walk.

This road curves around the factory boundary on the right — a modern concrete wall which incorporates pillars of older limestone masonry. These are the remnants of a dry dock which

lay at the junction of the Broadstone branch of the canal. A little farther on, a green lawn with a scattering of young trees marks the beginning of the linear park (p. 80) developed when the branch was filled in. A car park within the factory covers the dry-dock space and the entrance to the branch is closed by a low wall with a railing. Glyceria reeds grow along it in the water. On the other side of the canal, wild flowers abound on the steep banks and on the walls. Red valerian, hedge mustard and others are plentiful.

## The Wilderness

At the bridge officially titled Westmoreland, but generally known by the name of the adjoining townland of Crossguns, the scene changes dramatically. The ground rises steeply and the canal enters a deep cutting which ends in the high double locks, the fifth and sixth, at Shandon Mills. The apartment block, preserving its original mill façade, was John Mallett's iron mill, one of five water wheels in Co. Dublin, planned to use the power of the water at the locks. They were not a complete success because in dry periods there was never enough water both to drive the turbines and to maintain the level of the canals.

The fifth lock, just upstream of Crossguns Bridge, is a rich garden of wild flowers. Huge bunches of ivy-leaved toadflax hang from crevices in the stone wall. Hart's-tongue fern is plentiful and trailing grasses grow luxuriantly where water splashing from the lock gates keeps their roots moist. Buddleia bushes abound and water dropwort grows down at the bottom of the lock. There are splendid specimens of hawksbeard, a tall, dandelion-like plant.

Where the walls are wet with continuous splashing, liverworts grow. These are primitive plants, related to the mosses. But mosses can live in dry places while the liverworts must be kept permanently moist. They cover the stonework with a bright green, leafy growth.

The fifth and sixth locks are a permanent haunt of grey wagtails which, like the liverworts, seldom move far from water. The locks offer them everything they need: water to provide insects to eat and old walls with holes big enough to nest in.

Across the path from the dock which lies between the two locks, the railway goes through a tunnel and the path is bounded by a hedge of currant bushes, rather overgrown with bindweed and interspersed with elder. Mallows grow along the base of the hedge and sometimes stay in flower as late as November. Where the railway emerges from its tunnel there is a strip of waste ground, plentifully supplied with thistles and nettles.

At the western end of the dock are hawthorn and ash, and Japanese knotgrass appeared in the 1990s. Where the dock enters the sixth lock, a dog rose blooms and a sycamore has established itself. The 100 foot (30 m) contour crosses the canal banks just below the sixth lock and a benchmark 'on stonework of Up. Gate' is at an elevation of 116.6 feet (35.56 m). The canal, over a distance of only 3 kilometres from the Liffey to the 6th lock, rises by 92 feet (38 metres).

The path climbs steeply beside the sixth lock, and the towpath makes a surprisingly lonely walk, giving an impression that city and suburbs are a long way off. The effect is partly a result of the space created by the railway line, but is also caused by the fact that the high ridge, where the canal runs, forced the suburban houses to be kept some distance from it. Besides moorhen and mallard, swallows may be seen at this point in summer, perhaps their only regular haunt in the inner city. From time to time, a kestrel hovers over the waste ground and a heron also makes an occasional visit. Oystercatchers sometimes dig for worms in the playing fields to the north.

Toadflax, a flower of the waste places.

The ridge is a remnant of the thick blanket of glacial till, the conglomeration of stones and soil dumped by the great midland glacier of the last ice age. The Tolka on one side and the Liffey on the other have carried

much of this material away, creating the lower ground where city and suburbs have spread. The glacial till is composed mainly of limestone, scraped up from the plains towards the north. It drains easily, and the combination of good drainage and plenty of lime provides a habitat for a great variety of flowers and grasses. Many of the species were plentiful in other parts of the city area before homes and gardens banished them.

The canal itself, with its slow-flowing but relatively shallow water allows many 'submerged aquatics' to thrive. Its banks provide for a different group, plants such as the reeds glyceria and phalaris and yellow flags, which need water or wet soil to root in. Above the reach of the water, on the level ground, grasses and clovers take over. This sward is mown at intervals by the Office of Public Works. Between the level ground and the steep bank where the reeds grow, there is an intermediate strip: too soft to mow, too wet for trees and suitable for a number of the beautiful plants which live in damp meadows in the country: meadow sweet, water mint and wild angelica among others.

To the north of the towpath at the sixth lock, a little granite milestone carries a bench mark and the initials C and B. An elder bush stands beside it. Fifteen paces west of the milestone, a short section of a low wall of limestone begins. Limestone is the local material, abundant in quarries within easy reach, and was used for the greater part of all the masonry of the canal. However, this wall also contains two varieties of granite, a whitish, coarse-grained one probably from the Dublin Mountains and a much finer one of unknown origin. A single shining white block is a vein of calcite crystals, a deposit of pure lime formed in a crevice in the older grey stone. Opposite to the wall clumps of rush grow by the canal. Rushes, abundant in damp fields throughout the country, are scarce in the inner city.

Beyond the wall a thin strip of level ground, where elder and blackberry grow, stands at the top of a steep bank. This bank, before the days of the railway, sloped gently down to the nearly level lower ground. Railway excavations brought about today's cliff-like character.

After a short gap, the wall resumes and runs almost unbroken for the next 500 metres or so. Like the walls of the canal locks, it is richly endowed with wild flowers. There is the difference that the lock-walls have species that can accept the moist

conditions, while the higher wall is dry and has a different flora. The pale green fern, maidenhair-spleenwort, is plentiful, creeping cinquefoil sends its runners hither and thither, and tufts of yellow clover grow in places. In late summer, many tiny snails wander over the stonework. Bushes and brambles beyond the wall are kept in check by periodic burning

About seventy paces along the wall, the ground rises above it and horsetails are plentiful. The next gap is a planned opening and may have led to a signal cabin. Its curving jambs are built of a variety of stones, some of them recycled paving setts. There is a pink granite and pale blue diorite, possibly from the quarries of Ballinascornay Gap on the northern edge of the Dublin Mountains. On the opposite bank, a row of lime trees has been planted, providing nesting places for the magpies.

Hawthorn becomes plentiful along the high ground and the wall ends at a row of four delightful cottages. They were built for railway and canal workers and sold to their occupiers when the canal closed in 1966. Privet hedges border parts of their gardens and sparrows are plentiful. Greenfinches and chaffinches also use the garden space. Foxes live hereabout. They have become relatively tame and are tolerated by the people who live there — even though they brought to a tragic end one resident's attempts to keep a herd of geese.

Westward of the cottages, the railway curves away from the canal, leaving an interesting open space of dry grassland, inhabited now and again by friendly ponies. This adds another dimension to the flora. The ground is too uneven to be mown and there are not enough ponies to keep the growth of scrub in check. So the grass is gradually being taken over by bushes: hawthorn and elder around the edges and a few willows in the centre. Dog roses and blackberries grow by the towpath. There is more waste ground on the opposite bank, at this point higher than the canal which has turned to follow the north side of the ridge

The writers of *The Flora of Inner Dublin* found wild orchids growing in this region: spotted orchid, pyramidal orchid and fragrant orchid. There are not a great many and they have a relatively short flowering season. In some years very few actually flower at all so they are difficult to find and I have yet to see one. Quaking grass, bird's foot trefoil and kidney vetch are a

few of the other lime-loving plants that grow in the well-drained parts. An unusual variety found near Crossguns Bridge in 1980 was a non-stinging nettle. It was discovered by Howard Hudson, one of the foremost Dublin naturalists of the twentieth century, who brushed his hand against this nettle by accident and noticed that it had failed to hurt him. Deliberate hunting for similar specimens, however, amongst the less friendly common form is unlikely to be comfortable.

The *Flora* took the railway line, where it curves southwards towards Cabra, as the western boundary of the inner city at this point. The deep cutting which brings the railway beneath the canal adds a dimension to the natural history. Its steep sides are very much like those of a river valley. Lawn-mowers and horses are fenced out and the scrub has been left free to develop. Hawthorn is the dominant species, but elder, ash, dog rose and sycamore grow with it. Song birds abound: blackbirds, hedge sparrow, wren, robin and occasional song thrush live there. They provide a wonderful chorus early in summer while robin and wren continue to sing the whole year round. With securely-fenced factories on one hand and Glasnevin Cemetery on the other, the canal and its banks form a narrow strip of wilderness in the midst of the city.

The railway cutting was a logical boundary for the botanical studies, but the few hundred more paces which lead to the seventh lock have some very interesting features and, as late as 1997, provided a tiny remnant of genuine pasture within the bounds of the inner city. Building speculators were said to be casting developmental eyes upon the land and its days of rural freedom may be numbered.

Just beyond the cutting, the glacial till is exposed on the edge of a grass and scrub-covered hillock. It is a grey, clayey material with stones embedded in it. Most of these are limestone but there are occasional pebbles of diorite and sandstone. The hillock is the highest ground in inner Dublin, standing at about 40 metres above sea level. Hawthorn and dog rose grow around it and burdock and hogweed are plentiful nearby. Along the canal at this point, young willows are beginning to grow at the water's edge and phalaris is more common than elsewhere on the margins where glyceria is the dominant reed. Then comes the little farm, with its green pasture and even a tractor — an

islet of rural Ireland in a sea of suburbs and industrial estates.

The seventh lock stands between the railway at Liffey Junction to the south and industrial estates to the north. Its walls are covered with ivy and blackberry and a single buddleia grows from the stonework. Duckweed covers the water upstream of the lock and moorhens abound below it. Canal and towpath head off into the sunset.

# 4
# Down by the Liffeyside

## The Imprisonment of Anna Liffey

Since the eighteenth century Anna Liffey has been confined between stout stone walls for her entire journey through the inner city. Before the Vikings came, she wandered more freely over tidal sandflats, bordered by the high ground upstream of Nassau Street on the right bank and by Summerhill on the left. Downstream from these points, she broke into a number of streams which flowed between almost level sand banks to join in due course with the Tolka and the Dodder and ultimately to be swallowed up in Dublin Bay.

Sixty Viking ships sailed up the Liffey in 837 AD. Four years later, the Norsemen established a fortified settlement upstream of the original *Dubh Linn* — the Dark Pool — formed where the Poddle meets the Liffey. Excavations have shown that the first Viking quay was at the bottom of the hill below Christchurch Cathedral, underneath West Essex Street. However, the water inshore at this point was too shallow at low tide for the Viking ships. A wooden sea wall, therefore, was built farther out in the river and the tidal pool behind it filled in. The wooden breakwater in the course of time came to be known as Wood Quay, and so the urbanisation of the river began.

The natural history of the Liffey in inner Dublin is controlled in nearly all ways by the work of generations of harbour engineers who designed and built the quays in the course of some hundreds of years. The history of the port as a whole is set down in H.A. Gilligan's masterly *A History of the Port of Dublin*, published in 1988. His study provides the essential information on when and how the river came to be controlled in the interests of shipping.

A theory advanced by George Little in *Dublin Before the Vikings* suggests that the Liffey, easily forded opposite Church Street for roads going north and south along the coast, and at

the same time providing access to the central plain, made Dublin an important harbour long before the Vikings developed the town. But, besides constructing their ford of hurdles, there is no evidence that the Celtic people paid much attention to controlling or confining the river.

The Vikings constructed earthen banks so that their ships could be moored close to the shore beneath their settlement. The excavations conducted by Pat Wallace revealed traces of a series of banks and wooden walls, built farther and farther out into the old bed of the river. Eventually, early in the fourteenth century, the first stone quay wall on the south bank was made, close to the line of the present-day quays. This one, however, was not a success and was replaced some time later. There are references in the archives, from the seventeenth century onwards, to repairs being carried out to stone quays, which suggests that they had been well developed by that time. The definitive work, resulting in the present-day quays of dressed granite, began in the first decade of the eighteenth century.

In 1708, the 'Directors of the Ballast Office', as they were called, extended the south quay by arranging with the leaseholders of the foreshore to build retaining walls along the line of the present-day Burgh Quay. By 1712, reclamation of the shore along Eden Quay and Custom House Quay had taken place, and in 1715 work began on the construction of City Quay and Sir John Rogerson's Quay. The north quays were completed by 1728. Spoil from dredging the main channel of the river was spread behind the new quays to fill in the foreshore. This transformed the lower estuary of the Liffey, in the course of the eighteenth century, from tidal flats to level ground, above the reach of the water. It must have ended, too, the legendary right of Fellows of Trinity College to shoot snipe on college property.

## Change and Decay — The Chemistry of the Water

The water of the Liffey, even in its purest state before humans ever settled by its banks, has — like all rivers — always carried a substantial burden of organic material. Dead leaves, the excrement of fish and the last mortal remains of all kinds of animal life are carried downstream in suspension. In due course the human settlements added to the quantity and variety of this material. From the moment of death, plant and animal remains

begin to be broken down by bacteria into simple chemicals.

As long as there is spare oxygen dissolved in the water, this decay proceeds in a manner acceptable to living creatures. The organic waste is reduced to carbon dioxide and water for the most part, with traces of iron, sulphur, nitrogen, phosphorous and various other elements. The river water renews its supply of oxygen partly from the air and partly from the photosynthesis of the aquatic plants. The concentration of dissolved oxygen varies according to the temperature around the level of 10 milligrams per litre or ten parts in a million by weight. Although the quantity is so incredibly small, it is more than enough to supply fish with all the oxygen they need to live, and the bacteria with more than enough to recycle all natural organic waste without causing offence.

Two factors can upset this happy state: an overload of sewage in the water and an accumulation of organic particles in the mud. The overload of organic material provides such a rich meal for the bacteria that they multiply so fast that they use up all the available oxygen. The loading is measured as BOD, biological oxygen demand. When the BOD reaches too high a value, bacteria which can thrive in the absence of oxygen take over the recycling process. Their by-products include such unpleasant gases as methane, ammonia and hydrogen sulphide.

When the population of Dublin increased in the nineteenth century, the quantities of sewage carried by the Liffey reached an intolerable level and the river from time to time became a fetid sewer. Work to rectify this began in the main drainage scheme of 1906 whereby most of the sewers were joined ultimately to the treatment works in far-off Ringsend. Further improvements were introduced in 1985.

Improvements in the sewerage system greatly reduced the quantities of organic material reaching the silt on the bed of the estuary. But they could never completely remove the debris. At the surface of the mudbanks there is sufficient oxygen to render the material harmless. But a few centimetres below the surface, anoxic decay takes place, with the consequent release of gases, especially hydrogen sulphide, the gas which accounts for the smell of rotten eggs. The speed of the water flow is usually enough to dilute these gases and carry them away. Trouble arises from time to time in good summers when the high

temperature increases the speed of decay and there is not enough water to remove the gases. Bubbling up from below, the gases cause mud masses of black, smelly, spongy material to rise up and float on the surface.

## Quantities and Quality

The inner-city part of the Liffey begins at Heuston Station, where the river flows between relatively steep banks of glacial till marked by the hills of Steeven's Lane and Infirmary Road. Heuston Station itself occupies levelled ground, extending to a quay wall of granite. The factory complex on the left bank is equally well shored up. Here the river looks its best at high tide on a calm night when the street lamps are reflected from a mysterious black surface.

In daylight, the water is often dirty. This condition, however, is natural and the dirt is paradoxically clean. Turbid is a better word and it is the normal condition of estuaries. Fine silt is carried down and deposited on the river bed at this point. The incoming tide, meeting with the river water flowing in the opposite direction, causes turbulence which keeps considerable quantities of the silt in suspension.

When the tide falls, everything changes. At low water in dry weather, the Liffey is reduced nearly to a trickle and mud banks appear on either side. The mud occupies more than half the width of the river bed. The Liffey water is crystal clear and the mud banks grey and unprepossessing — but very interesting in that the mud provides a home for a variety of worms and other animals and therefore food for a population of gulls. In wet weather and flood conditions, even the fresh water at low tide is turbid, a yellowish brown colour resulting from the huge quantities of silt carried by it. A high flood covers the mud banks completely, even at low tide.

## Beasts, Birds and Fish

More detailed information on these inhabitants of the Liffey is given in Chapters 10 and 13. Bird life by the Liffey is quite limited in variety. The busy quaysides, with scant vegetation, provide little in the way of an attractive habitat. Magpies nest in the trees and from time to time pied wagtails roost in them in winter. Pigeons feed sometimes on the pavements or on

rooftops, and now and again dip down into the river. On rare occasions a peregrine falcon uses the parapets of the Four Courts as an observation post, with a view to consuming the same pigeons.

The regular Liffey birds are the gulls. Three species are present from early spring to late autumn, of which two remain throughout the year. The lesser black-backed gull is always there except in winter, but never plentiful. They have been known to nest on rooftops on Cunningham Road. Herring gulls used to be abundant, but their numbers were substantially reduced from the 1970s onwards when they began to succumb to botulism as a result of their predilection for feeding on rubbish tips. The black-headed gull is now *the* bird of the Liffey, with scores of them feeding daily on the mud banks at low tide. At high water, many rest on the parapets of the quayside buildings. Others go to the canals or ponds or down to the seaside.

Small numbers of great black-backed gulls hunt by the shore in Dublin Bay and probably move up the river from time to time but I was surprised to find that in several recent years of inner-city note-taking I never recorded even one of them. Rare gulls visit the city now and again. Over forty years ago, in January 1955, I was pleasantly surprised to meet an Iceland gull on the wall of Wellington Quay, just above the last remnants of the Dubh Linn. They have been seen there occasionally in other years. Any association between Iceland gulls and ancestral Vikings is wholly conjectural, even though there are ancient traditions of the souls of seafarers migrating to the bodies of gulls. In 1991, according to the *East Coast Bird Report,* a Mediterranean gull was seen at the Toll Bridge.

Cormorants are regular visitors to the river, likely to be seen at any point, usually at high tide. Swans turn up now and again, but the quay walls have no attraction for them. They prefer rivers or ponds with easily accessible grassy banks. Much the same is true of the mallard, which swim upstream or down but never remain for long. In summer, terns sometimes come as far upstream as O'Connell Bridge.

Grey seal and otter both visit the Liffey in the inner city from time to time. One or more seals turn up nearly every summer. The otter seems to be a rarer visitor but there are records both from the 1940s and the 1990s.

Eel, flounder and grey mullet are the resident fish. Salmon spend relatively little time in the city, simply passing through it on their journeys between spawning ground and sea.

## The Contribution of the Cammock

Just upstream of Heuston Bridge, on the right bank, an arch in the quay wall is the opening of a tunnel through which the River Cammock flows. The Ordnance Survey spells it *Cammock* but historians, fisherfolk and other Dubliners prefer the older form, *Camac*. A slightly sad little river, it rises on the slopes of Knockannavea, flows bright and clear through the Slade of Saggart and then plunges into dark culverts in the housing estates, coming up for air and light from time to time. In the inner city it appears above ground at Dr Steevens Hospital where it runs between the main car park and the grounds of St Patrick's Hospital.

The river flows out from a tunnel through twin arches, which formerly had sluice gates to control the level and, for 400 years or more, to divert water to a mill on Usher's Island at the bottom of Watling Street. The Cammock now runs between concrete walls, but, in spite of this dismal treatment, provides living space for mallard and heron. Above the walls on both sides, there is a strip of wasteland with elder and sycamore, ivy, Japanese knotweed and butterbur amongst many other wild plants. Bird life is abundant: hooded crows and gulls fly overhead while blue tits and chaffinches live amongst the shrubs. Slightly neglected in 1997, this stream could be transformed to a very attractive garden, while preserving the self-sown bushes.

The best thing that can be said about the Cammock is that its condition has improved steadily since the 1950s. For many years its water was heavily polluted and made a notable contribution to the poor state of the Liffey. The demise of some factories and the stringent application of effluent treatment from others gradually restored the Cammock to a healthy state.

At the northern end of the car park, the Cammock enters one last, long tunnel beneath St John's Road and the Heuston Station complex and emerges finally through a stone arch. On the side of the Liffey opposite to this point, there is a large brown mudbank formed by eddying of currents where the two rivers meet. It is a favoured feeding ground for gulls. Black-headed

gulls are the most plentiful — twenty or thirty or more on a busy day. In summer there are usually a few lesser black-backs, and herring gulls come from time to time. Kingfishers appear there now and again, especially in autumn when young birds are travelling far and wide in search of new territories.

## Victoria and Wolfe Tone Quays

Heuston Bridge has granite abutments and a cast-iron frame. Built in 1827 and known through most of its life as King's Bridge, it was named in honour of George IV who paid a memorable, if undignified, visit to Dublin in 1821.

At low tide, the mudbank extends nearly halfway across the river from Victoria Quay, a clear stream flows down the middle and there is a narrower strip of mud along Wolfe Tone Quay. Beneath Frank Sherwin Bridge, a reinforced concrete structure built in 1982, the stream is about 18 metres wide, while the mud extends for 30 metres. Between the tide marks, the quay walls are covered for the most part with green algae. The brown seaweed, bladder wrack, grows in isolated tufts on the walls and on some of the stones on the river bed. The salinity of the water even at high tide is not sufficient to allow it to dominate.

The outer face of the wall of Victoria Quay is something of a flower garden, even with an aspiration towards woodland. One little alder grows amongst the stonework and there are occasional sycamores. Red valerian, scentless mayweed, ivy-leaved toadflax, pellitory-of-the-wall and cocksfoot grass all thrive, some of them covering several square metres of wall. Across the river, ivy abounds in the angle between Heuston Bridge and the quay. Ivy-leaved toadflax, red valerian and a sycamore grow downstream of Frank Sherwin Bridge. Victoria Quay was one of the few footpaths on which the Engineering Department of the Corporation permitted trees (see Chapter 12) and the young London planes were planted in the 1970s.

## Ellis Quay and Usher's Island

Rory O'More Bridge, opposite to Watling Street, has had many names: Victoria Bridge, Barrack Bridge, Emancipation Bridge, while its original title of Bloody Bridge commemorates riots that occurred at its opening in 1674. Built first in wood and replaced in stone, the present bridge is of iron cast in St Helen's foundry,

Lancashire, in 1858. It bears an inscription on a limestone plaque. Limestone is not the best material for inscriptions in cities because it is very susceptible to weathering in the acid atmosphere. This one is virtually illegible.

The mud banks are narrower at Rory O'More Bridge, and the river occupies seven tenths or more of the width at low tide. Bladder wrack is much more plentiful than farther upstream. Flowering plants on the walls are few. Buddleia and pellitory-of-the-wall grow there but not in any quantity, although there is just enough buddleia to attract butterflies. The walls of Usher's Island are festooned with hart's-tongue and wall rue. Why they should thrive there and be much less plentiful on the other walls is difficult to explain. Both grow on the mortar rather than on the granite as they need a certain amount of lime. There are tufts of pellitory-of-the-wall, a bunch of nettles and a young elm tree as well. Down in the mud at low tide black-headed gulls and lesser black-backs feed.

Usher's Island appears in John Speed's map of 1610 as a rectangle, cut off from the city by a narrow tidal inlet. A century later, in Rocque's street map of 1756, it is named but stands high and dry, surrounded by streets, including one, parallel to the quay, with the unprepossessing name of Dunghill Lane. This suggests that the inlet may have been filled with rubbish and the land reclaimed. On the opposite bank in Rocque's street map, in place of Ellis Quay there is a broad inlet, about 70 metres wide and 60 metres long. Rocque marks the street behind it, now Benburb Street, as Gravel Walk and also shows a boat slip. His map of Co. Dublin, dated 1762, has no trace of the inlet.

## Arran Quay and Usher's Quay

These are the first quays to boast a thoroughly respectable degree of antiquity. Their present-day names appear in Rocque's street map, and Speed's map of 1611 shows completed quays in their position. The first bridge at the head of Arran Quay was built in 1683 and its replacement of 1768 still stands, the oldest of the Liffey bridges. It serves also as a worthy memorial to its designer, the polymath General Charles Vallency. Originally named Queen's in honour of Queen Charlotte, it became Queen Maeve and finally, in 1942, Liam Mellowes

Bridge. It remains one of the most beautiful with three granite arches and a pleasing curved profile.

Clair Sweeney postulates that a totally forgotten tributary entered the Liffey just downstream of Mellowes Bridge on the left bank. The contours of the land give a hint of the line of a valley running north-westwards towards the Navan Road. A little way downstream the western of the two branches of the Bradogue joined the Liffey. Completely covered in now and linked up with the sewerage system, the Bradogue's history is well established (Chapter 9).

Wild flowers are less plentiful than farther upstream but there are buddleia and ivy-leaved toadflax. Between the tide marks bladder wrack becomes more plentiful and the mud banks are narrower. Usher's Quay makes a claim to be the best fernery on the Liffey. Pale yellow-green hart's-tongue is the dominant species. Wall rue is plentiful and bracken grows just opposite to the petrol station.

The original Ford of the Hurdles, *Áth Cliath*, is believed to have crossed the river about 90 metres upstream of Father Mathew Bridge. There seems to be some confusion as to whether the hurdles lay flat to provide a paving of sorts over the mud or whether they might have stood up to form hand rails.

## Inns Quay and Merchants' Quay

On either side of Father Mathew Bridge, Church Street and Bridge Street rise steeply, indicating that, from the earliest times, the Liffey was confined here between relatively narrow banks. The second of the old three-arched bridges, Father Mathew's, was renamed in 1938 to commemorate the centenary of the temperance movement. The site of the bridge is the oldest in the city and the first crossing there was built in 1215 by order of King John. Carried away in 1385, it was rebuilt by Dominican friars in 1428. They built it well and it stood for nearly 400 years until a flood duly removed it in 1802. The present structure, designed by the canal engineer George Knowles, was built in 1816 of granite. Speed's map of 1611 shows the old bridge, like its successor, with three arches. The quays on both sides were well developed in Speed's time and the name of the south quay was already established, if spelt slightly differently as Marchants

Key. Although not naming the quay, the seventeenth-century map marks the Innes, a little way upstream of the present courts.

The wall of Inns Quay is unique on the Liffeyside in having a balustrade in place of the usual solid granite wall. It also has one of the oldest and best plantings of plane trees, making a worthy frontage for the Four Courts.

## Upper Ormond Quay, Wood Quay and Essex Quay

Wood Quay and Essex Quay were already well built by Speed's time and guarded by city walls and towers. Ormond Quay was quite another matter. The old map shows the main stream of the Bradogue and three tidal inlets. Reclamation of this area and building of the quay wall were carried out by Sir Humphrey Jervis, late in the seventeenth century. The Duke of Ormonde, who supported Jervis, persuaded him to alter his original plans. Jervis had intended to build a row of houses with their backs to the river. Ormonde suggested the creation of a quay with a broad thoroughfare, and to him goes the credit for giving the Liffey of the inner city its sense of space with tree-lined foot-paths rather than houses along the riverside.

Essex Quay and Wood Quay follow the line of Usher's where the south side of the valley sloped steeply down and allowed building close to the water. They formed the natural point for development of the port and the waterfront of the city from Viking times onwards. The quay walls have little in the way of plant life above the reach of the tide. On the lower parts of the walls and on stones on the bed of the river, bladder wrack has become the dominant sea weed, indicating that the water is salty enough to allow it to take over from the green algae.

## The Ancient Waterfront

Wood Quay has been tragically sanitised by the City Council who covered the old Viking city with civic buildings and green lawns — though not before archaeologists had made a very thorough investigation of the site. Numerous publications tell of their discoveries, particularly relating to the Viking settlement.

Frank Mitchell's *Archaeology and Environment in Early Dublin* gives an account of the development of the city and the gradual covering over of the natural riverside.

Traces of humans on the site go back a very long way before the Vikings. Larnian flint blades, dated to 3,350 BC were found, traces of the mesolithic hunter-gatherers. A polished stone axe head of neolithic age represents the presence of farming communities, and a bronze-age arrow head completes the succession of the pre-Celtic Dubliners.

The houses of Wood Quay and the lower part of the Civic Offices stand on more or less level ground between the river and the steeper south side of the valley. Excavations showed that, before the Vikings began to develop their town and port, a platform of limestone, covered by a thin layer of glacial gravel, sloped gently down to the river, meeting it at the level of high water at neap tides. This was in turn covered by banks of gravel and sand with salt marsh in places. About the year 920, the Vikings built a fosse and bank at the bottom of the steeper slope, along the inner edge of the salt marsh and in 1100 replaced this with a stone wall.

Salt marshes are covered by the sea at high spring tides so that the water for a few days, twice a month, would have lapped against the base of the wall. But the surface of the marsh is relatively dry and firm at other times so that building work can take place. The Vikings gradually reclaimed the salt marsh, by building a series of wooden revetments parallel to the wall and filling the space between revetment and town wall with their rubbish and with sods and mud. There is nothing new about urban rubbish tips. Where Fishamble Street meets Wood Quay there were traces of a small inlet. This seems to have survived for a long time and there are medieval records of a *fyssche slyppe*, which allowed fishing boats to land their catch for sale to the citizens in a street market.

The reclamation was continued by the Normans who built a strong defensive wall along the line of the fronts of the houses. They tipped their rubbish over this, out into the river, narrowing it more and ultimately providing a foundation for the road behind the eighteenth-century quay wall, the last of a remarkable succession of walls, revetments and defence banks spanning a period of 900 years.

## Isolde's Tower

The level ground of Wood Quay extends to the Civic Buildings, with their glistening veneer of granite. A little farther down the quay, the old houses stand some way back from the road and the decaying buildings have a good display of buddleia and other interesting wild flowers, including hedge mustard and fumitory.

By far the most interesting object is the base of Isolde's Tower, in 1995 firmly fenced in and looking rather neglected. Excavations around it left sloping earth banks — an ideal wasteland for wild flowers to invade and it was surrounded by a positive jungle: rosebay willow herb, buddleia, Oxford rag-wort and eastern rocket, among many others. The tower was a massive, circular structure of limestone, the walls about 3 metres thick. Building work which hides it began later in 1995.

## Lower Ormond Quay and Wellington Quay

Capel Street Bridge is inhabited by interesting cast-iron sea beasts with horses' heads and scaly bodies and tails and fore flippers resembling those of sea lions rather than of fish. They look friendly. Built originally as Essex Bridge in 1676, the present level structure dates to 1875 and is officially called Grattan Bridge.

Lower Ormond Quay covers what was an extensive salt marsh or mud flat. Speed's map shows a sea wall close to the line of the present-day quay. Behind it is the tidal flat, with a long, narrow lagoon between the wall and a road leading to St Mary's Abbey.

At low tide nowadays, only a few metres of shore extend outwards from the base of the quay walls. Immediately down-stream of the abutment of the bridge, where there is shelter from the main stream, the bed is covered in mud. Farther downstream, the mud is covered in rubble: mainly discarded building stones but with an interesting variety of traffic cones, supermarket trolleys and other debris of modern life. The solid objects provide anchorage for bladder wrack, and the brown weed festoons the river bed as well as covering the quay walls up to high-water mark of neap tides.

Ormond Quay above the reach of the tide is remarkably destitute of plant life. Upstream of Swift's Row, two miserable

A sea beast
on Capel
Street Bridge.

tufts of hart's-tongue struggle for survival and there are no plants whatever downstream. There are ten plane trees on the footpath. Opposite to Swift's Row is the arch with an iron portcullis in Wellington Quay where the Poddle flows in. The quay takes a small, but distinct, turn towards the north at the house No. 32. This bend is clearly marked on Speed's map and probably owes its origin to the influence of the Poddle on the far side. Swift's Row dips downhill away from the Quay, as do most of the lanes joining the quays between this point and O'Connell Bridge. It may simply be that the quay was built slightly higher than the adjoining land, but the dip may mark the position of the lagoon that was filled when the beach was reclaimed by Jervis.

Wellington Quay has two particularly interesting features. The first is the River Poddle. Even more than the Liffey, the poor

Poddle has been increasingly incarcerated and abused over the centuries. To this day it is kept beneath the streets in a series of dark culverts but, at least, it is no longer asked to carry sewage, and the water that flows out from the tunnel is usually clean.

The tradition that the Poddle formed the original *Dubh Linn*, the dark pool, is very strong and supported by logic and history. The river formed the eastern boundary both of Dublin Castle and of the old city, forcing the fortifications which ran along the banks of the Liffey to turn sharply towards the south-east. It formed a good natural harbour, sheltered from the powerful tides and occasional floods of the main river.

The other point of interest visible from Wellington Quay is an outcrop of limestone, which is the bed rock of the entire city. However, even where it is not covered with buildings, it has an overburden of glacial till. The outcrop at Wellington Quay forms an almost level pavement, visible beneath the water at low tide. In the days of sailing ships, it was known as Standfast Dick or Steadfast Dick and was the cause of several wrecks in the eighteenth century. This rocky platform provided the second ford within our area, about 800 metres downstream of the Hurdles. Its danger to shipping was one of the reasons why the old Custom House on Essex Quay was abandoned and replaced downstream by Gandon's masterpiece. Parts of Standfast Dick were quarried away for building stone from 1776 onwards and he probably had a more rugged visage in his days of wrecking.

## Bachelor's Walk and Aston's Quay

The Metal Bridge is more than just the most graceful of all the crossings of the Liffey. Built in 1816, it was an early example of the work of the iron-masters. The bridge was cast in England and floated down the Severn before being shipped from Bristol. A toll of a halfpenny was exacted from the citizens as recently as 1916 and the bridge in Edwardian times was considered an eyesore.

Bachelor's Walk was conceived as a broad quay for gentle recreation, but heavy traffic has sadly lessened its attraction. Just one small elm tree on the footpath in front of the shops tries to give an air of leisure. The quayside does have a touch of greenery in the form of eight well-established plane trees and four saplings. These and their counterparts on Aston's Quay

were planted early in the century. They were paid for by Hugh Lane, and remain the only lasting result of his dramatic plans for the Liffey, which included an art gallery bridging it. As with Ormond Quay, wild flowers are scarce: two bunches of pellitory-of-the-wall grow on the quay above the line of seaweed.

Speed shows no trace of buildings on Bachelor's Walk nor for some distance behind it. Salt marsh may have extended for a long way towards the north, forming the level ground now occupied by O'Connell Street. The quay dates to 1700.

A sea wall more or less along the line of Aston's Quay had been built some time before that and is marked on Bernard de Gomme's map of 1673. Behind the sea wall and extending eastwards to the present-day Hawkins Street, de Gomme shows as 'Ground taken in from the Sea' an open space, bounded on the south by Temple Bar and extending nearly all the way to Trinity College. The Bank of Ireland, marked by Speed as a hospital, stood close to an earlier seventeenth-century shoreline.

## O'Connell Bridge to Butt Bridge

As the reclamation work proceeded downstream, commerce and fashionable dwellings travelled with it. Carlisle Bridge was built in 1794, widened and renamed in honour of O'Connell in 1880. In spite of the ceaseless flow of traffic and pedestrians, O'Connell Bridge itself can offer a little wildlife. Two species of seagull seem to be on the move above it almost continually. Herring gulls and black-headed gulls now and again land on the water to float up- or downstream with the tide. More often they are seen in flight above the bridge or perched on the parapets, waiting for the tide to fall or for someone to empty a bag of crumbs into the water.

Pied wagtails sometimes use the plane trees on Burgh Quay for a winter roost, though their traditional sleeping place is in the middle of O'Connell Street. In summer, common and arctic terns hunt as far upstream as the bridge, swooping down to make a shallow dive and snatch small fish from just beneath the surface. They nest on pontoons in dockland, only just outside the limits of the inner city. The Portland stone of the parapets of O'Connell Bridge contains many fossil oysters.

While the south quays from the Cammock to Hawkins Street developed gradually over some hundreds of years, the extension

to Ringsend was a single undertaking. The significance of
Hawkins Street is that it marks the course of the long-buried
Stein River, an early landing place of the Vikings who erected a
pillar at the head of the inlet where it flowed. The pillar stood
there until the seventeenth century and its position is now
marked by a modern work in granite by Cliodna Cussen, put in
place in 1985.

Early in the eighteenth century, the City Council, owner of
the foreshore fronting George's Quay and City Quay, and Sir
John Rogerson, lessee of the area farther downstream, funded
the construction of the wall, begun in 1715, which has survived
to the present day. The tidal flats behind it in the course of time
were covered with dredge spoil and gradually built over. On
the north side, walls on the line of Eden Quay had been begun
about 1712. The first Butt Bridge was opened in 1879, but was
too narrow and too steep for modern traffic so it was replaced
in 1932.

## Butt Bridge to the East Link

Eels are abundant beneath Butt Bridge. I know this because I
fished for them in the summer of 1985, with the assistance of
two zoologists from Trinity College, Julian Reynolds and Russell
Poole. The operation, effected from a small boat, attracted an
element of derision from youthful bystanders but otherwise
passed off quietly. Occasionally, in summer, Liffey eels can be
seen swimming lazily in midstream but they spend the greater
part of their days burrowed into the mud, emerging at night to
hunt for small shrimps, crabs and other creatures.

The untamed Liffey occupied a very broad delta. Where Butt
Bridge now stands, it extended from the slight eminence of
Lazer's Hill, now Townsend Street, to a shoreline close to Beres-
ford Place. From this point it increased quickly in width, and at
the East Link the tidal flats were more than 2 kilometres from
north to south, bounded to the north by North Strand Road and
extending southwards to Irishtown. The estuaries of the Tolka
and the Dodder merged with the Liffey delta.

The greater part of this inner section of Dublin Bay was re-
claimed after the building of the quays. Enormous quantities of
silt accumulate in the estuary. Dublin Bay is unusual because, in
addition to the silt which every river carries down and deposits

in its lowest reaches, tidal currents sweep material from the sea bed into the bay. In the early days of the city of Dublin, the ships made a more or less perilous way between the sand banks which were continually changing shape. In 1708 the Ballast Office Act came into force and saw the beginning of systematic dredging of the river bed and the transport of the spoil to develop dry land behind the newly built quays. For purposes of administration the new land was divided into 'lotts', a term that has survived in some street names.

The reclamation works explain why Dublin's docklands are level in all directions. After the north wall was built, it was breached at the two points where the splendid iron opening bridges were built in or about 1890. The opening just downstream of Matt Talbot Bridge leads into the Custom House Docks which were excavated between 1796 and 1821. They remained hidden from the populace for many years, until their refurbishment and surrounding by new buildings in the 1990s. Now hidden under water, the docks are lined with cut limestone. The quality of the work can still be seen in the courses which stand above the surface.

One of the most remarkable of all the inner-city bird habitats was demolished in 1993. The great, grey gasometer, which stood just behind Sir John Rogerson's Quay, was the site chosen for an eyrie by a pair of peregrine falcons in 1992 when they reared three young successfully. The following year the falcons abandoned the site, although a stay of execution in the demolition work was arranged to make sure that they could use it.

I chose the East Link Bridge to mark the boundary of inner Dublin for this book. At the end of North Wall Quay, the gate of the Alexandra Basin on the one hand inhibits casual wandering, and on the other changes the scene from city to pure dockland. Sir John Rogerson's Quay extends on the opposite side to the point where the Grand Canal and the Dodder join the Liffey. Beyond them lies Ringsend, more suburb than city and for many centuries a remote community, isolated from the inner city by water. Even though there are 2.5 kilometres of quays yet to come on both sides of the river, eastwards from the bridge, the impression of open sea begins there, and the atmosphere is that of Dublin Bay rather than the Inner City.

# 5
# St Stephen's Green

St Stephen's Green may be numbered amongst the most beautiful city parks in the world. Its immaculate borders and flower beds, the bog garden and spacious lawns, trees old and young, and, above all, the pond, combine to make a paradise in the centre of the city. It is remarkable in having improved beyond all recognition since Georgian days. Malton's view shows a great, flat pasture with trees and a broad promenade confined to the outer margins. A lonely equestrian king stands in the centre. The most interesting fact about the Green of the nineteenth and twentieth centuries is that this haven of trees, shrubs, flowers and birds is an entirely artificial creation, landscaped, planted and controlled by the hand of man — and woman, its superintendent at the time of writing being Margaret Gormley.

Feeding the ducks in Stephen's Green is one of my earliest childhood memories. There was a signboard with illustrations of many species of waterfowl. At the time, in the 1940s, the only duck were mallard but a collection of exotic species had been maintained. In an article in *The Irish Naturalist* for April 1908, W.J. Williams mentions the presence of a family of Chilean Wigeon, in the context of their having attacked a lesser blackbacked gull which was attempting to catch one of their ducklings. The gull, exhausted by the attack, was duly dispatched with a stick by a Park Constable.

The tradition of feeding the descendants of the mallard is honoured to this day and continues to introduce countless children to the joy of close encounters with living animals. The mallard duck, although capable of misalliance with some of the domestic varieties present, are completely wild creatures which have made the important discovery that, in certain circumstances, tameness pays.

## The Growth of the Green

An excellent booklet on the Green, to celebrate the centenary of its opening to the public, was written by Alan Craig and

published in 1980. In it Dr Craig outlines the history of the park, which was named after a medieval chapel of St Stephen associated with a leper colony. John Speed's map of 1610 covers the site of the Green with part of his legend — suggesting that it then lay beyond the city bounds and was not enclosed within the street system.

In 1663 the City Assembly developed the area, reserving a central rectangle of 27 acres and dividing the peripheral land into 90 building lots. The rent from these lots was to be directed towards enclosing the green with a wall, and paving the streets. Each lessee was required to plant six sycamores near the wall. They are long since dead but their descendants grow in the Green to this day.

The wall was built and the ground within levelled, though it had probably not been particularly hilly. Within the wall was a gravel walk, bordered by elms and limes. On its inner edge a drainage ditch ran, bordered by a hawthorn hedge. Bernard de Gomme's map of 1673 marks this layout, and Malton's print, a hundred years later, shows fashionable citizens exercising their dogs on the gravel walk in the shade of the trees. To judge by their size, however, these were not the original trees of the City Assembly's planning.

In 1814, by Act of Parliament, control of the Green passed to Commissioners on behalf of the local householders. They improved the drainage, planted new trees and laid down curving pathways. The stone wall was replaced with iron railings, and a broad path was made on the outside, separated from the road by granite bollards joined by chains. Railings and bollards remain to this day. In this way the Green was transformed from grazing pasture for cattle and horses to a park — but the general public were expelled and admission confined to those willing and able to pay for the privilege.

Dubliners are indebted to the profits made by sales of stout and porter and the munificence of Sir Arthur Guinness, later Lord Ardilaun, for more than a century's enjoyment of the Green. In 1877, he organised the passing of the Act of Parliament, which entrusted the care and maintenance of the Green to the Commissioners of Public Works. Sir Arthur was closely involved in the landscaping, which resulted in the park's present-day appearance. Limestone blocks were brought in to form the

waterfall, and the hills surrounding it were created from spoil where the pond was excavated. The beautiful cottage for the superintendent was built at this time.

The waterfall is fed by pipe from the Grand Canal at Portobello, and the outflow of the pond returns to the canal near Huband Bridge. Alan Craig's book includes two very interesting photographs from the Lawrence Collection showing how the appearance of the Green changed between 1880 and 1900 as the trees grew.

## The Gardens

In Malton's print the centre of the Green is occupied by an equestrian statue of King George II. There he stayed until demolished by iconoclasts in 1937 — to be replaced by the circular flower bed. The fountains flanking it, bronze bouquets of lotus flowers and bulrush, together with the flower beds and the superintendent's lodge, were designed by J.F. Fuller. The rock constructions were the work of Pulham and Sons. The surrounding flower beds with their dazzling arrays of bedding plants are part of the original design. The border and the rock gardens had both gradually changed from their Victorian layout. The border was replanted in 1995, reverting to flowers popular in the 1880s, though some of the original varieties were replaced with modern forms which are more resistant to mildew and other diseases. The rock garden was cleared in winter 1995–96 to be planted with Alpines.

The waterfall had become so overgrown by the 1990s that it was no longer the major feature of the pond intended by the designers. By 1996 a plan had been drawn up to clear much of the vegetation and restore it to its former glory, with plenty of water to cascade over the ledges — as a Lawrence photograph shows. The western pond acts as a trap for the silt which is carried in over the waterfall by the canal water. Every two years — in winter to avoid upsetting the nesting waterfowl — it is drained and the silt removed by JCB. As late as the 1960s the removal was effected by a team of men with shovels and a train of horse-drawn drays. During this operation the ducks use the eastern half of the pond. Then the situation is reversed and the eastern pond is cleaned. The little bog garden to the east of the bridge is the only place where permanent water stays.

## Trees, Shrubs and Walks

The ash beside the O'Donovan Rossa memorial is one of the finest trees in the Green and one of relatively few native species. The great majority of the trees are exotics, partly on the very reasonable grounds that this is an urban garden and not a nature reserve. There is also a policy of replacing old trees with young representatives of the same species, when they fall or have to be cut down in the interests of public safety.

Most of the fine, old trees are London planes and they date from the nineteenth-century landscaping. Trees don't live for ever and the planes' age of more than 100 years is a considerable achievement. The big ashes, the holm oaks, the hollies and the Turkey oak on the east side of the Green are probably of the same age. It is likely that many of the first planting died relatively young, succumbing to the joint effects of air pollution — very much worse in the days of coal fires than in recent years — and of disturbance of the roots when underground pipes and cables were being laid.

The shrubs within the railings, quite apart from their attractive greenery, serve to insulate the Green from the noise of the traffic and its dust. They also provide the blackbirds with a favoured haunt. The laurel and other evergreens become thin and leggy with age and need replacement from time to time. A project extending over four winters, from 1993 to 1997, is rejuvenating the shrubbery, replacing the older bushes with young, but keeping to the dark-leaved species preferred by the Victorian gardeners.

There are no fewer than 200 species of trees in the Green, with more to come. New plantings will be of ornamental exotics, both for the contribution they will make to the appearance of the park and in the interests of giving inspiration to the many gardeners who come to visit. The middle-aged trees include a fine row of weeping ash on the north side and the limes which appear to be outside the park. This is not the case, strictly speaking. The fact is that the iron railings stand well away from the outer perimeter. The pavement around the Green shares with the lime trees and bollards a degree of extra-territoriality. Stephen's Green is managed by the State, through the Department of Arts, Culture and the Gaeltacht, and not by the City Council. The pavement on the east was known as Monk's Walk.

On the south, in front of Iveagh House, was The Beaux' Walk and the west and north sides were French Walk and Leeson Walk respectively.

Birches by the pond in Stephen's Green.

## The Pond and its Birds

The pond, surprisingly, is a slightly sterile environment. If it were left to its own devices, many kinds of water weed would

grow there and, in the course of the hundred years of its exis-
tence, would have choked the pond completely. The bed is
therefore drained and cleaned every two years. This means that
relatively little natural food is available for the waterfowl — but
the lack is more than compensated for by the breadcrumbs,
liberally dispensed by the populace, and by grain provided by
the authorities in winter.

Mallard are *the* ducks of the Green and have lived there for
generations. A number of pairs nest amongst the shrubs on the
island and in the fenced-off parts. Some deviationists go farther
afield, making their homes on the College of Surgeons and even
far-off Leinster House. Apparently they have greater security on
these august buildings over the month during which the female
sits on the eggs. But the ducklings must have open water as
they grow up, and so the mother duck has to conduct her brood
across the busy roads. This perilous journey needs to be made
only once by each family, since ducks abandon their nests as
soon as the young are hatched.

Mallard begin to breed early in the year and the first broods
appear on the pond in April. The downy ducklings are amongst
the most delightful of all wild birds: coloured in subtle shades
of green and yellow-green, with black bills and beady eyes.
They follow the mother duck or patter hither and thither across
the water, hunting for insects. Life for the ducklings is harsh:
eight or more eggs are laid and hatch, but most of the young fall
victims to cats or other predators within the first few days of
hatching. Every day that passes leaves them a little less at risk,
and those that survive long enough to develop their wings fully
have a good chance of living for many years.

The other long-established resident of the pond is the moor-
hen. Two or three pairs live there throughout the year but the
numbers are limited because the moorhen has very strong
territorial instincts and preserves a large area of pond margin
for its domain. Ducks and gulls are tolerated, but other moor-
hens besides the mate of the dominant bird, are driven away.
From time to time, angry pursuits of intruders take place, but a
balanced situation develops: the neighbouring birds quickly
learn to recognise and accept the boundaries of the territory and
feed peacefully within their own. The nests are built amongst
the branches of bushes that grow close to the surface of the

water. Fringes of reeds, which the moorhen would prefer for a nest site, are absent from the Stephen's Green ponds. Families of moorchicks may be present in any month from April to September, though the majority breed early in the year. The downy chicks are black and about the size of golf balls. The young of the year, with brown feathers, can be seen as late as November.

One more water-bird has taken up permanent residence in the pond. This is the tufted duck, and its presence needs a lot of explaining. Mallard are largely vegetarian and can thrive on breadcrumbs and grain topped up by any convenient animal protein in the form of worms or insects. But the tufted is a 'diving duck', which, in the normal course of things, hunts beneath the surface for insects and other invertebrates. Because of the regular draining and cleaning of the pond, these are relatively scarce in Stephen's Green. This would easily explain the fact that tufted duck were seldom seen there before 1980. Indeed, Alan Craig does not even mention them in his booklet. The mystery is what made them move into the Green and what change in their lifestyle now enables them to live there.

One or two tufted duck visited the Green now and again in the 1980s, having possibly migrated from the Blessington Street Basin where they were established for longer. The pioneers kept to themselves, usually staying a little way out from the shore and refusing to be lured by the providers of breadcrumbs. In 1982 three pairs were deliberately introduced and they probably were the first to breed in the Green. Nesting was successful and the population increased steadily. In the winter of 1995–96 there were more than fifty, and their feeding habits had developed to meet the increased pressure. While some continued to make their dives and swim under water, others joined the mallard and came to the shore for bread. Tufted duck have a much shorter breeding season than mallard and the young are seldom to be seen before the end of July.

Pintail, wigeon, mandarins and Carolina wood duck were released in the ponds in the 1980s, and the pintail and wigeon lived there for some years. The more exotic species disappeared before long — nobody seems to know what became of them.

The other waterfowl are visitors to the pond as opposed to the true residents that breed there. Black-headed gulls are the

most plentiful, eighty or more being present from time to time. Their numbers reach a peak at lunch-time on working days when the supply of breadcrumbs rises to a maximum. The gulls use the pond partly as a safe refuge, where they can sit and rest or preen their feathers, and partly as a vantage point from which they can swim or fly to the shore to join in when anybody begins to feed the ducks. While some relax on the water, others are in flight, constantly on the lookout for food.

Herring gulls used to outnumber the black-headed. They are bigger and stronger and may attack and eat the baby ducklings. Complaints about this behaviour from the citizens led the Green authorities in the 1960s to put up a notice asking people to stop feeding the gulls — the theory being that if there were no crumbs, the gulls would stay away. The only result of this prohibition was that the ducks got less bread and many an obedient child was disappointed at not being allowed to feed them. The gulls, predictably, stayed around. Two factors had not been taken into account. Firstly, herring gulls, although the seaside is their principal haunt, use freshwater to bathe in whenever it is available. And, secondly, during the breeding season they are constantly on the watch for ducklings and other young birds that live on the ground.

In the end, the herring gulls themselves began to disappear. They developed a habit of feeding on rubbish tips, and a great many died from botulism. The decline began in the 1970s and, from being the dominant species, these gulls have now become almost a rarity. In the past they were seldom absent from the pond but in the 1990s there were often none at all, though one or two could usually be seen in flight overhead.

From time to time, swans come to stay — these are often young birds that have not found anywhere with space for nesting. A pair nested in 1994 and raised one cygnet. On very rare occasions an Iceland gull has spent some of the winter months in the Green, though possibly never since the herring gulls departed.

Finally, there are geese and domestic ducks of various kinds. In the past, some of these had flown over from the Dublin Zoo and decided to stay. They include a Canada goose and a number of its descendants of uncertain parentage. The most interesting of the visitors was a flock of bar-headed geese, birds

imported from India which enjoyed a free range in the Zoo. For many years they flew in to the city daily and could be seen in the evening making their way homewards above Grafton Street.

## The Garden Birds

The Green has just the right mix of trees, shrubs, lawn and flower-beds to attract most of the common hedgerow and woodland birds. Blackbirds may be the most plentiful and are certainly the most conspicuous of the residents. The glossy black males are much more inclined to hunt in open spaces than are the more quietly coloured, dark brown females. They use all parts of the park, wandering over the lawns or hunting in newly dug soil for worms. In winter they shuffle through the fallen leaves, searching for insects. And in the early months of summer, the blackbird's song is the main contributor to the bird chorus.

Mistle thrushes nest in the taller trees and find most of their food on the lawns, as do their enemies, the magpies. Robins keep more to the cover of bushes but feed on the ground, taking particular advantage of the work of the gardeners whenever digging of the flower-beds reveals insect larvae. Song thrushes became rather scarce in the 1990s and, in any case, are more shy and retiring than the others. The two thrush species and the robin sing throughout the year, the robin more than any. Indeed, winter and summer, one or more robins will be in song nearly all day long. Flocks of starlings come by from time to time, especially in winter, but don't seem to take up residence. The two winter-visiting thrushes, redwing and fieldfare, make occasional visits to the Green, most frequently in really cold weather and seldom before Christmas. The lawns around the bandstand, with their numerous trees for refuge, are their favoured spot.

The dense hedges provide good cover for wrens and a small number of hedge sparrows. The trees and more open shrubs are the haunt of blue tits and, from time to time in winter, of coal tit and goldcrest. The great tit is a rarity. Nesting boxes were put up in 1991 and provide safe dwellings for many blue tits. They are provided by the Irish Wildbird Conservancy, and Ray Wills, who took care of them in 1995, reported that six out of twelve had been occupied, three had gone missing and two or three showed no signs of use. They are checked and cleaned in winter

and replaced early in spring.

Chaffinch and sparrow live amongst the hedges, and both are fearless hunters for crumbs at the feet of citizens relaxing on the park benches. Pigeons and, less often, wood pigeons join them as they forage on the paths. The special feature of the Green, from the point of view of bird-lovers, is its popularity for humans. The birds, over many generations, have come to accept people at worst as a harmless part of the environment, at best as a source of food, so they have become more tame there than anywhere else in the country.

Other birds of the Green include the pied wagtail, which is a regular visitor, especially on the pavement around the ponds. The chiffchaff is an early spring visitor and can be heard singing in April. The grey wagtail is rarer and likes the splashing of the waterfall. Blackcaps have been seen in winter from time to time and there has been one record of a spotted flycatcher. The most unusual happening in recent times was the arrival of a flock of waxwing in February 1996. And, a long time ago, in the first half of the nineteenth century, the barn owl was a regular visitor.

## Blow-ins

Now and again, the Green attracts unusual visitors. In the 1960s a fox took refuge in a tree and became one of the most celebrated inhabitants, his photograph making it to the front pages of the daily papers. Left to himself, he might have climbed down again and retired into oblivion. But the authorities summoned help from the Zoo, which dispatched two athletic officers, suitably furnished with protective clothing. They climbed the tree, apprehended the fox and put him in a bag. Public opinion, happily, required that he be taken to a safe place beyond the city and returned to the wild.

I have already mentioned the bar-headed geese and occasional Iceland gulls. The latest arrivals are equally exotic, but more domesticated. In or about 1990, French rugby supporters brought cockerels with them as team mascots. The men departed in peace — but the birds suddenly appeared in the Green and there they have stayed. Persons unknown felt that they needed female company, and so some bantam hens were introduced. The Green authorities have mixed feelings about

them: while the colourful Black Minorcas and other breeds attract a great deal of attention, they themselves are attracted by succulent, young bedding plants, to the extreme consternation of the gardeners. So the fowl are just tolerated and live in peace — but there are no plans afoot for adding to the collection.

London plane in Stephen's Green.

# 6
# Trinity College

Walking through the Front Gate of Trinity College is akin to entering a sheltered harbour on a stormy day. Outside, the frenetic world goes by, a storm of noise and exhaust fumes. Within is the tranquillity of the elegant eighteenth-century squares, the immaculate lawns, ancient trees and people old and young, tourists and scholars. The few cars permitted are aware of being second-class citizens, expected to serve and not to dominate.

The site has been a place of worship and learning at least since 1166 when the priory of All Hallows was founded by Dermot McMurrough. Its north wall ran close to the top of the tide in the Liffey estuary, and there is possibly an element of truth in the tradition that snipe were hunted within the precincts. In 1539, following the suppression of the monasteries in his realm, King Henry VIII granted the priory to the citizens of Dublin and they, in 1592, presented the property to Queen Elizabeth as a site for the university she was planning. In 1594 the 'College of the Holy and undivided Trinity near Dublin' was opened. At the time a considerable expanse of commonage pasture, Hoggen Green, separated the college from the city.

Patrick Wyse Jackson in *The Building Stones of Dublin* gives a comprehensive guide to the geological sources of many of the buildings. The lower courses of the red-brick building, the 'Rubrics' were built in 1700. The upper storey was added in 1894 and contains some stonework, Triassic sandstone possibly from Scrabo Hill in Co. Down.

To the south of the Rubrics stands Thomas Burgh's magnificent library. Its lower storey, originally an open arcade, is of calp limestone quarried near Palmerstown. Ballyknockan granite was used for the upper storeys. The pale stone of the cornices is St Bee's sandstone from Cumbria in England. This, the original cladding material of the upper storeys, weathered quickly and was replaced by the much more durable granite.

Wicklow granite is the stone used in most of the eighteenth-

and nineteenth-century buildings of the college. Its crystalline structure, however, makes it unsuitable for fine sculpture, so the Corinthian pillars and other decorative details are of Portland stone. The campanile has a granite base and cupola of Portland stone. The dark grey residential buildings of Botany Bay are of calp, with granite window-sills and doorways.

The Museum Building — also known as the Engineering School — was completed in 1857. Granite and Portland stone were again used, but the treatment is of Victorian flamboyance in contrast to the classical severity of the older buildings. Some of the details failed. Irish marbles were used for the circular panels on the outside, but the atmosphere of nineteenth-century Dublin was heavily smoke-laden and the polished surfaces decayed quickly. However, the interior remains magnificent. Ten different Irish marbles and a rare serpentinite from Cornwall were used for the pillars. Yorkshire flagstones and Welsh slates form the floor, and the interior walls are of oolitic limestone from Caen in France.

Planned as a museum with spacious halls to display the wonders of the world, the building was subdivided bit by bit. Lecture theatres, libraries and offices replaced the exhibitions, and the museums were relegated to display cases and one or two relatively small rooms. The skeletons of two great Irish deer guard the staircase. These superb animals roamed the country after the last glaciation. A surprisingly large number perished in peat bog where their bodies sank and the bones were preserved in the acid soil.

College Park with old Library and Museum Building.

The wall that runs along Nassau Street is of calp limestone and in places supports abundant fern life. Hart's-tongue is the dominant species, but polypody and bracken, both rather scarce in the city, were growing there in 1996. St Patrick's Well, an important source of water in late medieval times, lies at the foot of this wall — indeed Nassau street was once known as Patrick's Well Lane. The old well has been covered over by the entrance to the Arts Block.

## Trinity Birds

The playing fields of the park provide the greatest open green space within the city. With the trees largely confined to the periphery, the park has something of the air of the great country estates — with the difference that in the country the grass is kept short by grazing animals, while in the city the lawn-mower replaces them. This does not greatly worry the birds and worms and soil insects whose concern is simply to have short grass. Many of the birds that use the park are species that inhabit pasture elsewhere. *Birds of Trinity College* by Brian Madden, Lynn Mitchell and Tom Cooney listed fifty-eight species at the time of publication in 1993. Six have since been added.

Rising numbers of students have led to greater use of the fields by vigorous persons, and a consequent reduction in the time available to the birds for undisturbed feeding. This may explain the virtual disappearance of the common gull from the rugby pitch. In the 1950s they were regular inhabitants in the morning through the winter, and College Park was one of few places in Co. Dublin where they could be seen. Nowadays they are relatively rare visitors, though still present from time to time in 1996. One or two herring gulls can nearly always be seen in flight over the college and on winter mornings feeding on the playing fields. Although they are less plentiful than in the past, the Trinity herring gulls are considering taking up residence on the campus where they have been seen prospecting for nesting sites. From time to time in wet weather, when the ground is soft, black-headed gulls descend on the playing fields to hunt for worms.

At least since the 1950s, the park has been a haunt of hooded crows, birds which usually keep to the trees but are constantly on the watch for scraps of food — they will eat almost anything.

Hooded crows require large territories, and a single pair occupy College Park, tolerating their own family perhaps for a few weeks before packing them off to take care of themselves. Mistle thrushes and wood pigeons also find the combination of tall trees and open spaces especially to their liking. Like the hooded crows they nest in the trees and feed mostly on the ground. The thrushes dig for worms and grubs, while the pigeons graze. Both eat berries when these are available.

For some years, linnets have been regular residents in winter. One or two linnets might not be remarkable, even though they are birds of gorse and heathland, rather than garden dwellers. But in Trinity they gather in the park in large, loose flocks, as many as one hundred together. When some find something interesting to eat, others spot them and more and more fly in from the trees round about until the grass seems to be covered with them. Lawn seed is said to be an important part of the diet.

Blackbirds and robins favour the squares of the west end of Trinity College, where shrubs provide nesting places and flower-beds give open soil where insects and worms are easy to find. Pied wagtails, magpies and pigeons rest or forage amongst the buildings as well as over the open spaces. Wren and hedge sparrow haunt the shrubs, while blue tits keep more to the larger trees. Swifts nest in spaces between the cornice and eaves of the Museum Building; their numbers are reckoned at about ten pairs, but they are extremely difficult to count because several pairs can use the same entrance hole to the nesting place. As they travel for miles on their regular hunting expeditions and nest in many old buildings in all parts of Dublin, much larger numbers visit the college than actually reside there.

Besides the resident birds which can be seen throughout the year or for the entire summer or winter, many species spend

Swift.

some weeks in the college on passage or visit for short periods. Chiffchaffs can be heard singing amongst the trees for a few weeks in March and April and sometimes in autumn in the course of their migration. Redwings are often plentiful in winter, and fieldfares come occasionally.

*Birds of Trinity College Dublin* names about thirty other species which turn up now and again. The most remarkable of all was a squacco heron, a species that is extremely rare in northern Europe. An exhausted young bird found in October 1967 was only the twelfth Irish record. The woodcock is another extremely unlikely visitor. One was seen in the 1980s, and in November 1995 Lynn Mitchell disturbed another from some leaf litter in the Provost's Garden.

## Trees of Trinity

Trees have the advantage for writers that they stay in one place and a guidebook can lead you to them. *Trees of Trinity College Dublin* edited by David Jeffrey contains descriptions by the late David Webb, a most distinguished Professor of Botany for many years. The booklet describes seven specimens in Front Square, sixteen in New Square and twenty-seven in College Park. It concentrates on the exotics, all of them beautiful, many of exceptional interest because of their rarity or history. It is surprising that very few are of any great age, and the majority listed have been planted since the 1970s.

The most splendid trees in the college are the two Oregon maples to the east of the campanile. There were four originally, the other pair being in the lawn to the west. One was blown down in a storm in 1945 and its companion was brutally removed in the interests of symmetry a few years later. They were replaced by birches, probably a Far-Eastern variety, but one that puzzles the experts. Another Oregon maple stands in New Square, but the two senior maples in Library Square are reckoned to be the oldest trees in the college, possibly pre-dating the Famine.

The pair of oriental planes at the north-west corner of the main lawn in New Square are also senior members of the tree community. They were planted before 1870 and may be as old as the Oregon maples. The flowering ash, described in *Trees of Trinity*, has departed this life. Mature trees on the south side of the park, below Nassau Street, include Lombardy poplars,

which alternate with a smaller tree, *Malus x eleyi*, described unappetisingly as a hybrid crab. It is a cross between two crab apples, raised by Charles Eley in England early in the twentieth century.

## The Development of College Park

Charles Brooking's map of 1728 shows the main buildings of the college occupying the site of the eighteenth- and nineteenth-century squares. St Patrick's Well Lane runs to the south. To the north, College Street occupies its present position and leads to Lazer's Hill. There is no trace of the western portion of Pearse Street. There are buildings on both sides of Lazer's Hill and to the north of College Street. But to the south of the Lazer's Hill houses there is open space, extending nearly all the way to St Stephen's Green to the south and as far as the Dodder to the east. St Patrick's Well Lane was renamed Nassau Street, and Lazer's Hill became Townsend Street.

Dawson Street and Grafton Street are both named by Brooking. Between the college buildings and St Patrick's Well Lane there are two large formal gardens. The western of these survived as the Provost's Garden until the Arts Block was built in 1977. The eastern one was built over in part by the Berkeley Library in 1967. Trees are shown on the four sides of the main playing fields, surrounding a space that is open except for a great circle of trees in the centre. Seven fields, enclosed by hedges, have been replaced by the rugby ground to the north, and the science and medicine blocks to the east. These fields extended to Cumberland Street; Westland Row was a later addition and followed the line of a hedge.

Rocque 's map of 1756 shows that a road had been built in the position of Westland Row by his time, as had the main road which bisects College Park. Rocque has also inserted a remarkable N-shaped stream, extending from the bottom of Merrion Street to a half-completed Pearse Street. Its northern limb is lined by an avenue of trees. This may have been an open drain, to cope with flood water on the low-lying ground. An automatic pump operates to this day behind the Zoology block and raises the drainage water to the main storm sewers at a higher level.

St Patrick's Well is marked by Bernard de Gomme in 1673, to

the north of Leinster Street, roughly at the junction of Clare Street and Lincoln Place. In spite of its being marked clearly by de Gomme, the exact position of the well has been disputed by various authorities. The existing well is beneath Nassau Street, with an opening, now screened by a grille, beside the entrance to the Arts Block. There could have been more than one well along that particular line. Clair Sweeney tells that, in pre-Reformation times, major celebrations were held there on St Patrick's Day, attended on occasion by the Archbishop of Armagh. The supply of fresh water was abundant in ancient times, but it had dried up by 1731, probably as a result of other wells tapping the supply. John Rutty in 1757 described the water as saltish: evidently by that time the ground water in the park had been contaminated by the brackish water of the Liffey.

# 7
# The Smaller Parks

Dublin Corporation manages twenty-five parks within the inner city. In addition, there are privately-owned spaces such as College Park and the King's Inns Fields where citizens are permitted to wander. Most are very beautifully landscaped and tended, while a few are rather basic, receiving little more attention than occasional trimming of the lawn. Even the most neglected creates a breathing space amongst the stone and concrete: a place for people to sit and for birds to forage. The best are refuges for birds and sometimes butterflies and bees. They are the parks where, as in Stephen's Green, there are flowers for the insects, and trees and shrubs for the birds to shelter in, with wide open spaces where they can feed in safety.

The size of the park is a major factor in its attractiveness to wild creatures, but the variety of planting and the extent of the open space are important, too. Merrion Square is big, varied and wide open. The Blessington Street Basin is small but its lake gives an added dimension. The shrubs of St Audoen's Park are so luxuriant that few birds can live there because there is too little open space. Wolfe Tone Park is small but has plenty of lawn and about the right numbers of trees and shrubs to bring blackbirds and others into the very centre of the city. O'Connell Street isn't a park — but its trees are enough to provide nesting places for four species of birds and a winter roost for others.

Some of the parks are long-established, but no fewer than half of the twenty-five tended by the Corporation have been developed since the mid-1980s. This is far from the end of the story. The officials give an impression of being constantly on the prowl, ready to seize and beautify any suitable open space for the greater glory of the city and enjoyment of its citizens.

## Archbishop Ryan Park, Merrion Square

The land that became Merrion Square lay just a little way beyond the reach of the tide. It is shown in Charles Brooking's

map of 1728 as a number of fields lying to the east of 'Merryon Lane'. John Rocque in 1756 indicated that the fields were separated by hedges. A road, unnamed by Rocque, continuing from 'St Patrick's Well Lane', has been replaced by Grand Canal Street. In the seventeenth century this road had run along the edge of the strand and marks the boundary of the land reclaimed after Sir John Rogerson had built his sea wall. Maurice Craig quotes a pleasant tale of how, as late as 1792, a breach in the sea wall led to flooding, which enabled the Duke of Leinster to make a boat trip and land safely at Merrion Square.

The planning of the square began in 1762, and building of the houses continued for more than thirty years. It seems that no special attempts were made to develop the park, and a drawing published in 1895 shows a large open green with a few isolated trees. For a long period, Merrion Square was Diocesan property and was kept closed to the general public in anticipation of the building of a cathedral. A stone tablet at the gate on the east side of the square justly honours Archbishop Dermot Ryan, who made the decision to abandon that project, and records that the St Lawrence O'Toole Trust in 1974 leased the site to the Corporation for use as a public park. The Corporation's Parks Department moved in and created a garden to rival its neighbour Stephen's Green, with a combination of spacious lawns, exquisite flower beds, and footpaths shaded by hedges and shrubs.

The gardens are decorated not only with distinguished sculptures, but with a most interesting collection of Dublin's lampposts. Twenty in number, they had languished in an obscure Corporation store until rescued by an enlightened official. Cleaned and brightly painted, some ornamented with the city arms, they now illuminate the pathways of the square, conjuring memories of grace and gaslight of times gone by.

The boulder at the north-east corner of the square, across the road from Sir William Wilde's house, which forms part of the Oscar Wilde memorial, is quartz. This mineral usually appears as small crystals in granite rock or in narrow veins. Massive chunks like this one are rare. It came from Aughrim in Co. Wicklow.

On a sunny day the park is a riot of colour: green grass ornamented by flowers and by the populace in bright summer

dresses. Butterflies are plentiful, mainly small tortoiseshell, but in late summer red admirals regularly, and painted ladies occasionally, appear there. In winter there are fewer people and less colour, but the birds come into their own, with robins, thrushes and wrens singing, blackbirds busily hunting over the lawns, and blue tits in the trees. Fieldfares visit now and again.

Except when a flock of starlings invades the park, the blackbird is the most plentiful species. The combination of numerous bushes in which they can nest safely, and extensive lawn for digging for worms, makes an ideal habitat. Berries on many of the shrubs provide an important supplementary food for them in autumn and well into the winter. Bullfinch and greenfinch are often present. Blue tit, wren, sparrow and hedge sparrow are always there, and coal tits come in winter. Chiffchaffs visit the square on migration in March and April.

Mature trees are remarkably few. London planes were planted close to the railings, perhaps towards the end of the nineteenth century. The specimen in the north-east corner is shrouded in ivy, suggesting that it is well past its prime. Vigorously-growing plane trees have no problem in suppressing the growth of ivy. A big plane beside the south gate is a favoured nesting place for one of the several pairs of magpies that live in or around the square. The only other large tree is a holm oak, near the centre. Laurel and holly are the dominant shrubs which form a screen inside the railings, shutting out sight, sound and smell of the traffic. Both species look slightly unkempt and are probably self-seeded to some extent.

Perhaps the most exciting resident of Merrion Square is the vixen whose earth is concealed somewhere in the undergrowth and whose cubs may be seen by the truly committed naturalist. The gardeners of Merrion Square, while rejoicing in the presence of such distinguished wildlife, have a conflict of interests when the fox population turns its attention to grubbing up prized plants.

## Berkeley Road

This triangular park, the property of the Mater Misericordiae Hospital but tended by the Corporation, lies in front of the hospital and beside St Joseph's church. Although always bright with carefully tended flower-beds, it seems to have been created

Holm oak in Merrion Square.

to be admired rather than visited, since the gates are firmly padlocked against the populace. In 1996, hooded crows nested high up in the large plane tree near the church. The only other well-established trees are two big hawthorns. Magpies and blackbirds, which nest in nearby gardens, hunt for worms on the lawn.

## The Blessington Street Basin

To walk up the hill between the faded glories of the houses of Blessington Street, find an unexpected gate and railings and suddenly discover a hidden garden surrounding a pond with an island is a revelation no citizen can forget. Like many Dubliners, I was totally unaware of the existence of the Basin. It was on a summer evening, about twenty-five years ago, that I happened to make its acquaintance. At that time the garden was not the greatest, and the pond was surrounded by a dense hedge. A few senior citizens were relaxing on the seats. The pond was peopled with tufted duck and mallard, and many sparrows chirped in the hedge.

The Blessington Street Basin.

Much has happened the Basin since then. Its history, spectacular recent developments and present state are described in a little book, *Basin at the Broad-stone*, by Jerry Crowley, one of a group of local people who saved it from over-zealous improvement. Nowadays the park is more open, the dark hedge has gone, sculptures and a fountain have been introduced and the slight air of dinginess has vanished for ever. But still the Basin retains its secrecy, waiting to surprise and delight casual visitors who wander up Blessington Street or turn in through the un-obtrusive little black door with granite surrounds, which opens on to the Broadstone Park to the west.

The Royal Canal Company in 1803 suggested to the City Council that the canal could provide a reliable water supply. In 1807 plans for a reservoir were agreed, excavation began and the Basin was completed three years later. It was used to supply domestic water for the following fifty years but enjoyed a very much longer working life as the principal water source for the Jameson Distillery in Smithfield and Power's on High Street. The excavated soil was used partly to build up the south side of Dorset Street, and partly for the embankment of the canal

harbour at Broadstone. The delightful 'neat gothic cabin' for the Basin Keeper was built shortly after the excavation was completed.

The pond is 125 metres long, 58 metres wide and 2.5 metres deep on average. A high wall of quarried limestone surrounds it on three sides, while railings and a hedge guard the eastern approaches. The uneven grey calp stones of the old wall are relieved in places by blocks with a coating of white calcite crystals, and in others by veins of black chert, two or three centimetres thick.

In 1991, a scheme to develop the park was announced. It entailed removing the western wall to open it to the Royal Canal Bank, enlarging the existing island, and adding a new island with pavilion and bandstand. Had the Basin been a derelict site, the plan would have been admirable. Its error lay in the belief that a small and simple entity of considerable age and great charm could be improved by a major transformation.

The nearby residents, who had loved and used the park for generations, protested. The City Council agreed with the local Action Committee and a scheme for repair and restoration with a relatively small element of innovation was adopted. The work included the removal of 6,000 tons of 'accumulated sludge and rubble' from the pond, rebuilding of its masonry lining and laying of new paving. New trees included weeping willows at the corners of the pond and birches in the flower-bed on the north side. Flower-beds have been replanted and low-growing shrubs around the pond replace the old hedge. The arm-rests of the iron seats are embellished with the heads of hounds, while the legs coil as serpents. Above all, the high walls which contribute so much to the 'secret garden' quality of the park were retained, after repair and repointing. Work began in April 1993 and the restored park was declared open to the public, on 4 November 1994, by President Mary Robinson and, most appropriately, a Green Party Lord Mayor, John Gormley.

When the pond was drained in 1991, the dominant fish species present was the rudd, silvery shoaling fish with red fins which were introduced to Ireland in the seventeenth century or later. Until quite recently they were regarded as 'trash fish' whose presence inhibited the very much more popular trout.

Various factors, among them competition with a similar species, the roach, led to a major decline in rudd populations over much of their European range so that they are now regarded as rarities in need of conservation. The rudd of the Basin were transferred to the Royal Canal by the Eastern Regional Fisheries Board staff and, it is hoped, will return to the Basin and thrive. Of no great value as food, they are excellent park fish because they swim near the surface in the open water and can be seen. Eels also lived in the pond and will make their own way back through the supply pipe that brings in water from the canal.

The pond, or at least the outlet area at the Blessington Street gate, is the inner city's best site for duckweed. The walls of the outlet provide the shelter from wind which it needs and the surface of the water is covered with the tiny pale green one-leaved plants.

Jerry Crowley gives a remarkable list of no fewer than forty-eight species of birds seen in or around the Basin in 1991. The majority were more or less casual visitors, and the actual residents or regular visitors to the pond number about twelve. A pair of swans pay long visits from time to time. Mallard are plentiful and always have been. Tufted duck are the most interesting residents. They established themselves in the Basin in the 1970s, or perhaps a little earlier, and they nest on the island. The numbers have increased: there were fourteen pairs in the spring of 1996 and three of them had families of downy ducklings in July of the same year. They spend much of their time swimming in the pond or resting on the island but, now and again, adventurous couples fly off to the Royal Canal, and there is probably some exchange between the tufted duck of the Basin and their opposite numbers in Stephen's Green. Sometimes a heron patrols the margin of the island.

Sparrows and pigeons benefit from crumb-providing citizens around the Basin. The sparrows particularly liked the old hedge that surrounded the pond, but have adapted to the new shrubs. Blackbirds, chaffinches and black-headed gulls are regular inhabitants, and swifts are plentiful in summer. The pond is an important source of insects for them. Two species of bat — pipistrelle and Leisler's — also enjoy the insect production.

## Broadstone Park

In 1927 the Broadstone Branch of the Royal Canal was closed and subsequently filled in, levelled and planted with a lawn to form a linear park just 1 kilometre in length. It runs along a high ridge, 21 metres above sea level, giving a fine view from its western end over Constitution Hill and across the Liffey valley to the mountains. The canal branch originally ran to Broadstone Harbour and was carried across the road by an aqueduct spanning a single stone arch. Sadly, the arch was too narrow for modern traffic and has long since been removed. While the greater part of the branch followed the contours as far as the main canal beside Mountjoy Jail, the western end required a major embankment, which remains in place, forming a rock garden to the north of Western Way.

The 1837 Ordnance Survey map shows trees on both banks of the canal branch. They have not survived, and apparently were not replaced when the park was laid out. The trees that grow there now are relatively young. A neat row of houses lines the road on the north side of the canal bank. Many of them have privet hedges which provide cover for a community of sparrows. Between Geraldine Street and the North Circular Road a shrubbery, mainly of evergreens, is confined between a railing and the limestone wall behind the houses of Goldsmith Street. It is a little too dense and dark to support a population of song birds and, apart from magpies and over-flying herring gulls and swifts, birds are few. There is not quite enough cover to attract many blackbirds and robins.

A former bridge carrying the North Circular Road over the canal at Phibsborough was replaced with an embankment and flower garden and effectively ends the walk. The statue in limestone of an Irish Volunteer of 1913 stands on a granite base. To the north of the road a public library was built in the 1930s and a variety of conifers planted in front of it. A little patch of green survives between the library and the main canal.

## The Cabbage Garden

There are no cabbages and little enough in the way of a garden in this green square hidden away between the old houses of New Bride Street and the bright new red-brick terraces of Cathedral View. It was a cemetery of Capuchin monks, and a

portion at the northern end was later used for the same purpose by the Huguenot community. Tradition has it that Oliver Cromwell lived close by, and at his command the first cabbages to grace an Irish garden were planted for the nutrition of the troops in 1649. Opened as a park in 1982, it boasts few features besides a senior plane tree but, in spite of that, is a busy meeting place for birds. Sparrows chirp on all sides, starlings are plentiful and so are black-headed gulls. Rooks and hooded crow visit. The open lawn provides them with food and with sufficient space, free from shrubs, to forage without fear of hidden predators.

## The Croppies Memorial Park and Croppy's Acre

The Croppies Memorial Park is a railed-in, triangular enclosure close to the Croppy's Acre. Just inside the railings there is a dense shrubbery, and middle-aged sycamores, surrounding the lily pond, provide a heavy shade. Rooks from time to time use the trees as a resting place, after feeding in the open ground of the neighbouring Croppy's Acre. The fountain commemorates the bicentenary of the Dublin Chamber of Commerce in 1983.

One of many horrors of 1798 was the defeat of the United Irishmen, followed by the execution of many of those taken prisoner. They were buried in a common grave between the Liffey and the Barracks. Croppy's Acre probably occupies the spot. The slightly unkempt playing field is a haunt of rooks and wood pigeons and, in wet weather when digging is easy, of gulls. Plane trees shade its west end and, between buildings and goal post, there is a splendid display of rosebay willow herb and buddleia. The stone, erected in 1985 to commemorate the Croppies, is of Wicklow granite.

## Christchurch Park

The garden within the railings of Christchurch Cathedral is maintained by the Corporation. It provides a pleasant, though noisy, retreat, and gives just enough space in which to sit and contemplate times past. This was a central point of the old city and looked down over the wooden quays and the dark pool of the Poddle. The cathedral was virtually rebuilt late in the nineteenth century, but great care was taken to follow the design of the original. The south transept, with its round arches in yellow

sandstone, looks very much as it did 800 years ago. The foundations of the chapter house of the cathedral form the main feature of the garden.

## City Quay Park

A tiny park lies on land by the Liffeyside, reclaimed by the City Council in 1715. The quay and the reclaimed land remained the property of the Corporation, and the land is distinguished by some of the city's most attractive council houses. The railed-in rectangular park provides a little green space amid the houses.

## Custom House Lawn

In the 1960s, the Custom House lawn at its east end displayed the finest fairy rings in the city. Each narrow circle of darker green measured 5 to 10 metres in diameter, and few were complete as they were beginning to bump into each other. Fairy rings are made by several different species of fungus, but the principle of formation is the same. Except for the fruiting bodies, the toadstools, which appear for a few weeks usually in autumn, the body of the fungus is a mass of branching threads, the mycelia. From a single spore, the mycelia grow radially outwards. The living mycelia are on the periphery and digest the dead material of the lawn, releasing the chemical nutrients into the soil. This produces a circle of richer soil and greener grass. The rings grow outwards and finally disappear — which seems to have happened because I have searched for them in vain in recent years. Besides the fugitive fungi, the lawn is graced with beautiful flowering trees and fine weeping ash.

## Diamond Park

Diamond Park is something of a rarity in Dublin — a park on a hillside rather than on the level. It extends over a little less than one hectare on the prehistoric left bank of the Liffey, where Summerhill meets Gardiner Street. There is a row of young horse chestnuts along its south side and, behind them, the hill rises, with grassy slopes and steps with sea-shore cobbles. Sparrows abound and rooks and starlings hunt on the lawns from time to time. It is either too small or too new to attract the blackbirds and robins that live in nearby Mountjoy Square.

## Dubh Linn Park

In the 1990s a slightly unloved green patch to the south of the main buildings of Dublin Castle was transformed to a delightful garden and sculpture park. Serpents of glass and mosaic respectively stand in two corners, and a peacock weather vane surveys the scene from the nearby clock tower. The model's name was Harry and he lived in a garden on the edge of the Dublin Mountains. The name of the park is most appropriate because the level ground is partly in-fill over the valley of the Poddle, and may actually stand over the historic dark pool itself. The main castle stood within the moat formed by the Poddle, and the rising ground where the Coach House stands was the south slope of its valley. The gateway and other details of the west wall of the garden are made from polished Kilkenny limestone, with a particularly good display of fossil brachiopods and corals, white on a black background.

## Fitzwilliam Square

In Rocque's time, fields extended east and south of St Stephen's Green. Roads ran eastwards from the two adjacent corners of the green, named by Rocque 'Gallows Road' and 'Road to Donnybrook', the precursors of Baggot Street and Leeson Street. There was a small element of ribbon development along both. The Georgian houses were built over a long period, and the square itself was not completed until early in the nineteenth century. The park is securely fenced against the common people but it is a pleasant place to walk around and peer through the railings. The design is simple, a large lawn in the centre, surrounded by trees and shrubs. Blackbirds, robins, wrens, blue tits, wood pigeons and magpies are numbered amongst its residents. Long-tailed tits visit the square from time to time.

Perhaps its greatest claim to fame in natural history is the fact that Robert Lloyd Praeger, Ireland's most influential naturalist, lived on the south-east corner in No. 19 from 1922 to 1952. In 1974, the Corporation placed a memorial tablet to him there.

His house looked out on one of the big beech trees that still stand at each corner of the square, and which may have been planted in rows rather than in isolation. Their trunks are massive, implying considerable age — probably extending far into the nineteenth century. Like nearly all the other trees in the

square, they grow slanting in various directions rather than straight up. They appear to have been growing in whatever direction light may have reached them through the shrubbery. Other fine trees include lime, plane, horse chestnut, holm oak and ash, and a remarkably contorted, though large, laburnum. These, the laurels and the variegated hollies are all likely to have been planted. The sycamores, smaller than the beeches, and the common hollies are self-sown. The ground beneath the trees is carpeted with wild ivy.

The houses in Fitzwilliam Place and along the south side of the square are cladded with granite on their ground floors, and most of them have granite portals. Below the granite, the basements are built of limestone. The bases of the railings of the buildings and the park, the steps, the pavements and the kerbs were all of granite and most of it survives.

## Great Western Square Park

Great Western Square is a delightful development of two-storey terraced houses with neat front gardens, built in the nineteenth century for railway workers. Its south-western side backs on to the abandoned cutting of the Broadstone railway line. The park is an open rectangle, surrounded by a hawthorn hedge. This, together with privet in many of the gardens, makes an ideal habitat for sparrows, and the first sound you hear on entering the square is their chirping. Blackbirds and pied wagtails live there, too. Within the hedge lies a lawn and a considerable expanse of tarmacadam. There is a magpie nest in a lonely almond tree, and a number of elms have been planted in the centre of the square. The elms are *Ulmus clusius,* a variety which it is hoped will prove resistant to the Dutch elm disease that devastated the elms of Dublin during the 1970s and 1980s.

To the north of the park, the North Circular Road crosses the railway cutting by a bridge of limestone, and a sycamore, rooted in the mortar, has been growing there for some years. The sides of the cutting are lined with masonry, shrouded in ivy and bearing many clumps of red valerian. To its north-west, dark holm oaks stand out above the forbidding wall of the garden behind St Peter's great church built of a pale limestone.

## Green Street

Having visited this park in 1995, I wrote the following doleful description: 'Green Street Court House signifies a farewell to freedom for many citizens and the grim park in a dismal region reflects this'. Surrounded by railings, it was locked on a Saturday morning in spring when I first visited it. Mature plane trees, severely pruned, cast enough shade to discourage the growth of grass; the lawn was more mud than green and contained a more than ordinary population of dandelions. No birds sang.

Within a year, all had changed. The plane trees remain, but grass and tarmac have been replaced with a terraced garden and a bright, new play area created for children. The park is actually the footprint of the demolished Newgate Gaol.

The classical façade of Green Street Courthouse is of granite, with columns of Portland stone. To the right of the portico the turret has an unusual arrangement of masonry: two courses of granite at the base, limestone forming the greater part of the wall, and a single course of granite at the top.

## Huguenot Cemetery

The Huguenot Cemetery in Merrion Row, bearing the date 1693 on its granite portal, spent many years of the present century encased in a high and opaque wall. The higher part of the wall was replaced by railings and, while people are still excluded from the grounds, they can at least enjoy looking at the flowers and trees that shade the recumbent tombstones. Bluebells cover much of the ground — probably planted deliberately in the past, they have spread widely and can tolerate the shade cast by the trees. Ivy is a companion to the bluebell as ground cover and has also climbed high on the east wall. The holly bushes may have developed from seed, while laburnum and copper beech have both been planted. Blue tits visit the bushes from time to time and may be able to find nesting holes in the old masonry.

## Iveagh Gardens

In 1939 Lord Iveagh presented the gardens that bear his name to the Government, which, two years later, passed them on to University College Dublin, whose home in Earlsfort Terrace has since become the National Concert Hall. The gardens were first

planted early in the nineteenth century, went through a period of neglect, and were redesigned in the 1860s. They were an integral part of the International Exhibition of 1865. In 1883 they reverted to private ownership for more than fifty years until, in 1941, they became a very popular part of University College.

Their position, surrounded by tall buildings on three sides, gives a wonderful feeling of seclusion, another of the city's 'secret gardens'. In the 1990s the Office of Public Works began to restore Iveagh Gardens to their former glory, conscious of the charms of the nineteenth-century plan and the value of preserving it. Great grey limestone walls protect the east and west sides. To the north the garden is screened by a wall of granite or by the houses of Stephen's Green — some of which have surprising back gardens, still alive and well rather than covered by outbuildings. The south side, on Hatch Street, has railings which allow a glimpse of the garden itself. A gateway at the end of Clonmel Street and a small door behind the Concert Hall provide access.

The path, which joins the two entrances, divides the 'archery ground' to the north from the central parterre, in Italian style, with its two classical fountains, supported mainly by blocks of andesite, a blue-green fine-grained volcanic rock from the western Dublin Mountains. The tall hollies lining the path are a mistake. The original garden design saw them as dwarves, but neglect over many years allowed them to grow as nature, rather than designer Ninian Niven, intended.

The parterre is overlooked by the classical sculptures of the great fountain at the west side. Its basin is supported by massive blocks of stone — most are granite, but white quartz, blue andesite and a purple slate brought all the way from Long Hill in north Wicklow make up an unusual pattern of colours. Gates on either side lead by stone steps to a viewing platform.

The outer edges of the garden became pleasantly overgrown with ivy, which invested the ground beneath the trees and climbed the walls, producing — by the modest standards of ivy — massively thick trunks in places. The leaves of the plants growing near the south-east corner are of rare size, possibly equalling Eugene O'Curry's Glenasmole specimens preserved in the Royal Irish Academy nearby. Many splendid old trees remain, planes, horse chestnuts, pine and ash, together with the

inevitable holly and holm oak. The Scots pine is something of a rarity in the inner city, the park designers by and large having preferred broad-leaved trees to conifers.

The resident birds include magpie, blackbird, robin and blue tit, and the park's secluded position, shielded from traffic noise by tall buildings, tall trees and high walls, makes the spring bird song especially pleasing.

## King's Inns Fields

The tree-studded lawn gives Gandon's magnificent King's Inns building a generous breathing space. The park is owned by the Benchers but tended by the Corporation. The legal owners have placed a large notice near the gate to inform citizens of their duties. Among other injunctions, the admission of four-footed creatures is firmly circumscribed, it being forbidden 'to bring any animal into the park other than a dog on a proper lead'.

The park retains something of an eighteenth-century air, reminiscent of the days when the land around the great houses was strictly utilitarian. Pasture extended right up to the house or the carriageway, and few of the landowners indulged in gardening. They did plant trees, and the great London planes in

Gandon's King's Inns building.

the King's Inns may be as old as the building. Birch, lime and a few others have been added since. There are no flower-beds and very few shrubs, and therefore relatively little bird life.

The plane tree nearest to the south gate on Constitution Hill is one of the most remarkable in the city. Perhaps 100 years ago, an iron-framed seat was firmly fixed in the ground close to its trunk. As the tree grew and the trunk increased in girth it came up against the seat and then grew over and around it.

A small rookery in some of the old plane trees was abandoned in the early 1990s. In the spring of 1996, rooks were back there again, and in March one pair had built a new nest. Magpie, wood pigeon and mistle thrush are established residents. Redwing appear occasionally in early spring. Jackdaws, starlings and pigeons feed on the lawns, and the gulls use the parapets of the building as a resting place.

## Leinster Lawn

The greater part of Leinster Lawn forms the most exclusive park in the city, to be enjoyed only by parliamentarians, policemen and government officials. However, the plain people have ready access to the adjoining greens in front of the Natural History Museum and the National Gallery. A venerable plane tree stands just inside the gate of the museum and may date to the time of its foundation in 1856. The younger trees along the south railing are birches. Six ash trees line the main railing of Leinster Lawn, and there are two holm oaks symmetrically placed beyond them. A low hedge of yew in front of the gallery surrounds the grass at the foot of Dargan's statue.

There is too little cover to allow many birds to enjoy Leinster Lawn, but magpie, wood pigeon, hooded crow and blackbird all appreciate its combination of open space and trees for perching. There are just enough bushes to induce blackbirds to establish nesting territories.

Leinster House and the adjoining buildings display a pleasing variety of stone. The great eighteenth-century house was built on the very edge of the city to the design of Cassells in 1745. Its front, facing Molesworth Street, is of Ardbraccan limestone quarried in Co. Meath. Its hardness and suitability for finely detailed carving appealed to architects at the time. The fact that it gradually changes with age from grey to black has

The treed seat in King's Inns Fields.

given subsequent generations a rather drab building. The west side is very much more attractive, being of a golden granite.

Fifteen years after it was built, the Duke of Leinster sold the house and land to the Dublin Society, which occupied it until 1921. Leinster Lawn was the scene of many exhibitions, and saw the establishment of the Dublin Horse Show. In the nineteenth century the Royal Dublin Society, with the assistance of substantial government grants, created the museums, library and art gallery. The Merrion Street buildings are of a grey granite, paler than that of Leinster House. Those in Kildare Street are mainly of granite but suffered an unfortunate choice of sandstone for the doors and windows. A pleasant, buff-coloured, stone from Mountcharles in Co. Donegal, it was promised by geologists to be safe from weathering. They had not reckoned with Dublin air pollution and, as early as the 1930s, replacement had to begin. Major repairs have been carried out from the 1960s onwards. Ardbraccan limestone was used for the National Library, and Leinster granite for the Museum.

The plinth of Dargan's statue, Patrick Wyse Jackson tells us, is of Galway granite with pink and green crystals of feldspar. It

was not quarried, but was cut out of a great boulder found at Ballagh, Co. Roscommon, where it had been deposited by the movement of the ice field of the last glaciation. Dargan's arm rests on a block of Peterhead granite from Aberdeen. Other notable stones were used in buildings nearby. Government Buildings are of Portland stone, resplendent since cleaning in 1990. Fossil oysters may be seen in some of the pillars.

## Liberty Park

Liberty Park is a well-hidden garden, concealed amongst the houses to the east of Gardiner Street. It lies on the level ground created by the reclaiming of the Liffey after the building of Custom House Quay early in the eighteenth century. The park was developed in 1979 on the site of some demolished flats on Foley Street. Laurels and other evergreens have allowed a population of sparrows to develop but, apart from occasional visiting starlings, it has little bird life. Ultimately, the limes and other trees will grow up to make a very attractive shaded park.

## Millennium Garden

The Millennium Garden is tucked in between the City Hall and the opulent building of the former Munster and Leinster Bank. The City Hall was built in Portland stone, the bank opposite of Ballinasloe limestone with pillars of a red granite from Scotland. The garden has just enough evergreen shrubs to provide a habitat for sparrows, and has an interesting assortment of stones. About half the hand-shaped paving sets are dark blue-green diorite from Parnell's quarries in Co. Wicklow. The outer perimeter of the paths and the surrounds of the pond are Liscannor flags. The three rather formidable ladies, representing the crafts of wood, metal and stone, are of Portland stone. Their clothes richly invested in a film of green algae, they once graced the skyline of the Exhibition Hall in Earlsfort Terrace, now the National Concert Hall.

## Mountjoy Square

High above the Liffey, 18 metres above sea level, most of the buildings of Mountjoy Square were completed by 1798. It was

part of a noble concept of Luke Gardiner, Lord Mountjoy, which included the great sweep of Gardiner Street down the hill to Gandon's Custom House.

The square is roughly on a level with the dome of the latter, and gives a wonderful vista across the city to the distant mountains. The hill marks the northern edge of the prehistoric valley of the Liffey, which cut its way down to the level of the sea before developing the tidal sand flats that extended over the level ground as far north as Seán McDermott Street.

In the square, green lawns are enclosed within dense hedges. The granite centrepiece is surrounded by cobbles, mostly limestone, some with white veins of calcite. Mature sycamores are the most plentiful tree species and there is a fine horse chestnut. Weeping ash and rowan have been planted. There seems to be too little variety of vegetation and perhaps too few flower-beds to encourage many birds. Several pairs of blackbirds live there, sometimes a robin and some sparrows may be seen, usually one or two blue tits and the ever-present magpies. Black-headed gulls and starlings make occasional visits.

## O'Connell Street

O'Connell Street is not a park — but, besides the occasional fox, it has a truly remarkable variety of wildlife for a busy, central thoroughfare. The wildlife dimension results mainly from the plane trees that line the centre of the street. From time to time, mistle thrush and wood pigeon have nested in the trees. Magpies are well established and, in 1989, rooks took up residence in the trees just north of the O'Connell monument. There were seven nests in 1993, but only three were occupied in 1995 and two in 1996. Rooks also nest in the King's Inns Fields and it is possible that some members of that community moved to O'Connell Street. Or they could have come from the large rookery at the Islandbridge gate of Phoenix Park.

Herring gulls and black-headed gulls can nearly always be seen in the air above the street in the course of their unending search for scraps of food. They perch from time to time on roof tops or lampposts and descend to the street itself after dawn on summer mornings when the daylight is bright and they can easily dodge the occasional car. From time to time, herring gulls

have nested on the roofs of buildings in O'Connell Street — the first ones were discovered by Paul Hillis in 1972. Since then, the gulls have bred successfully on the roof of the GPO. Together with the pigeons and an occasional pair of blackbirds, that makes a total of seven nesting species in the street.

Oystercatchers fly over Parnell from time to time and in March curlews can be heard migrating northwards at dead of night. Starlings gather on the roof tops at dusk in winter to prepare for roosting on any available perches. But the most famous of all the birds of O'Connell Street are the pied wagtails (pp. 142–4).

A note by a distinguished Dublin naturalist, W.J. Williams, in the January 1930 issue of *The Irish Naturalists' Journal* announced their arrival in 1929. The numbers increased and, in 1934, C.B. Moffat reckoned that there were 2,000. In that year he was the first birdwatcher to record a sparrow hawk attempting to catch one of them. Sparrow hawks and also merlins have since been seen on the prowl — but only occasionally, which would suggest that they often failed to make a kill.

The numbers of wagtails have varied over the years and are reckoned in hundreds rather than thousands, but the roost has become a permanent feature of O'Connell Street. One night in December 1986, 648 were seen, but not only is counting wagtails difficult, it also draws public attention and requires an uncommonly thick human skin. Plenty of wagtails were there in December 1996 and, no doubt, they will return for many years to come.

## Oisín Kelly Park

This park comes as something of a surprise in a faintly run-down part of the city. Beside Basin Street, it lies close to the great curved wall which marks the former terminus of the Grand Canal. The park is in two parts, one a well-used tarmac sports pitch, the other a fenced-off garden with lawn, shrubs and roses. It commemorates Oisín Kelly, the sculptor who provided Dublin with some of its finest twentieth-century bronze statuary and who was born nearby.

## Parnell Square

Parnell Square — Rutland Square as it was — must have looked superb when it was first developed. The Rotunda Hospital was

the brain-child of Dr Bartholomew Mosse, a very remarkable man with a profound love for humanity in all forms, for nature and for art and architecture. These he combined to build, in 1751, his maternity hospital, which was to benefit women of all ranks of society, from the wealthy and fashionable to the destitute who lived at no great distance from them. His love of art, music and good company were brought together in choosing Richard Cassells to design the hospital, and in attaching to it the buildings that have since become the Ambassador cinema and the Gate Theatre. Behind the hospital an exquisite garden was laid out, with flower beds, terraces and shady walks. All were designed for pleasure — but at a price. Those who enjoyed the music, theatre and garden parties were part of the fund-raising that allowed the hospital to be free to the poorest citizens.

Sadly, the value of the open square was not fully appreciated and much of the old garden has been covered with hospital buildings. Relatively little grass remained, and much of that was covered in stone when the Garden of Remembrance was built in 1966. Blue tits and robins live in the trees and bushes round about, and blackbirds find just enough lawn and flower-bed to survive. But the pond is just a little too hygienic to attract more than a passing interest from the ducks and gulls that fly above from time to time. The only real concession to nature is Oisín Kelly's noble sculpture: the enchanted swans of *The Children of Lir.*

Some fine old trees have survived, notably the lime on the east side of the square. One of the most attractive features of the garden itself is the beech hedge, something of a rarity in Dublin.

## Peace Park

The Peace Park is in Nicholas' Street, the street commemorating the good saint, a patron of seafarers and greatly admired in this part of Dublin. The park was developed for the Millennium in 1988 and has a fine display of heathers. The gateposts are of granite, and Liscannor flags provide most of the paving.

## Pearse Square

This, the first open space to be purchased by the Corporation for the enjoyment of the public, was developed in the latter

years of the nineteenth century. The greater part was covered in tarmacadam, leaving only a narrow strip of lawn and trees railed off at the Pearse Street end. The reason was purely pragmatic. The small classical houses on three sides of the square were inhabited by large families, and the park was so popular amongst the children that any lawn would have been transformed to a mudbath. The migration of the old community to the suburbs has reduced the number of children and relieved the pressure on the open space, so that restoration of the green can be achieved once more.

## St Audoen's Park

Just down the hill from the old St Audoen's Church, one of the most delightful small parks of Dublin incorporates a remnant of the first stone city wall, built about 1100 AD, and the last surviving gate, St Audoen's Arch — rescued from demolition but restored possibly with more imagination than accuracy in the 1880s. This was part of an inner defence of the old city, which was already protected by the river and an outer wall. Going westwards, the wall is of limestone blocks with a series of buttresses, and it finally ends in an earthen embankment, planted with shrubs. The arch was built in 1240 and the door of the church fifty years earlier. The church tower is very much younger, built in 1670. Audoen was a seventh-century bishop of Rouen and his name replaced that of Colmcille on the site of the old church. The city wall was restored in 1976, and the park, surrounded by railings from the old cattle market on the North Circular Road, was opened in 1982.

Ivy and buddleia grow in crevices in the masonry, but most of the park is well tended, with neat walls and dense shrubs. Blackbirds are the only residents. The main attraction of the park is its setting and the feeling that the walls evoke of a long-past age. The steep ridge that it defended was the south side of the valley of the Liffey at its widest extent, and along the top of the ridge runs High Street, the main artery of the Viking city.

## St Brendan's Hospital

The great mental hospital complex in Grangegorman is a private institution, but it does provide the most extensive green space in the inner city. Well-tended gardens mark its entrance,

St Audoen's Arch.

and there are many trees, old and young. The grounds are of particular interest to botanists, however, because they contain an area that was never built on and in which hedgerow and woodland plants such as ground ivy, herb robert and stitchwort have survived from the days when it was open farmland. At the time of writing, there are prospects of a substantial part of the property being developed as a public park.

## St Catherine's Park

The little churchyard of St Catherine's, used as a cemetery since 1552, was opened as a park in 1986 after a long period of neglect. Four old ash trees, coated in a luxuriant growth of ivy, stand in a group near the gate. Together with horse chestnuts and lime trees they keep the central lawn so well shaded that the grass has problems in growing. One interesting sculpted seat by Jim Flavin and some formidable benches invite the citizen to relax and listen to the sparrows in the hedges.

## St Kevin's Park

Well known to the students of the Dublin Institute of Technology on Kevin Street, this is another of the hidden parks of the

city. It lies to the south of the original buildings of the college, approached along Camden Row. It was a churchyard, surrounding the undistinguished, unroofed and unloved St Kevin's Church, its grey limestone walls draped in ivy. The church had a short life, built in 1780 and abandoned in 1820. A fine old ash tree makes a centrepiece and there are whitebeams along the walls. The park is an attractive spot, with neat lawns and well-kept flower beds. There are enough shrubs and open space for several blackbird territories, and the little gardens of the houses nearby have privet hedges and, therefore, sparrows.

## St Patrick's Park

This park provides a generous space to the north of the cathedral, which is otherwise beset by buildings and busy traffic. The main branch of the River Poddle flowed to the west along the line of Patrick Street and, before the city developed, created a broad flood plain. The rising ground of its left bank is largely hidden by the houses of Patrick Street but can be seen through the archways which give access to the little streets behind them. The right bank has been hidden in the park by the red-brick arcade and terraced lawn, but it can be seen clearly to the east of the cathedral where an old poplar and some young sycamore grow. The river must subsequently have cut a new and deeper valley because the cathedral stands at a considerably lower level than that of the flood plain. Where the ground rises to Christchurch Place, it is easy to trace the old valley by turning right along Bride Road and left at Bride Street, then along Little Ship Street to the south wall of the Castle.

A helpful stone tablet at the western gate of the park tells that: 'Near here is the reputed site of the well where St Patrick baptised many of the local inhabitants in the fifth century AD'. It's a pleasing tradition, with possibly no foundation in history — though history in the Dark Ages has large gaps and can't be used to disprove anything. Plane trees line the west and north sides of the park, the south is overlooked by the cathedral, and the east by the brick arcade. Blackbirds and magpies are plentiful, and robins scarce or absent. Blue tit and hedge sparrow can be seen sometimes.

Red valerian by the Royal Canal.

**Above:** Ivy.

**Right:** Red
Admiral
Butterfly.

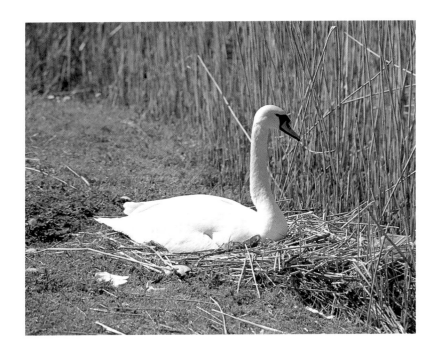

**Above:** Swan nesting by roadside on Grand Canal, 1995.

**Right:** Glyceria reed by Royal Canal.

**Above:** The Huguenot cemetery, Merrion Row.
**Below:** Lock and lock-keeper's cottage, Royal Canal.

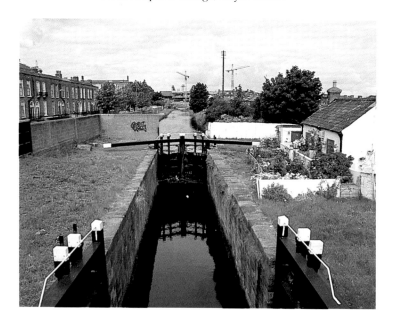

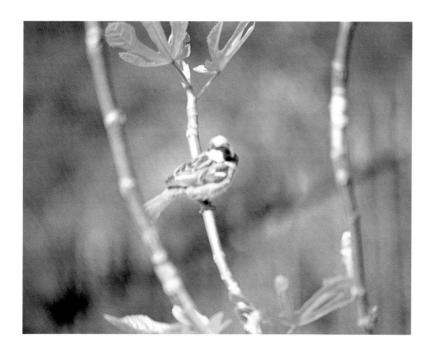

**Above:** House sparrow by Grand Canal.

**Right**: Wall rue fern on limestone.

**Left**: Snail population on limestone wall.

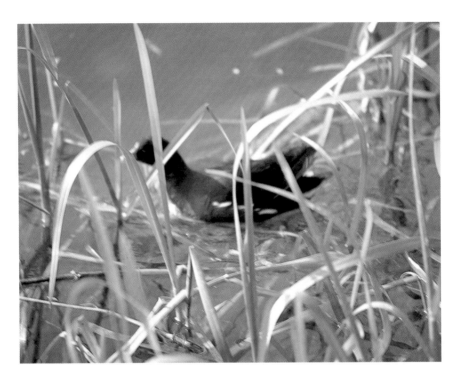

**Above:** Moorhen by Grand Canal. **Below:** Hawthorn berries.

**Above:** Rosebay willow herb.

**Left:** Bulrush at Portobello Bridge.

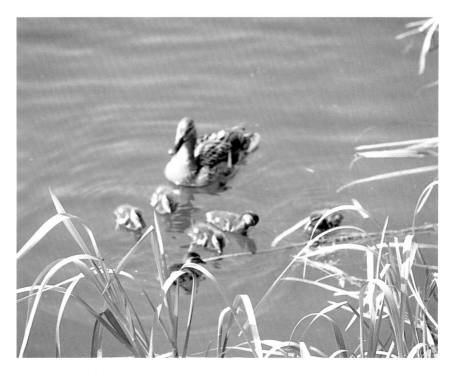

**Above:** Mallard family on Grand Canal.

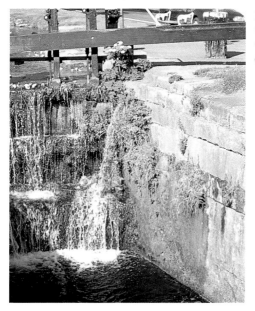

**Left:** Mother-of-thousands and other vegetation on Grand Canal lock.

## St Michan's Churchyard

A secluded place, almost like a country churchyard, complete with sexton's house and neat garden, lies behind the railings of St Michan's. The church is built on an ancient foundation, going back to a bishop of Danish extraction. The famous vaults, with their desiccated bodies, are remarkable also for the veils of spider webs that drape the surroundings. Rumour has it that there is a population of colossal spiders — but I never enjoyed the privilege of meeting any. In such a situation, free from predators, it is likely that some hunting spiders — which do not build webs — have long lives and grow to a considerable size.

The enormous webs are surprising because small flies, the staple food of web-spinning spiders, can't be plentiful in the vaults and it is difficult to see how there would be enough well-fed spiders to do the construction. Possibly the webs are extremely old and took many years to make. In the open, wind and rain destroy cobwebs quickly but the calm, dry air beneath St Michan's may allow them to last almost indefinitely

Out in the brightness, the cemetery has a well-tended lawn separating the headstones, which are all of limestone. The south wall is something of a wild rock garden with abundant ferns and flowers, wall rue, maidenhair spleenwort and hart's tongue, with willow herb, wall flower and sow thistle among other flowers. Lime and laburnum trees have been planted, holly and sycamore may be self-sown.

## Shandon Park

Shandon Park is very well hidden, tucked in between the lanes that lead to the garages of the neighbouring houses. It seems to have been originally surrounded by a hawthorn hedge into which various other shrubs were inserted and where many elders managed to plant themselves. A row of cypresses screens its western end. The lawns within are carefully cropped and tended for pitch-and-putt and other sports. The combination of trees, hedge and short grass provide living space for blackbird, robin and mistle thrush. Starlings visit it and, from time to time, so does a grey wagtail, making expeditions from its headquarters at the nearby seventh lock of the Royal Canal.

## Shandon Park Gardens

The nearby Shandon Park Gardens, on the gentle slope of an embankment of the Royal Canal, comprise a neat lawn with a fine row of mature lime trees. They make a suburban walk along the canal bank, in contrast to the path across the water, which constitutes a tiny trace of wilderness within the city. Black-headed gulls, jackdaws and hooded crows find the lawn in wet weather a good place to hunt for soil organisms.

## Wolfe Tone Park, Jervis Street

This was the cemetery of St Mary's Church. Church and tombs have been put to new uses: the church to commerce and the graves to public recreation. The tombstones, all of limestone and most from the eighteenth century, stand neatly ordered along the east wall of the park. Wolfe Tone was one of a number of Dublin's greatest citizens to be baptised in St Mary's. The dedication of the church, to say nothing of the name of the adjoining Mary Street and nearby Abbey Street, all owe their name to the twelfth-century Cistercian Abbey of St Mary, which enjoyed nearly four centuries of wealth, power and influence.

Privet hedges line much of the wall of the old church and support a large and noisy population of sparrows. There are enough bushes and lawn to provide a home for several pairs of blackbirds. Pigeons enjoy the open space and occasional crumbs from citizens. The park is simple, but delightful, a little resting place in the midst of the frenetic shopping that surrounds it.

# 8
# Building Stones

The earliest Dubliners used clay and wattle rather than stone for their buildings. Their choice may well have been influenced by the scarcity of rock in the inner city. There is an outcrop of limestone in the bed of the Liffey at Wellington Quay, and Linzi Simpson uncovered a medieval quarry in her excavations just to the south of Adam and Eve's Church. Elsewhere the bedrock is covered either by silt in the estuary or by glacial material on the higher ground, and the nearest quarries for it were at Donnybrook and points upstream on the Dodder and at Rathgar, 2 kilometres or more from the old city.

The glacial till contains plenty of stones, many of them large, but it seems that they were not used as building material by the Celtic Dubliners. Trees for the wattle — hazel and alder — are plentiful to this day in the Liffey valley close to the old city and would have been abundant in the valleys of the Poddle and the other tributaries. Clay was readily available both from the glacial till and from estuarine deposits.

Dry stone had been used in construction in Ireland for more than 3,000 years before the Vikings, and mortared stone appeared in the monastic round towers in the eleventh century or earlier. Even so, Dublin seems to have lacked stone buildings until Christchurch Cathedral was rebuilt in 1170 on the site of a wooden structure. It bears witness to Dubliners' ambivalence regarding local and imported stone. Dark-coloured calp limestone, probably from Lucan, and a pale oolitic limestone from Dundry in Somerset were both used. From the end of the twelfth century more and more stone appeared, first in the churches and castles, then for the city defences. Stone paving and cobbles came later, followed in time by the private dwellings of the wealthy, and the great public buildings of state and civic authorities. Even where brick was used extensively, stone was added for embellishment.

The Geological Survey at Beggar's Bush has an excellent

exhibition of building stones. The entrance hall to the head-quarters of the Office of Public Works, No. 51 St Stephen's Green, is decorated with panels of named Irish marbles, and the Museum Building of Trinity College boasts the greatest variety used in construction in the city — each of the many interior pillars is made from a different polished marble. On a small scale, several Bewley's cafés have a collection of photographs by Patrick Wyse Jackson and Declan Burke of the marbles used in the firm's cafés.

The pioneer treatise on building stones in Ireland is George Wilkinson's *Practical Geology and Ancient Architecture of Ireland*, published in 1845. Wilkinson, an architect, takes former members of his profession to task for their ignorance of the elements of geology:

> Many of the public buildings of Dublin have been erected with very little regard to the quality of the stone, or rather without sufficient care in the selection and use of good beds of the quarry, and the consequence is that the stones on exposure become like so much laminated clay in a perishable state.

He gives a list of the sources of the stone used in twenty-two churches and public buildings. It is particularly interesting in mentioning the state of decay of the two cathedrals before restoration work was undertaken later in the century. The book was published in 1845, before the opulent development of banks and other large offices, which added so much colour to the streets by using imported materials. The architects of classical Dublin had favoured local limestone and granite, and the pale grey Portland limestone from southern England. Some of Wilkinson's entries simply state that the granite and Portland stone are used. The following give a little more detail on the place of origin of the material:

TRINITY COLLEGE. — Entrance front, Chapel, Examination Hall, Dining Hall, Printing Office, of Portland stone; New Buildings of granite, from County of Wicklow. Library, piers to supporting arches and basement story [*sic*], of calp limestone; upper part newly faced with granite from County of Wicklow, was originally of sandstone, which had decayed so much as to render it necessary to remove it; Provost's House, chiefly sandstone from Liverpool. [According to

Wyse Jackson, Ardbraccan limestone is the principal material and no trace of any Liverpool sandstone can be found.]

POST OFFICE. — Granite from Counties of Dublin and Wicklow; some Portland stone, as in pediment, entablature, &c.

ROTUNDA AND LYING-IN HOSPITAL. — Granite from County of Wicklow, with some from Kilgobbin, County of Dublin; the latter in bad preservation; some Portland stone, as in pediment, entablature, &c.

LAW COURTS. — Portico, pediment, &c., and columns of dome, of Portland stone; rest of granite, chiefly from Golden Hill and Kilbride, County of Wicklow; some in the gate entrances and walls, from County of Dublin, much decayed.

CUSTOM HOUSE.— Principal front, and all the ornamented parts of the other, plinths, columns, entablatures, cornices, pediments, &c. of Portland stone. The remainder of the fronts are of chiselled granite, and generally in good preservation.

CUSTOM HOUSE DOCKS. — Of dark, calpy limestone, from quarry near Leixlip on banks of Royal Canal.

CASTLE. — Entrance gateways, granite; chapel, calp limestone; Birmingham tower, calp; general materials brick, with granite and Portland stone dressings: brick sound, other materials decaying.

NELSON'S PILLAR. — Granite from Glencullen, Kilgobbin, &c., in County of Dublin; statue of Portland stone, soaked in oil.

ST. PATRICK'S CATHEDRAL. — Chiefly of rubble work, rudely constructed, of calp limestone; dressings of sandstone and granite, very much decayed; west front repaired in limestone from King's County; north transept rebuilt in punched calp, from Leixlip; spire of granite and decomposing.

ST. PAUL'S CHURCH. — Granite from Glencullen, County of Dublin.

METROPOLITAN CHAPEL, MARLBOROUGH STREET. — Faced with granite, from County of Dublin; columns of porticos and pediments of Portland stone, soaked with oil.

ROMAN CATHOLIC CHAPEL OF ST. FRANCIS XAVIER. — Ionic portico, entablature, pediments, &c. &c. of granite from Ballyknocken, County of Wicklow.

Patrick Wyse Jackson, Curator of the Geological Museum in Trinity College, is the geological expert on the building stones of Dublin. His book on the subject gives references to 110 kinds, showing where to find at least one specimen of each in the course of four guided walks. This chapter makes no attempt to cover this ground again but gives an outline of the principal types of stone used, and adds a few examples which lie outside the area covered by Wyse Jackson.

## Limestone

The rock that lies beneath the glacial deposits and peatland of the midlands and makes the inspiring scenery of the Burren and Ben Bulben is limestone of Carboniferous age. It is the source of most of Dublin's building stone. The Carboniferous extended from 355 to 290 million years ago. The name means 'coal bearing' but most of the Irish coal-bearing strata were eroded while the limestones remained. Limestone is a sedimentary rock, solidified from deposits of debris and mud on the sea bed.

The sea which covered much of Ireland during the Carboniferous was rich in plant and animal life. Most of the animals, whether microscopic plankton or large and visible creatures ranging from sea shells to sharks, had skeletons composed mainly of calcium carbonate (lime). When the animals died, this material sank gently to the seabed to form deposits, often hundreds of metres deep. Much of this material has a fine granular texture. In places, however, fossils abound where the shells of the animals were replaced with lime or other materials so that they clearly show the original structure.

These fossils are visible in many of the building stones. The limestone of the Point Depot is a convenient example. Three types of creature predominate: brachiopods, crinoids and corals. The brachiopods superficially resemble present-day cockles. In some cases the curving shell is exposed but, more often, the fossil is cut in two so that only a cross section is visible. Crinoids or sea lilies are related to sea anemones and are attached to the seabed by stems about the thickness of a pencil. The whole animal is hardly ever preserved, but pieces of the stems a few centimetres in length often littered the seabed and can be seen as twig-like fossils. Corals are colonial animals which, like the crinoid, spend the greater part of their lives permanently attached to the seabed.

A common Carboniferous coral built tubes about 5 millimetres in diameter. In cross section the fossil resembles a honeycomb.

Pale grey limestones were formed where the sea was clear and free from silt — which happened at some distance from inflowing rivers. The resulting rock is pale grey and hard and composed almost entirely of lime. Near the coast, in shallow water, conditions were different. In coastal lagoons and river estuaries the lime was often adulterated. Sometimes the decay of the dead plants and animals was interrupted so that some carbon remained in the sediments, in extreme cases producing a jet-black limestone. Black Kilkenny marble results from this. In some cases organisms with skeletons of silica rather than lime abounded and the silica built up in places to form veins of the black mineral chert. Chert fractures to produce a sharp cutting edge and was used by the very earliest Dubliners in Stone-Age times. Flint, which makes better-quality tools, has a similar origin but it is associated with chalk rather than limestone and, except where it appears as beach pebbles, could not be found nearer than Co. Antrim.

In muddy conditions, the limestone is dark coloured, softer, and contains particles derived from clay. The quarries south of the city contain such dark-coloured, muddy rock. Known as calp, it had been quarried extensively since the twelfth century and used in great buildings and for paving stones. Wear and tear released the clay particles, making the paved streets muddy in wet weather, which might explain the dirt of 'dear dirty Dublin' (on the other hand, many cities with no calp at all were dirty and muddy in bygone days but their names didn't begin with D so the alliteration was lacking).

Whatever of dirty Dublin, the calp was very widely used and may be seen in nearly all the churches built before the eighteenth century, in the city walls, the Castle and the lower storey of Thomas Burgh's Trinity College Library. A great many walls of gardens and houses used

Fossil brachiopods in limestone on canal bridge at Dolphin's Barn.

the calp and it also forms the rubble filling of the walls of some of the great buildings of the eighteenth century.

Limestone of Carboniferous age from farther afield was used in later buildings and generally is a tougher rock with pale grey rather than blackish colour. Wyse Jackson lists no fewer than thirty-three Irish limestones, of which the most frequently used are from Ardbraccan, Co. Meath and Ballinasloe, Co. Galway. The former Munster and Leinster Bank building beside the Castle actually used both: Ballinasloe in the original building of the 1870s, Ardbraccan in the extension built about eighty years later.

Ardbraccan limestone has been used on the major restoration work on the National Museum and National Library in Kildare Street. Windows and other details were built of a beautiful yellow sandstone from Mountcharles in Co. Donegal. It proved highly susceptible to weathering in the polluted air of Dublin and was being eroded at a dangerous rate.

Oolite is a pale-coloured, grainy limestone of Jurassic age, imported from England. Some 90 million years younger than the Carboniferous strata, it is almost unknown in Ireland. The lime was deposited in tiny spheres. It makes an attractive building stone and was used in Iveagh House in Stephen's Green and in modern buildings in Smithfield.

## Granite

The Dublin Mountains form the northern end of the Leinster Chain and extend to the hills and islands of Killiney and Dalkey. The bed rock is granite whose origin lies at the opposite extreme to that of limestone. The geological history of limestone and many other sedimentary rocks is of an almost imperceptible accumulation of microscopic particles in the placid conditions of the depths of the sea. Granite is an igneous rock whose origin is one of titanic events, deep below the surface of the earth. The Leinster granite, which extends from Dublin to Wexford, was formed when a great ocean was obliterated.

A hundred million years before the Carboniferous period, two continental plates moved together, meeting in Ireland along a line from Clogherhead to Nenagh. They crumpled the rocks of the land mass, and the heat and pressure led to the formation of a molten magma in the deepest parts of the folding. This

magma cooled slowly, allowing time for big crystals to develop. In granite, crystals of three different minerals predominated: quartz, mica and feldspar. Quartz is white and shiny, extremely hard and resistant to weathering. Mica is also shiny but crystallises in flakes so that it has a mirror-like appearance. Feldspar fills in the gaps between quartz and mica crystals. Mica and feldspar both weather fairly easily and this fact explains why the mountains south of Dublin have such gentle slopes and smooth appearance.

Granite and limestone courses in warehouses at Grand Canal Basin.

The idea of just three minerals in granite is a serious over-simplification: to begin with, there are at least two micas and two feldspars. What is more important in considering building stones is that the feldspars may be whitish or have various shades of green or pink. The Dublin and Wicklow granites have white feldspars and large mica crystals, which make a very attractive greyish white stone, sparkling when the sunlight catches the mica. Some of the pink granite used in the city — for example, the stone of the Parnell monument — comes from Galway but most of it is imported. Balmoral red granite from Sweden was very popular, used in the facing of many buildings and most notably in counter and table tops in Bewley's establishments.

After the limestone, granite is the most widely used building stone in Dublin. For pavements it is much more durable and clean than limestone. It is, unfortunately, more expensive than concrete slabs and therefore has declined in use. Fine examples survive: Molesworth Street, Lord Edward Street, much of Merrion Square, among many others. Granite kerbstones continue to be used, often in association with concrete slabs. Granite also forms the stone base of countless old railings and is the usual material for the steps of classical houses. A little farther above street level, granite cladding was added to many eighteenth-century houses. Quarries in the Dublin Mountains, especially

Three Rock and Glencullen Mountain, were used, but the major source was Ballyknockan in west Wicklow.

Granite is also the material of the quays and quay walls of the Liffey and, indeed, of all the harbours to the south. This implies a sound knowledge of building stones on the part of the engineers. Limestone was available closer to hand and is much easier to cut into blocks. But it is also very much more soluble in water and would have been less durable.

Above all, granite was used both for the cladding of the most important eighteenth-century buildings and for decorative finishings on bridges, walls and many of the limestone buildings. For these purposes a higher quality stone than could be found in the Dublin Mountains was preferred and the quarries of Ballyknockan and Golden Hill in west Wicklow were the main sources. Thin slabs of Ballyknockan granite are used as cladding for the Civic Buildings

## Portland Stone

Limestone and granite are Dublin's two local stones and by far the most widely used. To a considerable extent, the classical styles of the eighteenth century were content with these. The incorporation of more colourful stones from far and wide began in the late eighteenth century. It was a feature of the more flamboyant architecture of Victorian and Edwardian times and, more recently, of affluent shop fronts and office blocks — those not imbued with a spirit of cost-cutting. The outstanding exception to the use of local materials was the importation of Portland stone.

It is an oolitic limestone, granular rather than smooth and often with fossil shells. Portland stone is of Jurassic age, between 140 and 190 million years, deposited in the days when dinosaurs roamed the earth. The off-white colour and good texture for carving made it an ideal material for architectural detail. The fact that it could be brought to Dublin by ship from the quarries on the south coast of England made it relatively cheap. The columns of most of the great Georgian public buildings are of Portland stone. The recent restoration and cleaning of Government Buildings show it in all its glory. The balustrades of O'Connell Bridge give a particularly good display of fossil oysters.

## Marble

Marble means different things to different people. To a quarryman or stone mason it is a rock that can be polished to present a smooth and shining surface. Geologists restrict the word to define a metamorphosed limestone. The original limestone has been subjected to intense heat or pressure which has destroyed any trace of fossils and re-crystallised the rock. The green Connemara stone is, by the latter definition, the only true marble widely used in Dublin. Such familiar stones as black Kilkenny marble and the majority of marble-topped tables are wrongly named according to the requirements of geology. The use by scientists of long-established vernacular terms regularly leads to confusion, and in this chapter I have opted to use the term in its broader sense of any polished stone.

Limestone marbles used in Dublin include the black Kilkenny stone with white fossils which has come and gone from Grafton Street buildings within the past fifty years, but which was used in the 1990s in the gateway and other details of the gate to the Dubh Linn Garden beside Dublin Castle. Most of the other marbles are polished granite from many localities — Wyse Jackson gives details and useful coloured illustrations of a wide selection of them.

## Slates

The roofing material of the majority of Dublin's older buildings, slate is formed when sedimentary rocks derived from clayey deposits are subjected to immense pressures by geological movements, forcing the minerals to re-crystallise with their long axes perpendicular to the direction of the pressure. The result is 'slatey cleavage' and it is characteristic of the rocks of the Silurian and older strata, from 410 million years ago and more. Most of the rocks, though slatey enough, are disobligingly contorted and of little value as roofing material.

In a few, scattered, localities, slates with marvellously flat and even surfaces have been formed. The quarries of Valentia Island yielded enormous ones, which have been turned into billiard tables and shelving — as well as being used in roofing. Ashford in Co. Wicklow and Killaloe in Co. Tipperary were important sources for the city of Dublin in the eighteenth century and well into the nineteenth. Then disaster struck the slate-

quarrying industry in Ireland. Slates of even higher quality were discovered in Wales. What was worse, it was actually cheaper to ship the slate across the Irish Sea than to bring it by rail or canal from the banks of the Shannon.

## Cobbles, Paving Setts and Flags

The cobbles of Trinity College were laid long before women students were admitted and therefore may not be explained as a devilish chauvinistic plot to make life uncomfortable for wearers of stiletto heels. They are beach pebbles, mostly of limestone and were collected in uniform size rather than being cut to shape. The stones were scraped up from the bedrock by southward-moving ice and ultimately deposited on the seashore. Hundreds or maybe thousands of years of being knocked against each other, as they were rolled hither and thither by the surf, smoothed away their sharp edges and polished them. Quite a feast for lapidaries lies amongst the cobbles: besides limestone there is quartz, diorite, andesite and granite.

Paving setts were quarried and shaped. They have survived in Smithfield, in places in dockland, and in the city centre in Foster Place. Many of the setts were made from the igneous rock diorite from Charles Stewart Parnell's quarries at Avondale in Co. Wicklow. Two hundred sett dressers were employed for years, but the business failed soon after the death of the leader in 1891.

The structure of a number of sandstones allows them to be split easily to give flat, parallel faces to provide the flagstones used in many places for paving. The flags from Liscannor in Co. Clare became very popular in the twentieth century, and in the inner city they have been laid in a number of the memorial gardens of the 1970s and 1980s. Their distinctive feature is the worm-like pattern, the fossilised burrows of marine animals.

## Horse Troughs

Horse troughs, until well into the twentieth century, were quite as important as filling stations. The few that remain, even the damaged ones, merit preservation as monuments to a past way of life. Most of them were hewn from massive blocks of granite and are supported on stone legs. Sadly, the modern jarveys of

Stephen's Green consider them unhygienic, and the modest revival of horse traffic has not been matched by a new lease of life for the troughs.

The finest ones stand beside an equally disused drinking fountain on the north side of Stephen's Green. The eastern basin, with a dog trough below, displays an interesting vein of aplite, a fine-grained granite, which was intruded into a crack after the main mass of the rock had cooled. The western one is of Cornish granite, with long feldspar crystals. A good specimen of a purely utilitarian trough survives in St Patrick's Close. It has a lengthy, but badly weathered and scarcely legible inscription.

One with a clear, but brief notice stands in Adelaide Road, the work of 'Clifton & Cooper Paviors and Asphalters Dublin DSPCA'. The trough is of concrete, supported on granite pillars, and possibly replaces an earlier all-stone creation.

Sea horses on a lamp standard in College Green.

# 9

# Beneath the Streets:
# Rock, Soil, Silt and Streams

Buildings hide the structure of the city to such an extent that only the steepest hills are apparent. And, in the course of Dublin's thousand years, many of the ancient valleys have been filled in and levelled, their streams incarcerated in culverts. Although hidden, this infrastructure has had a profound influence on the history of the city, indeed on its very existence. Some of the details are revealed only by observations on occasional boreholes, others appear for a brief period when the foundations for buildings are being dug, yet others are known from the archives, from old maps and from the all-important water supply and drainage schemes.

## Water for the Citizens

Human life in the city would be impossible in the absence of the water supply, and intolerable were there no drainage. Both depend entirely on when and where the rain falls — an aspect of nature whose control remains far beyond the powers of human endeavour. Which is why, although the systems of supply and control are essentially man-made, they merit inclusion in this book. It is also true, if sad, that these subjects seldom receive the prominence they deserve in the literature, though an honourable exception appeared in the form of Clair L. Sweeney's delightful book on *The Rivers of Dublin* published in 1991. James Joyce, too, in *Ulysses* offered some paragraphs in praise of piped water.

Long before the days of Leopold Bloom, the people of Viking Dublin depended on wells and on the River Poddle. Being a small, lowland river, about 12 kilometres from its source in Tallaght to the sea, the flow of the Poddle in dry weather has always been feeble and it soon became far from sufficient to provide the citizens of the growing medieval city with the water

they needed. To make matters worse, the monks of the abbey of St Thomas, to the south of Thomas Street, diverted the Poddle at a point near Mount Jerome and built a high-level canal, the Abbey Stream, to supply their needs about the year 1200.

Not surprisingly, the citizens resented this move, and their complaints led to the remarkable engineering works carried out on the River Dodder at Firhouse or Balrothery, some 6 kilometres to the south. A high weir was built in 1242, which diverted the Dodder, through an open culvert, to the Poddle. The Dodder, a longer river rising on Kippure, with a catchment including extensive mountain land and, consequently, a higher rainfall, provided a much more reliable supply — though the diversion resulted from time to time in the lower Dodder's being left without water.

In 1244, further work on a city water supply was put in hand under the order of Maurice Fitzgerald, Justiciar of Ireland. This led to the development of a second high-level canal, the City Watercourse, which also tapped the Poddle. The Tongue, a wedge-shaped piece of masonry in the grounds of Mount Argus, diverted two-thirds of the water to the Abbey Stream and one-third to the watercourse. The watercourse ran to the west and north of the Abbey Stream and ended in a cistern near Marrowbone Lane, close to where, appropriately, the Corporation's Waterworks Department has its headquarters. From there an open channel down Thomas Street, followed by a series of wooden troughs and lead pipes, brought water to a public fountain near Christchurch.

The cistern at Marrowbone Lane was replaced about 1670 by a larger reservoir, the City Basin, to the west of Crane Street. From Dolphin's Barn, the water was carried by an aqueduct to maintain the high level. The original reservoir lay to the west of Crane Street, and an overflow ran down Watling Street to the Liffey.

In 1721 the level of the Basin was raised, and the water was widely distributed through the city by lead pipes, but by 1735 demand had outstripped this supply. The first major new development was a pumping system at Islandbridge Weir to supply water to the north city. When the Grand Canal was developed (pp. 13–26), the City Basin was enlarged and served as a canal terminus as well as water-supply reservoir. In 1814

the Blessington Street Basin (pp. 76–9) was built and fed from the Royal Canal. However, the canal water came to be seen as a source of disease. It was also rich in lime and therefore undesirably 'hard'. A further problem was that the basins were not high enough to provide pressure to bring the water to the upper storeys of buildings. Such luxury was undreamed of in the eighteenth century, but came to be expected in Victorian times. The City Basin was tragically filled in when the canal ceased commercial operation.

A Royal Commission, appointed in 1860, advised that the Vartry in Co. Wicklow, in spite of its distance from the city, would be the best source of supply. It enters the inner city, over the Grand Canal, through the two magnificent black pipes beside Leeson Street Bridge. The requirements of the expanding city and suburbs led in due course to the incorporation of the Dodder in the 1870s, and the Liffey seventy years later, in the 1940s.

## The Substrate

Deeply buried beneath the streets, lie strata of limestone and shale of Carboniferous age, laid down as sediments on the seabed between 290 and 355 million years ago. In the course of geological time these beds were covered over by great thicknesses of younger strata. Earth movements raised the newer rock and the upper parts of the underlying Carboniferous above the surface of the sea. There they were worn away once more by rain and rivers until the limestone was revealed again to form a land surface rather than a seabed. An ancestral Liffey flowed down from the mountains of even more ancient rock and carved out a shallow-floored valley and flood plain between Howth and the Dublin Mountains. Then everything changed. Ice fields covered Ireland, flowing slowly from north to south, propelled by the greater thickness of ice in the colder northern regions.

Of greatest importance to the shape and history of Dublin were the effects of the ice age and the final advance of the ice, which began 100,000 years ago and ended not much more than 10,000 years before our time. The glaciers tore soil and rock from the surface, crushed and ground the fragments and carried them southwards. When the ice fields finally melted, they left the flood plain and the valleys coated with litter on a scale

never contemplated even by the most passionate devotee of the use of landfill for waste disposal.

This material, the glacial till, formerly known as 'boulder clay', has almost completely hidden the limestone bed-rock which underlies the entire inner city. The only visible outcrop is in the river off Wellington Quay and was known as Standfast Dick (p. 51). The glacial till is a conglomeration of powdered rock and stones, which weathered quickly to form a soil rich in lime and easily drained, an ideal soil for grassland and cattle rearing. So, while the river formed a natural haven for the boats of the Viking raiders and traders, its hinterland was as good a source of food as could be found anywhere in Europe — an ideal spot for the development of a city.

High ground on the south side of the Liffey valley, now the site of St Andrew's Church and Suffolk Street, was the home of some of the earliest-known Dubliners. Two copper axeheads were found associated with a cist burial of the bronze age in excavations at Suffolk Street in 1959. The nearby Dublin Mountains were the scene of considerable bronze-age activity, and there is little reason to doubt that the Liffey estuary, with its abundant salmon, eels and other fish, was a busy place at the same period.

The glacial till formed something of a plain, albeit an uneven one, extending around the margins of Dublin Bay. Over a large area of Co. Dublin, its surface lies at about 50 metres above sea level, though it rises to 300 metres on the flanks of the mountains where the south-flowing ice pushed it uphill. Closer to the coast, the covering of till grew thinner, and the land surface slopes gently to the sea, except at points such as Howth where quartzite, a much harder rock than the surrounding limestone, stood out.

When the ice had gone, melt water from the snow-covered mountains supplemented the rain so that torrential streams rushed over the plain, carrying unknown quantities of gravel, sand and particles of clay away to the sea. In the course of time Anna Liffey reasserted herself and carved out the central valley that we know today. The Dodder, the Tolka and a number of smaller streams did likewise, but the Liffey was the dominant influence. By the time that history began to be written, some fourteen or fifteen hundred years ago, the land form had

reached its present-day shape in most parts of the city. The lower reaches of the big three rivers flowed over broad estuaries, while the smaller ones formed sheltered tidal creeks.

Within our area, the Liffey formed a relatively deep, steep-sided valley, clearly visible today on the south side in the slopes of Winetavern Street, Bridge Street, Steeven's Lane and the other roads leading down from the old city axis on the high ground between High Street and James' Street. Across the river, Infirmary Road, Blackhall Place and Church Street run down the upper, steep-sided, part of the valley.

The first aim of a river is to cut its way downwards. As it grows older, it meanders more and more to form a flood plain, with the sides of the valleys farther and farther from the river bed. The post-glacial Liffey never had time to redevelop her plain in the course of the very few thousands of years that she had before the Vikings established their settlement. Her ambitions were forcefully curbed late in the seventeenth century with the building of the continuous line of stone quays. And there she will remain as long as Dubliners continue to exist.

## The Raised Beach

Closer to the sea, the glacial till becomes thinner and its surface lower, so that the valley of the Liffey is wider and has gentler slopes. One of the most interesting geological boundaries in the inner city runs on the south bank from Maquay Bridge on Lower Mount Street, at the boundary of the original Grand Canal Basin, along Grand Canal Street and Fenian Street and the south border of College Park. Then it takes a remarkable loop northwards in the Temple Bar area, followed by a tongue skirting the Castle and extending to St Patrick's Cathedral. The boundary turns back towards the Liffey and runs parallel to the river, about 100 metres south from the quays. The geological map describes the ground between this boundary and the river as *alluvium over raised beach*, and that is far from self-explanatory.

The alluvium is a simple enough concept. It is the material that the river scoured away from its banks and carried downstream. The silt particles are heavier than water and tend to sink. But, as long as the river is flowing swiftly, they are carried with it. As the river approaches the sea, its gradient decreases.

The water moves more slowly. Indeed, it stops and reverses its direction on a rising tide. So the silt is deposited on the bed as alluvium, and builds up in the course of time. The river carves a narrowish and deeper bed with the alluvium on either side. From time to time, it changes its course, and the overall effect is to create an alluvial plain or fan. It is fan- or delta-shaped because the steeper gradient and faster flow at its apex allow the river to cut downwards rather than outwards.

Alluvium and its formation have been known to geographers since classical times. The wonders of the raised beach did not begin to be revealed until the nineteenth century, and were not fully understood until the twentieth, when geologists realised that land masses were in effect suspended in the elastic rock floors of the surrounding ocean basins. The ice of the glaciers was so heavy that it caused the land it covered to sink a little. At the same time, so much water was locked up in the ice and held above the surface that the sea level was lower. When the ice melted, the sea level rose again and, while it was high, a beach was formed.

The sea had risen relatively quickly, but the Earth's crust, relieved of the weight of the ice, slowly regained its earlier height and caused the land in Dublin to reach a height about 3 metres above the present-day strand line. So a 'raised beach', an area of almost level ground, can be traced around much of Dublin Bay and within the city. Incidentally, Ireland tilted in this period so that the raised beach in the north is some 16 metres above sea level, while on the south coast, dry land on which stone-age people lived has been submerged.

When the land surface was lower, the Liffey spread her silt over the beach. But when the land rose, it carried the alluvial material with it so that its surface is up to 7 metres above sea level. This is only one of the unusual features of Dublin resulting from the youth of its landscape. The usual pattern of behaviour for a river is to carry silt downstream and deposit it in the sea — and so the rivers of Dublin do. But the Irish Sea has not recovered from the disruptions caused by the moving ice, which at one time filled its basin. The marine currents are to this day carrying the finer particles of sand hither and thither. Among other diversions, the sea actually brings sand into Dublin Bay from grounds to the north of Howth. This sand, together

with the alluvium, is deposited in the vicinity of Ringsend and Dollymount, the South and North Bulls, and the Bay is inexorably being shrunk. Under natural conditions, these flats would gradually rise above the reach of the tides, be invaded by marram grass and other pioneer plants and ultimately form great expanses of almost level, dry land.

## New Land for the City

Dubliners are an impatient breed and, long ago, gave up waiting for this slow process. By building quays and sea walls, they formed barriers to keep the sea out, long before sand dunes and marram grass could have accomplished this. De Gomme's map of 1673 is the earliest accurate plan of the city, and shows a shoreline in our area running along Grand Canal Street and Hogan Place, but turning northwards to follow Sandwith Street, reaching nearly as far as City Quay, then westwards past Tara Street and north to Burgh Quay.

In the region between the canals, ridges stood out, the remnants of high ground that had been carried away by the rivers. South of the Liffey, the ridge from Dublin Castle along High Street towards Kilmainham formed the nucleus of the medieval city. Its summit is about 10 metres above the level of high tide. The ridge falls away towards the south and the valley of the hidden Poddle, and rises again gradually towards the mountains. The South Circular Road runs more or less level between 15 and 18 metres above sea level, and the long level stretch of the Grand Canal, west of Portobello Lock, is a little higher at 22 metres.

North of the Liffey, the ground rises quite steeply from close to the river up Infirmary Road and Constitution Hill. Farther downstream, the Liffey has spread itself farther to the north, and the hills can be seen to begin along the line of Cathal Brugha Street and Seán McDermott Street. The main roads travelling north and north-east climb over the Royal Canal, which runs close to the top of the next ridge, and then descend to the Tolka valley. Mountjoy Square is 18 metres above sea level, the Blessington Street Basin 23 metres, while the Royal Canal above the sixth lock at Crossguns Bridge runs at 29 metres. The loftiest eminence in our area is near the seventh lock, just about making the 100-foot (30-metre) contour.

The Custom House Dock under reconstruction, 1995.

## Rivers of the Past

Clair L. Sweeney's *The Rivers of Dublin*, published by Dublin Corporation in 1991, describes all the rivers of the county. In the context of the inner city, it is the definitive work on the many tributaries of the Liffey which have disappeared to a greater or lesser degree beneath the roads and buildings of the city. All of these streams influenced the life of the citizens in the past. The larger ones, such as the Poddle, in prehistoric times played a part in shaping the landform. By providing drinking water at a high level, and a safe anchorage down below, the Poddle then made an essential contribution to the development of the medieval city. The other streams, to say nothing of Anna Liffey herself, made a less savoury contribution to the survival of the citizens of the past in serving as open sewers.

The Poddle today makes no appearance above the ground within the city. It enters our area in a closed culvert underneath the Grand Canal, 110 metres west of Harold's Cross Bridge, and runs a little to the west of Clanbrassil Street. It flows beneath Blackpitts, so named because, before its burial beneath the

streets, the river there was reduced to a series of black pools in dry weather. Beneath Fumbally Lane it was joined by a tributary, the Tenter Water or Hangman's Stream and, a little farther down, at Kevin Street, by the Commons Water.

The Poddle divided into two parallel branches flowing beneath Patrick Street, to part again at Back Lane where one branch flows north-west to enter the Liffey at Usher's Island. The other goes eastwards and around the south and east walls of Dublin Castle. In spite of being a small river, the Poddle and its valley constituted an important part of the defences of the Castle in its earlier days. At the north-east corner of the Castle a diversion to the west formed a further part of the moat, and this may still be seen beneath the ground where the old foundations are displayed. The main stream flows beneath the Olympia Theatre and into the Liffey at Wellington Quay. The buildings of the castle conceal the valley, but its position is very clearly visible at the Olympia where the long downhill of Lord Edward Street and Dame Street ends and the road rises again towards the east.

The other hidden streams were of much less strategic importance than the Poddle. The Cammock or Camac scarcely enters our area but does make a brief appearance and forms an important little sandbank at Heuston Bridge (see p. 43). To the east of the medieval city the Stein River and the Gallows Stream ran from south to north into the Liffey. Both had to be short because the drainage south of the South Circular Road goes to the Dodder.

The Stein rose near Charlemont Street, ran northwards to the Concert Hall, turning north-west to Cuffe Street, and thence nearly straight to the front of Trinity College, and so to the Liffey (see p. 53). Speed's map of 1610 shows the Stein flowing to the east of Grafton Street, forming a large pool just in front of Trinity College and then disappearing mysteriously at a gate in the college forecourt. It is not shown at all in de Gomme's map of 1673 and may have been covered over even at that early stage.

The conjectural Gallows Stream was even shorter than the Stein, running in a more or less northerly direction from the south-east corner of Stephen's Green, beneath the eastern end of College Park to the Liffey.

The Bradogue rose in Cabra and flowed towards the south-east in a valley which brought it along the northern side of St Brendan's Hospital grounds where it divided in two. A western branch flowed due south to the Liffey, going beneath the Richmond Hospital and Smithfield. An easterly branch ran north of the King's Inns and south to Ormond Quay. It drained the southern flank of the ridge which forms the watershed between Tolka and Liffey and has been completely taken over by the city's drainage system.

The Bradogue certainly existed as an open stream in the past. To the west of it, Clair Sweeney has postulated an 'Oxmanstown Stream' on the basis of the contours of the land. Its valley begins at the junction between Navan Road and Skreen Road from which it runs towards the south-east, passing north of McKee Barracks to Stoneybatter and Arran Quay.

## Drains and Sewers

As late as the seventeenth century, alleys ran down the centres of streets, and litter and worse was thrown into them. Rain-water sooner or later helped to carry this away to the Poddle and other rivers, and so to the Liffey. Some improvements developed in the eighteenth and nineteenth centuries as the fetid rivers were covered in beneath stone arches. Nevertheless, what went in came out again in the Liffey. Ultimately, foul sewage was diverted from the open rivers and carried to the treatment works at Ringsend.

# 10

# City Birds

The birds that have adapted to city life are species that use trees, shrubs or water for refuge. Some of the land birds find most of their food amongst the branches but others forage on the ground, at least for some of the time. Similarly, such water birds as cormorant and tufted duck hunt for fish or for submerged snails and other aquatic creatures, while the gulls feed mainly on dry land or on the foreshore between the tides. The majority of urban birds are very adaptable species and can eat food of many different kinds, from breadcrumbs to insects to berries. In winter many species of small bird travel the country in mixed flocks and usually draw attention to themselves by a continuous chattering. Flocks of tits and goldcrests, of chaffinches and others appear here and there in the city, moving off from one park or canal bank to another every few days.

References to birds of the inner city in the ornithological literature are relatively few. The first to come under scientific scrutiny were the wagtails, which began to roost in O'Connell Street in 1929. The most recent spectaculars were the peregrine falcons, nesting on the great grey gas reservoir on Sir John Rogerson's Quay. In the 1980s urban swans were studied by R. Collins and J. Whelan, and magpies by Brendan Kavanagh. Scattered references to city birds can be found in *The Irish Naturalist*, its successor *The Irish Naturalists' Journal*, in the *Irish Bird Report* and, best of all, the *Irish East Coast Bird Report*, which has been chronicling birds of Dublin and the other coastal counties since 1980. Tom Cooney has kindly provided me with many observations of city birds — and other creatures. Only one publication has devoted itself to the inner city: *Birds of Trinity College, Dublin* by Brian Madden and his colleagues, published in 1993. The scientific names are those used by Clive Hutchinson in his *Birds in Ireland*.

The scarcity of published scientific references to the birds of the city has less to do with any lack of interest or importance of

the subject than with the fact that ornithologists, by and large, are conditioned to expect birds to live in the wide open spaces rather than in the urban desert. Since nobody has ever taken the matter in hand, this chapter attempts a comprehensive catalogue of the birds of inner Dublin.

## Cormorant *Phalacrocorax carbo*

The Liffey, when the tide is high, is a regular haunt of cormorants. They also visit the Grand Canal Basin and, occasionally, the Blessington Street Basin. Large, black birds with long necks and a faintly reptilian appearance, they are rather unloved. When hunting, the cormorant swims on the surface and dives, having taken a half jump in the air. Beneath the surface it can see clearly and swim rapidly, and from time to time when it appears again can be seen subduing an eel or, less often, some other small fish. More often, it comes up simply looking satisfied, having swallowed the prey before surfacing. They are solitary hunters and, as a rule, only one cormorant at a time can be seen on any reach of the Liffey.

One of the most remarkable facts about the cormorant is that, unlike the great majority of water birds, it cannot produce sufficient oil to repel the water from its feathers. Cormorants therefore have to take frequent rests on the land and hang their wings out to dry. They usually move downstream to perch on buoys in the river, but from time to time take their siesta on the quays of the Grand Canal Basin. They are more sociable at nesting time, and breed in colonies, the nearest being on Howth, Ireland's Eye and Lambay.

## Squacco Heron *Ardea ralloides*

The squacco is a small, neat, pale-brown African heron, which migrates to Mediterranean Europe and, on very rare occasions, strays farther north. One of those strays was found, injured, in College Park in October 1967 and died shortly afterwards. It was only the twelfth to be recorded in Ireland.

## Heron *Ardea cinerea*

Herons stand and watch for fish in the Blessington Street Basin and the Royal Canal. They fly over Trinity College from time to

time, usually in the evening and seldom during the breeding season. Although suburban herons tolerate people in fairly close proximity, Stephen's Green may be a little too populous for them.

## Mute Swan *Cygnus olor*

What most people simply call 'swan' requires a qualifying adjective to distinguish it from two species of 'wild' swan. These, which visit Ireland in winter, make splendid trumpeting sounds, while the resident swan can do little better than snort. It does make up for its lack of voice with a loud noise as it beats its wings rising from the water or changing direction in flight. The wild swans keep to wide open spaces and are unlikely to find the city ponds attractive.

It seems that swans stayed away from the inner city for a long period and that led Oliver St John Gogarty to introduce them to the Liffey as a thank-offering after his spectacular escape from Republican soldiers in 1922. History does not record whether they stayed there. Gogarty probably failed to notice that the Liffey in the city provides no suitable ground for them to build their massive nests. From time to time, however, one or two swans sail majestically up or down the river. They also visit Stephen's Green, sometimes remaining there for months at a time, and a pair nested and raised one cygnet in the summer of 1995.

They nested fairly regularly at Portobello in the 1940s and 1950s when there was an inaccessible, reed-fringed bank at the Ever-Ready factory. In the 1990s they successfully reared families on both canals. In 1995, the Royal Canal pair found an element of seclusion by the towpath below the wall of Mountjoy Jail, which is never a particularly busy place. They were delightfully tame, even when guarding their newly hatched cygnets, allowing human admirers to come as close as they wished.

The Grand Canal pair chose a much busier site, beside the footpath on Grand Parade, where they sat on their eggs over the greater part of April, and hatched early in May. Citizens, dogs and traffic failed to disturb them in the slightest. Many people came daily to watch their progress, and the surroundings of the nest from time to time took on the appearance of a rubbish-heap as more bread than the swans could cope with was contributed

by over-generous admirers. The local rat population, however, did notable work in ensuring that the bread never stayed too long.

## Brent Goose *Branta bernicla*

The Latin word *bernicla* is a reminder that this seaside goose was believed to hatch from the goose barnacle, a crustacean whose body is shaped and coloured like the goose and which attaches itself to floating timber by a black, goose-neck. It even has a cluster of feathery feet, which gives the impression of a bird's tail. Moreover, the nesting places of the brent goose would have been unknown to medieval observers. Giraldus Cambrensis, in 1183, gives an account of this marvel and adds the helpful comment that holy men were free to eat it on days of abstinence because of its fishy origin.

In the 1950s, geese could fairly regularly be seen in flight over the city. They were Indian bar-headed geese, which belonged to the Zoo but were allowed to fly freely. They discovered interesting places like Áras an Uachtaráin and Stephen's Green, and would go off for a change of scene. But they regarded the Zoo as home and returned there every evening. Since those days, geese have been rare visitors to the city, but they may very well move in once more. This time they will be the truly wild brent geese, which nest in arctic Canada and winter in Dublin Bay.

They are small and neat, black and grey-coloured geese, which rest on Bull Island and feed on green seaweeds when the tide is low. The Dublin Bay population has increased greatly since the 1970s and, at the same time, they have discovered many sources of food besides the estuarine weed. In particular, they graze on the lawns of the larger parks at Fairview, St Anne's and Ringsend, and on the lawns in the Corporation's sewage treatment works. There are occasional records of their feeding a little way inland, and so it is not surprising that they fly over the city from time to time.

Tom Cooney has seen them occasionally since the early 1990s, flying inland over the city, as many as ninety on one occasion. On 11 January 1995 I saw a flight at sunset, crossing College Park, where they were also seen by Lynn Mitchell. As the years go by, the brents have changed from being timid and

unapproachable birds to a state of ignoring humans and their dogs until either or both move very close to them. If the trend continues, they will possibly honour College Park or any of the larger lawns with a visit. The citizens by and large will welcome them — only the groundsmen may have reservations as droppings accumulate on their otherwise immaculate territory.

## Mallard *Anas platyrhynchos*

*Platyrhynchos* is a pleasant-sounding but less than complimentary term meaning 'flat-nosed'. Mallard are true winners in the evolutionary race. Not only have they developed such a perfect state that they thrive in the wild over a great part of the northern hemisphere, but they have adapted fully to life in towns and cities of the world. Wherever there is water and a bare minimum of bushes — or occasionally of buildings alone — mallard make a living. The inner-city population numbers between 100 and 200 pairs, nesting in Stephen's Green, the canals and the Blessington Street Basin, and frequently visiting the Liffey. They can be seen in flight above the streets anywhere.

Most of them nest on the ground on dry land, not far from the water's edge and carefully hidden amongst bushes or in long grass. But there are unusual mallard in Dublin and, indeed, in other cities. Some build on roof tops: the Royal College of Surgeons, Leinster House and an office block in Burlington Road are known nesting places. Very soon after the ducklings hatch, the mother leads them to the water. This is simple enough when the nest is close to a pond but it raises difficulties on the roof tops. For the ducklings, getting down is merely traumatic — they are very light and do not fall heavily, even from a considerable height. The greatest risk comes when roads have to be crossed, but the motoring public by and large is tolerant and traffic grinds to a halt to allow the duck families to reach the safety of the Green. After hatching, the family stays away from the nest, the mother brooding her ducklings on the ground. So the road-crossing does not have to be repeated.

The duckling's expectation of life is tragically short. Eight or nine eggs or more are laid and hatch. But the flotillas of beautiful, downy, creatures which scamper hither and thither on the surface of the pond, are decimated in a matter of days. Cats, rats, magpies and herring gull all take their toll, so that the

family is rapidly reduced to three or four young or fewer. Those that do live long enough to grow feathers and fly have a greatly increased chance of survival, and mallard can live for many years. The large size of the clutch has evolved because of the very high risks faced by the young.

The breeding season in Dublin is long: ducklings may be seen from March through the summer to September or later, though the peak time for ducklings is around the month of May.

## Shoveler *Anas clypeata*

The shoveler's name refers to its outsize bill and its habit of guzzling in the mud to extract small insects and snails. A handsome species, with white breast and patches of blue and chestnut on its flanks, it is plentiful in winter in the Bull Island lagoon. One was seen in the Blessington Street Basin in 1991.

## Pochard *Aythya ferina*

With red head and silver back, the pochard is one of the most handsome of our ducks. In winter they abound on some of the larger lakes, in flocks numbering thousands. Smaller numbers live within Co. Dublin on the Brittas Ponds. Almost unknown in the inner city, there is one record from the Blessington Street Basin for 1991.

## Tufted Duck *Aythya fuligula*

Tufted duck began to nest in Ireland in the 1870s when they established themselves in the larger lakes. In the 1950s they arrived in Co. Dublin, and they appeared in the inner city ten or twenty years later, beginning with the Blessington Street Basin. Tufted duck are very much less adapted to people than are mallard and they are far from common as city birds in Europe. The fence and hedge which surrounded the Basin in the 1960s may have given them a sense of security, while the island provided a resting place completely free from human disturbance. Six or more pairs can be seen there in early summer, and that may cause problems because the area of the Basin is small and there is a limit to how many duck families can live in it.

It seems likely that, as they bred successfully in the Basin, population pressure built up and made some of them look for

other homes. This probably brought them to Stephen's Green, where thirty pairs were counted in May 1994 by Oscar Merne, and to the canals. They are regular summer visitors to the Grand Canal at Herbert Place, where they first nested in 1993. To the Royal Canal they still seem to pay only occasional calls. Wherever they live, they have a much shorter breeding period than the mallard, and the ducklings seldom appear until July.

As in other species of duck, the male loses his bright plumage in the autumn moult and takes on an appearance very similar to the female. For some weeks they are unable to fly and the brown shades act as camouflage. In November, some of the drakes regain their glossy black background colour and pure white flanks, and by Christmas all are looking properly masculine once more. The tufted duck in Stephen's Green are so tame that you can enjoy eyeball-to-eyeball contact. Their eyes are golden and the black heads of the drakes have an exquisite purple sheen.

### Red-breasted Merganser *Mergus serrator*

The merganser is a scruffily handsome, fish-eating duck, which breeds on the larger lakes of Ireland, spends the winter on the coast, and is a regular visitor to Dublin Bay. Tom Cooney has seen them occasionally as far upstream as Matt Talbot Bridge, usually on calm winter days at high tide.

### Sparrow Hawk *Accipiter nisus*

Sparrow hawks lead furtive lives and may be more plentiful than they seem. Their hunting forays are usually brief: a rapid flight close to a hedge or bushes, which may end in the capture of a small bird or may fail. In the latter case, the hawk retires to a hiding place before making another dash. The small birds retaliate by mobbing any hawk that they spot in the open. The mobbing birds don't actually come in contact with the hawk or harm it, but they make its hunting almost impossible because success depends on taking the victims by surprise.

Sparrow hawks from time to time look for roosting wagtails in O'Connell Street. They visit College Park in autumn and winter, feeding on blackbird and greenfinch. A pair attempted to nest there in the 1970s. Tom Cooney has seen them elsewhere in the city and watched their mating display in January.

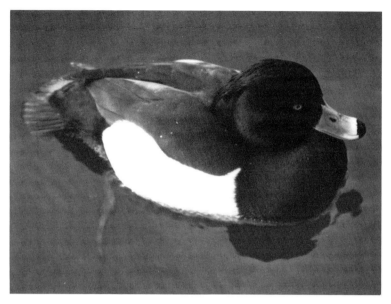

Tufted drake.

## Kestrel *Falco tinnunculus*

The kestrel is the most familiar falcon of the inner city. A solitary bird can be seen quite often, hovering above wasteland, especially by the canals. Kestrels possibly breed within the city area. Like other falcons, they cannot build nests and usually raise their families in second-hand homes; the magpie's is a favourite and there is no shortage of these.

## Merlin *Falco columbarius*

The merlin is a small falcon that normally hunts small birds in open places. From time to time one can be seen at dusk, in flight or perched on a parapet overlooking the O'Connell Street wagtail roost. The *Irish Bird Report* gives definite records on 11 and 29 December 1968 and 1 January 1969, but few have been seen since. They never became regular visitors and presumably found that the wagtails did not provide an easy meal.

## Peregrine *Falco peregrinus*

The peregrine falcon, after some years of a near collapse of population, has been increasing in Ireland and, in 1992, became the most spectacular — and most publicised — of the city's nesting birds, when they selected the gasometer on Sir John Rogerson's Quay and raised three young. In 1993, although demolition of the gasometer was postponed to allow them to breed, they abandoned the site. They were seen roosting on the Four Courts but have not been recorded as breeding birds since.

The city provides the peregrine with most of its requirements. Tall buildings take the place of the cliffs used by the falcon in wilder places to scan the surroundings in search of prey. Pigeons are just the right size as victims, and they are plentiful. The buildings also provide the equivalent of the cliff ledges used by the peregrine as breeding sites. Possibly the more built-up parts of the city do not give the falcon space enough for the high-speed pursuit of its prey, while the relatively open lower Liffey quays were acceptable.

## Coot *Fulica atra*

The coot is a reasonably common water bird in Ireland, a dumpy black bird with a Chinese white bill and forehead. It feeds by diving from the surface for plants on the bottom in the shallows. The depth of water in the canals is apparently not quite right for them and, because submerged weeds are assiduously controlled in Stephen's Green, they don't inhabit the pond there. At least they didn't until the bright, frosty morning of Tuesday 26 November 1996 when I saw a single coot there, which had not been present the previous Saturday. It remains to be seen whether it was the first of a band of pioneers set to inhabit the pond, or a lone, wandering individual who spotted the water down below and decided to explore it.

## Moorhen *Gallinula chloropus*

Moorhens maintain relatively large territories. So although they live by both canals and in the larger ponds, they are never as plentiful as the other common water birds. One or two pairs live in each of the reaches between locks on the canals and they are well spread out on the long stretch of the Royal Canal between

Crossguns and Liffey Junction. Two or three pairs occupy Stephen's Green, and a couple live in the Blessington Street Basin.

The breeding season is very long: the little black, downy moorchicks — about the size and shape of a golf ball — can be seen any time from March to October. Wherever there are plenty of reeds, the nest is neatly woven between the stems at the very edge of the water. Where reeds are scarce, the lowest branches of bushes overhanging the water are used. Moorhens make no special effort to conceal their nests and are often easy to see as they sit on the eggs. The chicks can swim — and do — as soon as their down has dried after hatching.

## Oystercatcher *Haematopus ostralegus*

The word *Haematopus* means blood-red legs. Thousands of oystercatchers spend the winter in Dublin Bay, many young birds remain there through the summer and a few pairs nest by the seaside. There are not many oysters for them, but cockles abound and are acceptable. Smaller numbers of oystercatchers, hundreds or fewer, come inland and feed on lawns and playing fields, digging for worms. This explains why they can quite often be seen in flight above the city, drawing attention to themselves by their loud, piping calls. They are seen on the ground in College Park from time to time, usually early in the morning, but they generally prefer more open spaces, free from surrounding trees and tall buildings.

## Lapwing *Vanellus vanellus*

In harsh weather, lapwing wander far and wide and from time to time fly over the city. On rare occasions they have been seen feeding in College Park.

## Woodcock *Scolopax rusticola* (and Snipe *Capella gallinago*)

Woodcock have been seen and noted by bird-watchers in College Park no fewer then four times. That is a very high score since the college provides little of the dense cover usually chosen by woodcock for their habitat. The most recent was disturbed from some leaf litter in the Provost's Garden by Lynn Mitchell in November 1995, one was seen on an autumn day in

the 1980s, and two in the course of the previous hundred years. There was always a strong tradition that Fellows of the College — and no lesser mortals — were permitted to shoot snipe in the park. In the seventeenth and early eighteenth centuries, before the building of the sea walls, it is likely that the park was a swampy place and inhabited by this delectable wader. They have not been recorded in recent times.

## Whimbrel *Numenius phaeopus*

The whimbrel is a small species of curlew, known as the 'May bird' in the west where it is much more plentiful than on the east coast. It is a bird of passage, visiting Ireland in spring and autumn on its migrations northwards and south, and rarely seen in summer or winter. The greatest numbers pass in the month of May. According to Tom Cooney, they are regular spring visitors, flying over the inner city in small flocks in April and May, and one was seen flying up the Liffey in January 1995.

## Curlew *Numenius arquata*

Curlew abound in Dublin Bay and occasionally move inland to feed in playing fields. They can often be heard at night in March, flying over the city. These are believed to be making a return journey from wintering grounds in Ireland to nesting places in the north of England and in Scotland.

## Green Sandpiper *Tringa ochropus*

The green sandpiper is never common in Ireland. Every autumn small numbers pass through, and a few spend the winter. Spring migrants are very much rarer, but one honoured the city with its presence for one day on 7 May 1990 when it was seen in the Blessington Street Basin.

## Mediterranean Gull *Larus melanocephalus*

One Mediterranean gull was seen at the very edge of the inner city, on the toll bridge, on 11 November 1991. It is an interesting bird, first seen in Ireland in 1956 and still rare, but now appearing every winter in small numbers and mostly on the east coast. None but the most assiduous ornithologists are really likely to be aware of meeting one. According to the bird books it

resembles a common gull but has a heavy red bill and white wing-tips. In summer, the adults have black heads but, again, the white wing-tips distinguish them from the black-headed gull.

## Little Gull *Larus minutus*

This diminutive gull visits the east coast from late summer on, but in very small numbers. It is extremely rare inland. One was seen on the Liffey at the Four Courts on 23 August 1982.

## Black-headed Gull *Larus ridibundus*

This is the very beautiful, small and neat gull, which roams all over the city, though with a preference for open water and green fields. The name is faintly misleading, as the dark hood is worn for only half the year, from February or March to July. Indeed, the appearance of more and more gulls in their black-headed state is as sure a sign of spring as the blooming of daffodils. Their numbers have grown since the 1950s, when most of them kept to the Liffey. More recently, the herring gulls, which used to be the dominant species, have been decreasing, so that the black-headed is now very much the top gull of the inner city.

Black-headed gulls usually feed on the ground, but can be seen from time to time on the Liffey and almost permanently on the Grand Canal Basin, swimming and dipping their heads beneath the water to grab some shrimp or insect that happens to be passing. More often, they use the water as a resting place: some sleep, some preen their feathers, and others simply social-ise. On lawns and playing fields they walk hither and thither, ready to dig for worms or soil insects. At high tide on the Liffey there are hardly any to be seen, by half tide they are lining the parapets of the buildings in wait and, as soon as the mud is left bare by the falling tide, they descend and enjoy a diet of worms.

The gulls that fly above the roof tops are constantly on the lookout for chance scraps. Sometimes one spies a crust of bread or some tasty morsel on the footpath, dives down and, skilfully avoiding traffic and pedestrians, snatches its prize. All goes well if it can swallow this on the spot, but if the first gull has to carry the crust in its beak, its friends and neighbours turn on it and try to grab the prize. When a generous citizen empties a bag of crumbs into the canal, the gulls gather from all around. Only one may have been visible from street level but, up above,

the gulls in flight are watching each other as well as searching for food on the ground. When one dives in a meaningful way, the others get the message and, within minutes, ten or twenty or more are clamouring for the meal.

Most of Ireland's black-headed gulls nest on lake islands or in bogs, and the numbers in the city are greatly reduced from April to July when the adults retire to the country to breed. After the young have been reared, gulls return to Dublin Bay, to the suburbs and the inner city. Some come from the lakes in the west and midlands, but others are immigrants from England and Scotland. As many as 8,000 have been counted in Dublin Bay in winter, but the actual numbers may be two or three times as great. A spectacular dawn migration of black-headed gulls takes place over the Liffey in winter. Tom Cooney has counted these and reckons that between 100 and 200 pass per minute over a period of two hours from a little time before dawn. That makes a total in the order of 20,000 each morning. Their return journey to the Bay is less conspicuous.

## Ring-billed Gull *Larus delawarensis*

This North American species closely resembles the common gull and may have been overlooked in Ireland before the first definite record in 1979. Since then, it has become a regular visitor in small numbers, Dublin Bay being one of the most favoured spots. In the inner city one was seen on the Grand Canal in 1994.

## Common Gull *Larus canus*

The English name is unfortunate, because other seagulls are very much more common. In the inner city the common gull is fairly rare except in winter when ten or twenty may be seen at high tide on the Liffey and in the Grand Canal Basin. They were considerably commoner in the 1950s when a flock of between thirty and forty could be seen every morning on the Rugby field in College Park throughout the winter — though seldom on the cricket ground and rarely after midday. Nowadays they are only occasional visitors to these former haunts and remain slightly aloof from people in the city, preferring the digging of worms to the competition for crumbs. Playing fields are a favoured inland winter haunt, though the great majority in

Dublin, one or two thousand in all, live in the Bay, feeding on the sand flats at low tide. In the breeding season, common gulls leave Dublin and migrate to the west, to nest on lake islands or by the sea.

### Lesser Black-backed Gull *Larus fuscus*

Romantic epithets such as 'harbinger of the spring' relate to swallows and other species that can be readily recognised by the plain people. The lesser black-backed gull has too long a name and too confusing an appearance to merit a poetic title. Even so, it has the honour to be the first spring migrant to arrive in the inner city, in contrast to its larger relative, the great black-back, which spends the winter there. The early birds can be seen by the canals or on the Liffey in February, having arrived from winter quarters in southern Europe or northern Africa, and they will remain until late summer. However, times change and the appearance of a lesser black-back can no longer be used to tell the time of year. In the mid-1970s they began to spend the winter in Ireland fairly regularly. In the city, although occasional wintering ones have been met, they remain essentially summer visitors.

The numbers are never large, solitary birds or pairs are the rule. They used to be regular inhabitants of the Grand Canal but are less often seen there now. The Liffey is the favoured haunt and they can be seen, with the black-headed gulls, hunting for buried worms on the mud at low tide. In 1991 a pair nested on a roof in the vicinity of Conyngham Road, and the following year one that appeared to have a nest nearby was seen in Merrion Square. Roofs, free from any predators besides cats and magpies, make secure nesting places for birds big enough to defend themselves. For the most part, the parapets are as inaccessible to ornithologists as they are to vandals, and scientific proof of nesting is consequently difficult to obtain. Tom Cooney saw three possible breeding pairs on Liffeyside buildings in 1996.

### Herring Gull *Larus argentatus*

This is the real seagull, the bird with a wailing cry which follows ships and nests on rocky islands. Probably not capable of catching a fish, the name is likely to have come from the flocks

that attend the herring fleet at sea and in harbour. At the end of the nineteenth century when Ussher and Warren published their *Birds of Ireland* it was strictly maritime, seldom seen at any distance from the shore. W.J. Williams in 1908 noted that they were plentiful on the Liffey from autumn to spring but were seldom seen in the breeding season. While still keeping mainly to the coast for nesting, herring gulls took to moving inland in the course of the century. A little note by Eugene O'Mahony in the *Irish Naturalists' Journal* in 1935 describes one on Leinster Lawn, pulling earthworms from their burrows. Above all, the herring gulls discovered a new feeding ground in the form of municipal dumps. Early every morning hundreds fly to the rubbish tips from their roosting places on the coast.

In the 1950s they were the dominant gulls of the city, always plentiful on the Liffey and often outnumbering the ducks in Stephen's Green. They earned an evil reputation as destroyers of ducklings, leading the authorities to put up a notice asking the populace to refrain from feeding them. The gulls remained, since, among other things, they were attracted to the ponds as they like to bathe in freshwater. Ducklings and crumbs were merely icing on the cake. In recent years they have been far fewer, and often there are no gulls at all on the Stephen's Green pond. The Grand Canal Basin remains a favoured haunt, and small numbers visit the canals and the Liffey at low tide.

The herring gull population of Co. Dublin began to explode in the 1960s but reached a peak in the 1980s. Botulism, contracted from the rubbish tips, took a heavy toll and there was also a culling campaign because the gulls of Lambay were endangering aircraft. There may have been less obvious factors, too, brought on as a result of overpopulation. Whatever happened the main communities of herring gulls, a small number of deviationists deserted the seaside in favour of the buildings of Dublin as a home. In 1972 Paul Hillis discovered a pair nest-building on the roof of the abandoned Findlater's building in O'Connell Street. They failed to rear a family, but in 1984 a pair nested in Kildare Street and the following year another raised a family on an O'Connell Street building. Since then, residence in the city has become more regular, and nowadays more than twenty pairs nest annually. In 1994, Brian Madden found

eighteen families of chicks within an area of about a square kilometre. Abbey Street and the Quays were favoured sites. Tom Cooney reckons that as many as fifty pairs were nesting in the city in 1996.

Like the black-headed gulls, herring gulls patrol the skies above the houses all the time, watching for some scrap of food down below. In wet weather, when the ground is soft, they hunt for worms on playing fields. They learn quickly to recognise good spots, and regularly visit windowsills where office-workers are prepared to feed them crusts of bread. They are just too big to risk going to the ground between traffic and pedestrians. But in summer they take the city over for the seagull hour: that peaceful time after sunrise before the traffic builds up when it is safe for them to walk the streets and inspect the dustbins, with few creatures other than party-goers, gardaí and foxes to disturb them.

## Iceland Gull *Larus glaucoides*

Iceland gulls spend the winter in Iceland and retire to Greenland to breed. Now and again, young birds and, very rarely, adults get swept off their normal migratory trail and arrive in Ireland. There they join with flocks of herring gull or, less often, lead a solitary existence, perhaps hoping that some of their own kind will turn up some day. A little smaller than herring gulls, they have similar habits of scavenging for any chance morsel of food they can spot.

The first known inner-city Iceland gull was seen on the Liffey near Grattan Bridge by W.J. Williams in May 1906. The next on record visited Stephen's Green for a few days in May 1944. Nearly fifty years after Williams' observation, an Iceland gull took up residence on Wellington Quay in 1952, swimming in the Liffey where the Poddle joins it. I saw another one there a few years later, in January 1955, and yet one more in May the same year by the Grand Canal. That was forty years ago and I've been looking in vain for them for most of that time. The exception was in October 1968 when one arrived in Stephen's Green and remained there on and off for two winters, until May 1970. It bravely survived being watched by the entire community of Dublin's ornithologists. One more visited the Green for just one day at the end of November 1985.

## Great Black-backed Gull *Larus marinus*

Large and powerful, with a wing span of six feet or more, the great black-back generally prefers open spaces to the city. Hundreds of them spend the winter in Dublin Bay and nest on the nearby islands. Many of these visit Dublin port but, as a rule, only isolated pairs or single birds come into the city. They visit most of the places where the herring gulls feed, including College Park, the canals, and the ponds of Blessington Street and Stephen's Green. But they seem to be very much chance visitors, rather than fully adapted city birds. W.J. Williams, who wrote about the gulls of the inner city in 1908, said that they were never to be seen upstream of 'The London and North Western Boats', which berthed on Custom House Quay.

## Sandwich Tern *Sterna sandvicensis*

The sandwich tern is usually the first of its tribe to arrive in spring. Tom Cooney has seen them a few times downstream of Matt Talbot Bridge.

## Common Tern *Sterna hirundo*

The Latin name *hirundo* translates as 'swallow' and the terns are poetically, and very aptly, known as 'sea swallow'. Not only are their tails forked and elegantly tapered, but they arrive in spring and retire to the south in autumn. Swallows time their stay in our climates to coincide with an abundance of flying insects, while the terns come to feast on the young fish which hatch and swim close to the surface over the same period.

The terns of the inner city nest just outside our boundary, as many as fifty of them on the mooring dolphins in the port. Some make no nests at all; others use anything that is available, including flakes of paint. Oscar Merne has studied their breeding in the Liffey and has observed both common and arctic species there. They usually go seawards to hunt, but now and again a few fly up the river as far as O'Connell Bridge. There they flit gracefully or hover above the water, diving suddenly as soon as one spots a small fish. When there are young to be fed a tern that succeeds in catching a fish carries it off in its bill, down the Liffey to the nesting place, often pursued by a gull. At other times, it swallows the prey as quickly as possible to avoid such unwelcome attention.

## Arctic Tern *Sterna paradisaea*

Common and arctic terns resemble each other very closely, the common having a plain red bill, the arctic a red bill with a black tip. In 1940, Harry Fogerty published a note in the *Irish Naturalists' Journal* describing terns fishing between Butt Bridge and O'Connell Bridge in July, and he was able to identify one of them as a definite common tern. City bird-watchers seldom have the opportunity to make a close enough inspection to see whether the bill tip is red or black. However, Tom Cooney has identified both common and arctic within our area in the 1990s.

## Black Guillemot *Cepphus grylle*

The black guillemot lives in coastal waters, diving to hunt for small fish and shrimps. In breeding plumage it is black all over, except for a large rectangular white patch on the wing. Small numbers nest on the Howth and Bray cliffs, on Ireland's Eye and Lambay. It would seem to be a most unlikely inner-city bird and I was very surprised to see one in the Liffey at high tide in March 1996. Tom Cooney, however, has known them as nesting birds just outside our boundary since 1990. Black guillemots are happy to use man-made substitutes for crevices in cliffs, and a pair nests in a pipe opposite the Alexandra Basin.

## Pigeon *Columba livia*

On remote parts of the coast, rock doves nest on cliff ledges. They have mostly grey plumage and come from the same ancestral stock as domestic pigeons. The wild ones also live as close to the city as Howth, but these quite often show some of the varieties of colour of the 'feral' birds, whose ancestors returned to the wild after generations of domestication. Dovecotes were built by medieval monks and landowners, providing the birds with safe nesting places in which to rear their young until they were fully grown and ready to fly — when the owners would catch them for the pot. The breeding doves enjoyed a well-fed and secure life, and evidently considered the sacrifice of the family a reasonable price to pay for their comfort. So the pigeons came to regard humans as benefactors and sources of food and, as the dovecotes went out of fashion, the birds found their own nesting places but continued to live in town.

The pigeons nest on window sills and roof parapets — the essential feature being a ledge of some kind, far enough above the ground to be out of the reach of cats. They gather in flocks to feed, and can be seen anywhere in the city. More than any other species, they have adapted to urban life and have no need for trees or grass or wide open spaces. Seeds and green vegetables, particularly clovers and cabbages, are their basic food. The dockland population lives to a considerable extent on spilled grain from trucks, and the vegetable market is a very busy haunt. But they are equally happy with cooked things, and so they flock in the public parks where people feed them. Some go back to ancestral habits and patter over the mud of the Liffey at low tide, searching for food, while more adventurous parties fly off to Dublin Bay for the same purpose. Others simply wander at random, on the lookout for scraps of any kind.

## Wood Pigeon *Columba palumbus*

The gentle cooing of wood pigeons is a sound that brings images of country life to the very centre of the city. They have been increasing in numbers since the 1950s or earlier, and have changed from a population of a handful of isolated pairs to being one of the species most likely to be seen in the parks. Although flocks of hundreds can rove in the country, particularly in winter when huge numbers come to Ireland from the continent, the inner-city numbers remain small. It seems that the winter visitors are strictly rural birds which avoid built-up areas, while the Dublin population may be the extended family of the few pioneers who decided to forsake the country.

Wood pigeons feed mostly on the ground, eating clover and other green plants. Although they have a great liking for grain and do considerable damage in tillage, only the bravest of the city dwellers will come for crumbs. The majority stay on the lawns or occasionally raid flower beds, but keep a safe distance between themselves and people. From time to time, they feed on berries, having a special liking for the hard black fruits of the ivy. The name wood pigeon is an old one and dates back to some centuries ago when the species was virtually confined to woodland. Trees remain essential in the pigeon's life, as a refuge at any time, and as a secure site for the big, untidy mass of twigs which passes for a nest.

## Cuckoo *Cuculus canorus*

The cuckoo is an unlikely inner-city bird at any time, and the single one that has been recorded was all the more remarkable in being present in October, months after the normal departure time. It was seen in College Park by Lynn Mitchell in October 1994.

## Barn Owl *Tyto alba*

Owls were more plentiful than nowadays in Ireland in the nineteenth century, when rodent control was less effective, and rats and mice more abundant. According to J.J. Watters' 1853 book on the birds of Ireland, they appeared regularly in Stephen's Green.

## Swift *Apus apus*

Swifts, in contrast to the pigeons, use people simply as providers of homes, and have not the remotest interest in sharing their food. They are remarkable birds in many ways, above all in the perfection of flight. Their skill in flying is obvious, with speed and agility far beyond the powers of most birds. They seem to rejoice in it, gathering together of a summer evening simply to fly hither and thither, calling to each other with high-pitched screams. What is less obvious is that they can remain on the wing, day and night, without needing to settle. Almost all their bodily functions: eating, sleeping, mating, and even collecting feathers to line the nest, take place in flight. The only thing they have failed to do is incubate their eggs and brood their young in the air. So they find holes under the eaves of old buildings and make nests in the dark beneath the slates. Modern buildings, by and large, are too carefully finished to provide the caverns that the swifts like.

The Museum Building in Trinity College is a favourite haunt, but there are many others. Between ten and twelve pairs nest in there, according to Tom Cooney. The swifts range far and wide in search of insects, so that they can be seen anywhere in the city. The one problem with their frenetic activity is the need for plenty of food to provide the energy. They cannot tolerate periods of cold weather, and so they rarely arrive in Ireland before the second week in May and few stay here beyond the end of August. The swallow announces spring, but the swift is a symbol of high summer. In spite of their appearance, swallows and swifts have no close relationship, except that both evolved a shape and structure to enable them to capture flies on the wing.

## Kingfisher *Alcedo atthis*

The city has relatively little to offer the most brilliantly coloured of Ireland's birds. Kingfishers need streams with plenty of overhanging bushes on which they can perch to look for small fish. They also require river banks made from muddy sand of just the right consistency to allow them to nest in. Some tropical species of kingfisher have given up the idea of fishing and dive down from high perches to snatch insects from the ground, but our species is a traditionalist and keeps to water and fish.

Kingfishers maintain large territories and chase any intruders away. After a few weeks of tolerance, the kingfisher's own brood are sent off and have to wander in search of a solitary home. From August into September or October, therefore, they can be seen in unusual haunts, and this habit brings them into inner Dublin where they are spotted now and again. I have seen only two, to date: one in August 1994 above the creek of Spencer Dock on the Royal Canal, the other in September 1995 at Sean Heuston Bridge on the Liffey.

Kingfisher.

## Skylark *Alauda arvensis*

Few birds have inspired so many poets — but the poets, like the larks, have lived in the country. Skylarks need large areas of rough pasture with plenty of cover, and the lawns of the inner city are too small for them. In autumn and in cold winter weather they wander far and wide and can be heard flying overhead, far from their usual haunts — which include Bull Island and Ringsend Park. October is the month in which migrants from the north can be heard flying southwards over the city, according to Tom Cooney. They are on the Trinity College list and, in October 1960, six were heard above Parnell Square.

## Swallow *Hirundo rustica*

Breeding swallows need flying insects, and plenty of them, close to their nests. The inner city has become too hygienic for

them. The days of abundant horse manure and other fertile breeding grounds for flies have passed away and, with them, the swallows of the city. They still turn up regularly in spring and autumn on migration, and can be seen anywhere. In summer they are attracted from their few suburban nesting places to the canals and the Blessington Street Basin, because the undisturbed water now and again provides the necessary swarms of small insects. The Stephen's Green pond is too regularly cleaned to allow the insect population to develop.

Swallow.

### Sand Martin *Riparia riparia*

Sand martins nest in colonies in burrows which they dig in sand banks. The sand needs to be of just the right consistency, which is why they are very localised birds. There are colonies in the sand quarries to the south of Dublin. Outside the breeding season, they wander and have been seen in the Blessington Street Basin. Tom Cooney has records of these and house martins in spring, usually early in April.

### House Martin *Delichon urbica*

House martins are found in most parts of Ireland but are never as plentiful as swallows. They were probably common in the inner city in the days of horses, manure and more insects, but are now quite rare. In recent times, since May 1995, they have occasionally been seen over Trinity College by Tom Cooney.

### Meadow Pipit *Anthus pratensis*

The authors of *Birds of Trinity College Dublin* have just one record of a meadow pipit in town — on 2 November 1992, and one

was seen in the Blessington Street Basin in 1991. Howth, Bull Island and Ringsend Park are favoured haunts, and they fly over the city from time to time, but the lawns are a little too smooth and short of cover for them.

## Yellow Wagtail *Motacilla flava*

This species is quite a rare visitor to Ireland, and the first known one in the inner city stayed for a few days in Trinity College towards the end of October 1996.

## Grey Wagtail *Motacilla cinerea*

The name is slightly misleading, because it is the brilliant lemon yellow plumage that commands attention and makes it one of the most beautiful of the city's birds. The reason for the name is that the previous species is even yellower. The grey wagtail never lives for long at any distance from a stream with clear water. Occasionally it visits lake shores and even gardens with ponds. The canals flow just quickly enough, and their water cascading over the lock gates may be an added attraction, even a necessity.

The Royal Canal at Crossguns Bridge is the only place in the city where you can be sure of meeting grey wagtails. The resident pair usually stays close to the locks. They nest in holes or crevices, and there are plenty of suitable sites in the old masonry. On the Grand Canal, Huband Bridge is a favoured spot but doesn't seem to have the same hold over the wagtails. Possibly, the high walls of the Crossguns locks give a greater degree of security. Grey wagtails visit Stephen's Green and College Park from time to time, and may have nested by St Patrick's Well below Nassau Street.

## Pied Wagtail *Motacilla alba*

The emblem of The Dublin Naturalists' Field Club shows the Corporation's coat of arms, superimposed on two wagtails in a plane tree. More than any other species of bird, the 'Willy wagtail' is a true Dubliner. It thrives in all parts of the city, from the most spacious and salubrious parks to the grimiest regions of dockland. Having very little fear of people, it nonetheless asks nothing of them because it feeds exclusively on insects and

spiders — rarely, if ever, condescending to accept a crumb from a citizen. Wagtails evolved as birds of the shoreline, whether stream, lake or sea. But the pied wagtail, while still perfectly happy to continue to dwell by the water, adapted to a life ashore. They like the lawns, the canals, the rivers and ponds, and the roof tops. The point about the less prepossessing places such as gutters is that they often have an accumulation of mud in which insects breed.

But none of this would explain the wagtails and the tree as chosen by the Dublin Naturalists. The tree in the emblem represents one of the planes in the middle of O'Connell Street, to the north of the GPO. To those same trees in the winter of 1929 came a vanguard of the wagtails of Dublin. The first naturalist to welcome them was the taxidermist, W.J. Williams, who published this note in the *Irish Naturalists' Journal* for January 1930:

> During the past month, in a tree not twenty feet high in the middle of O'Connell Street, in the full glare of electric light and the noise of traffic, over 100 Pied Wagtails have come to roost every night. There are no leaves on the tree and every bird roosts facing the wind. They slept on the slender branches during a night of torrential rain and high wind.

C.B. Moffat took up the story the following year with a detailed account. The little flock that Williams had seen had left the roost early in December, and none were seen again until the middle of October 1930. This time the observer was no less a man than the Jesuit, Fr P.G. Kennedy, one of the pioneers of conservation in Ireland. Each evening the birds began to gather about twenty minutes after sunset and continued to fly in for twenty minutes more. That winter, the flock had grown to number at least 450, and in March they began to leave again, though the last to go remained until 15 April. The following year there were 1,500 or more in midwinter. The highest ever count made was in 1950, when 3,600 were recorded.

Numbers have dwindled since, to less than 1,000, but hundreds may still be seen. Between 1977 and 1980, Don Cotton and John Lovatt counted the wagtails on many occasions and found that they tended to keep to the trees just north of the GPO in harsh weather, and spread out more widely in milder conditions. In their paper they mentioned some very interesting observations made a few years previously by E. Hannon of

UCD's Geography Department. He had discovered that the temperature in O'Connell Street in winter could be as much as 2° C higher than in the surrounding countryside, and the centre of the street was warmer than the ends. On Christmas Eve of 1994, 650 were counted, but numbers between 300 and 500 appear to be more usual nowadays. Tom Cooney has seen them fly into the Christmas Tree on particularly cold nights, the dense foliage, and possibly the light bulbs, providing a little added warmth.

Pied wagtails — and many other species of birds — make a habit of communal roosting, in spite of spending the day either in solitude or in the company of a mate. But a wagtail roost as big as the Dublin one is rare, and their choice of a brightly lit and noisy part of the city makes it all the more remarkable. Sixty-five years since their first arrival, the majority remain faithful to the original three trees, though some thorough deviationists have slept in trees on Burgh Quay since the 1960s, and in 1991 a small group was seen roosting at Heuston Station. In winter 1995–96, they were in the traditional trees north of Anna Liffey before Christmas, but in early February were occupying eight of the older trees between Abbey Street and the GPO, and there were none to be seen north of the Post Office. In March they had moved to the two trees nearest to Parnell. Their moving from tree to tree was a change in behaviour from the 1950s when they kept much more strictly to the centre of the street.

The fall in numbers since the 1950s is probably associated with cleaner streets and fewer animals in the city. The virtual disappearance from the inner city of horses and stables, pigs and piggeries has seriously reduced the breeding places for the small insects needed by the wagtails.

## Waxwing *Bombycilla garrulus*

Although it is extremely rare, the waxwing is a relatively well-known species because, when they do turn up, they come into parks and gardens, while the majority of rare birds are sought in remote places. Waxwings breed in Scandinavia, and from time to time the population there explodes and they migrate much farther to the south and west than usual. The last really big waxwing 'invasion' of Ireland was in winter 1965–66, which was when I saw a party of seven of them, one day in January, behind the Rubrics in Trinity College. Two years later some

were seen again in Trinity, in February, and in 1973 a little flock visited Phibsborough, also in February. The next big invasion took place in 1996, when as many as thirty-seven were seen in College Park in January, and 150 in Stephen's Green the following month. Red berries are their favourite food, which explains their readiness to visit gardens.

## Wren *Troglodytes troglodytes*

The wren is a very remarkable bird which has adapted to life in virtually all parts of Ireland. Perhaps it is not so surprising that a bird which can thrive on our most rugged islands, provided that there is a trace of scrub or bracken cover, can also be at home wherever there are shrubs in the city. Like the pied wagtail, it is content to live very close to people, but without depending on them in the least, since it feeds entirely on small insects and spiders. Wrens abound in the big parks and anywhere with plenty of cover in the form of dense bushes. Most of the time they keep hidden, hunting amongst the branches and seldom remaining in the open for long. The nests are nearly always built in holes, which sometimes brings a wren indoors, into a dilapidated shed or some such place. Except in extremely cold weather, when a group will huddle together for warmth, wrens keep a good distance between each other. Each male maintains a large territory and there are probably not more than half a dozen pairs in an area as large as Stephen's Green.

Territorial birds that can't be seen have a problem: they can only defend the territory if they know where their rivals are. The solution is to sing, and what the wren lacks in size, it makes up for in sound. The song is loud and very distinctive, something of a jumble of notes but always interrupted by a long trill. At its best in spring, the wren sings in every month brightening the day even in the depths of winter.

Wren.

## Hedge Sparrow *Prunella modularis*

Like the wren, the hedge sparrow is a slightly unobtrusive bird — until it sings. The song, a rather breathless outburst

which always seems to be delivered in a hurry, can be heard in any month. Excessively serious ornithologists use an alternative English name — 'dunnock' or, worse, 'hedge accentor' — because it is not phylogenetically related to the sparrow. But it looks very like a sparrow and, when in town, lives in much the same places even though it belongs to an extremely small and highly specialised family of birds. They all have sparrow colouring, but an important anatomical distinction is the narrow bill, which shows them to be insect-eating rather than seed-eating birds. However, they ignore their anatomy and in winter readily take to feeding on seeds and crumbs.

Hedges and shrubberies are an essential part of their habitat and therefore city and suburban gardens suit them perfectly. There they build neat, cup-shaped nests in which they lay eggs of an exquisite, pale, sky blue. Except when singing, they tend to lead retiring lives, but in hard weather they leave the cover and feed at bird-tables. All the well-established city parks have a population of hedge sparrows but the numbers are small because they are territorial and demand plenty of space.

### Robin *Erithacus rubecula*

Robin redbreast, a bird which James Stephens tells us is specially protected by the leprechaun community, deserves his place on the Christmas card as a symbol of friendship. Few wild creatures have taken to quite so close a relationship with people. One theory is that ancestral robins followed stone-age hunter-gatherers through the forest, darting in as the men disturbed the fallen leaf litter, revealing hidden insects. Or perhaps the behaviour goes back no further than the first farmer, when the robin discovered that it paid to come near enough to spot the soil insects turned over by digging or ploughing. Whatever the origin of the habit, robins had no problem in following their benefactors into the city, always provided that there were bushes to sing from and a patch of open ground to dig in. The human race has also provided the robin with another essential, a hole to nest in. The robin likes to have a roof above its head, and crevices in walls, gaps beneath the eaves of low buildings and an endless variety of discarded artefacts suit it very well.

So the robin, together with wren, hedge sparrow and blackbird, is one of the most familiar of birds in the inner city. The

heavily built-up areas have no attraction for them, but they abound in parks and gardens and extensive patches of waste-land. Male and female robin are identical in appearance, but radically different in habits. The male sings sweetly, nearly every day of the year, and establishes a territory in which each has a number of specially selected song perches. The song is usually enough to keep rival robins away and within their own domains. On rare occasions neighbouring males square up to each other and, even more rarely, they fight for a few moments. Each dominant male tolerates his mate within the territory — always provided that she knows her place and behaves with due deference. In harsh weather, the urge for exclusive territories is suppressed, and three or four or more robins feed together ami-cably, reinforcing the Christmas ideals of peace and goodwill.

## Wheatear *Oenanthe oenanthe*

The wheatear is a very beautiful little thrush, coloured in shades of grey and pale brown. It is most certainly not a typical bird of the inner city, but belongs to the seashore and moorland pas-ture. Although they are regular visitors to Bull Island and Dún Laoghaire, it is surprising that there have been as many as two city sightings: one in 1939 and one in the late 1980s in Trinity College.

## Blackbird *Turdus merula*

Robin, blackbird and the thrushes all belong to the same family. Colours and size vary a good deal, but the shape is a common feature and, whatever the colours of the adult, the young are always brown with speckled breasts. Blackbirds are seldom as confiding as robins but otherwise behave in much the same way. They, too, have well-defined territories and defend them by singing. The blackbird's song period is generally quite short, from March to June or July, but there are exceptions. I heard one brave bird singing in the grounds of the National Gallery on a January morning.

There are possibly more blackbirds than robins in the city. Smaller parks such as the Garden of Remembrance, Wolfe Tone Park and Mountjoy Square usually have blackbirds in plenty, and they have nested in O'Connell Street since 1993. On open lawns, surrounded by bushes, in Stephen's Green, Merrion

Square and other large parks, several blackbirds can be seen at a time, hunting for worms. The exclusive part of a bird territory is close to the song perches in the trees or shrubs, and a large lawn can be accepted as common ground. Aggression flares up now and again, and the males chase each other, but before long the combatants relax and resume their search for soil organisms.

## Fieldfare *Turdus pilaris*

In Scandinavian countries, where they breed, fieldfares are familiar birds in city parks in summer. They migrate south after the breeding season, reach our shores in large numbers in late autumn and travel the country. Very handsome, big thrushes with grey heads and tails and russet-coloured backs, they generally keep to wide open places. In harsh weather, and usually after Christmas, small numbers venture into the inner city and visit the big lawns, those of College Park, Stephen's Green and Merrion Square.

## Song Thrush *Turdus philomelus*

Except when singing — which it does nearly the whole year round and with one of the finest songs in the business — the song thrush is a faintly subdued bird. Its beautiful, warm brown colouring with quietly speckled breast, is calculated to keep it hidden rather than to draw attention to its presence. Like the blackbirds and robins, they find plenty of living space in the parks and gardens. My own notes have more records for them in Merrion Square than anywhere else, but this may be because the lawns there are relatively small, so that it is easier to spot them than in Stephen's Green and College Park.

In the 1990s song thrushes became quite scarce in Dublin, but they seemed to be increasing again by 1995. Innumerable theories were put forward for their disappearance, but none of them seemed very convincing. Song thrushes nest in dense bushes and, for a day or two after they leave the nest, the fledglings hunt for food on the ground and can't fly quickly enough to escape from cats and magpies. But young blackbirds have much the same problem and they have been as plentiful as ever.

## Redwing *Turdus iliacus*

Like the fieldfare, the redwing breeds in Scandinavia and winters in Ireland. Both species keep strictly to their migratory pattern and unseasonable ones are extremely rare. October and November are the usual months for redwing arrivals in Ireland, but they generally stay in open country until midwinter. After Christmas, they turn up fairly regularly in the larger parks where they either eat berries on the shrubs or hunt for worms on the lawns. Their appearances in the inner city are sporadic, and often, though not always, associated with harsh weather conditions.

## Mistle Thrush *Turdus viscivorus*

There is not much mistletoe in the inner city or anywhere else in Ireland, but the mistle thrush thrives nonetheless. Both the English and the Latin names credit the bird with feeding on the mystical white berries, but in Ireland it has to settle for red ones: rowan, holly, cotoneaster and many others. These are plentiful in the parks and gardens and contribute to the thrush's success as a city bird. The other great attraction for the species is the extent of lawns surrounded by trees for refuge and for nesting. Like the other resident thrushes, robin, song thrush and blackbird, the mistle thrush is territorial, but seems to need a very much bigger territory than they do. So, although it can be seen in all the bigger parks, the numbers are much smaller.

The mistle thrush nests in trees rather than bushes, sometimes high up. The nest is tucked into a fork and is seldom well hidden. This raises a potential risk of attack by magpies and, no doubt, explains the thrush's implacable ferocity towards them. At any time of the year, inside the breeding season or out of it, mistle thrushes can be seen furiously chasing any magpies that come near, and drawing attention to their attack by a machine-gun rattling call. The fact that mistle thrushes thrive in the midst of large magpie populations suggests that their aggression pays.

Like the magpie, the mistle thrush is a relative newcomer to Ireland. The first ones arrived in Co. Down early in the nineteenth century, and they established themselves quickly down the east coast and across the country. They are bigger and brighter than the song thrush, with pale brown back and boldly speckled breast, and they live in the open to a much greater extent.

## Melodious Warbler *Hippolais polyglotta*

Melodious warblers visit Ireland nearly every year on migration on remote parts of the coast. The sole inner city one was seen near Merrion Square on 20 August 1907.

## Lesser Whitethroat *Sylvia curruca*

The lesser whitethroat is a very rare little brownish warbler, usually seen only in the south-east of the country during the spring and autumn migration seasons. In spite of that, the inner city claims one. It was heard singing one day in May 1990 in Merrion Square.

## Blackcap *Sylvia atricapilla*

Most of the warblers that live in Ireland are soberly coloured birds with few distinguishing marks — other than their songs. The blackcap is one of the exceptions, a grey-green bird with a very distinctive black crown in the male, brown for the female. The majority are summer visitors and confined to broad-leaved woodland. But small numbers, believed to be migrants from farther north, remain in Ireland for the winter. They seem to keep hidden most of the time, but now and again visit gardens and join the more familiar species at bird-tables. The south Dublin suburbs have been particularly favoured. They are regular winter visitors to Trinity College, and there are also records from the bushes beside the pond in Stephen's Green, the latest in March 1994. Because they usually keep hidden in the bushes they are seldom seen and are likely to be more plentiful than the records suggest.

## Chiffchaff *Phylloscopus collybita*

The Latin — or rather more Greek — generic name implies looking at leaves, and this species and the willow warbler are birds of trees and bushes, beautifully coloured in shades of green and very well hidden as they hunt amongst the branches for insects. They are almost identical in appearance but have completely distinct songs. The chiffchaff's English name perfectly describes its repetition of two rich notes. They are summer visitors and can be heard singing in spring in Trinity College and the bigger parks where they appear again in

autumn. Small numbers spend the winter in Ireland. One of these was seen in Stephen's Green in December 1987, and three have been seen in Trinity College, the latest in January 1996.

## Willow Warbler *Phylloscopus trochilus*

The willow warbler's song is a very pure descending cadence — the chaffinch also goes down the scale, but in a more hurried and slightly untidy way. Like the chiffchaff, the willow warbler visits Dublin on the spring and autumn migrations. While the chiffchaff needs well-grown trees for the summer, the willow warbler is content with bushes, and the large parks might provide just enough cover for nesting. The nests are very well hidden but the male demonstrates his parenthood by singing while the family is being reared.

## Goldcrest *Regulus regulus*

I have a theory that the wren is not the king of all birds, never was and never will be. 'Wren' was a general term for many kinds of very small birds, and my theory is that the royal bird is this even smaller species — which used to be called 'golden-crested wren'. The point about the goldcrest is that it actually has a crown, the top if its head being coloured red and gold. Its Latin name, *Regulus*, translates as 'little king'. The fact that it is the smallest Irish bird, even smaller than the wren, adds to the propriety of declaring its kingship. Small numbers of goldcrests come to the inner city during the spring and autumn migrations and in winter.

They are very active and easy to see as they hunt for insects on the outer branches of trees and shrubs. The fact that they are seldom seen implies that their visits to the city are casual and that they don't settle for long periods. They nest in coniferous woodland but travel far and wide during the winter.

## Spotted Flycatcher *Muscicapa striata*

A slightly nondescript small, brown bird, the spotted flycatcher is a summer visitor. Its habit of perching on a twig or electric wire and taking short flights in the air to catch flies makes it a conspicuous species, unlikely to be overlooked. It used to breed in Trinity College but has seldom been seen there in recent

years. One was seen in Stephen's Green in June 1981. A favoured nest-site is an ivy-covered wall, and the Iveagh Gardens would be an ideal habitat.

## Pied Flycatcher *Fiedula hypoleuca*

Although reasonably common in west Wales, pied flycatchers are seldom seen in Ireland except on the coast in autumn. One spent three days in Trinity College from 22 to 24 November 1994, where it was seen by Lynn Mitchell and Tom Cooney.

## Long-tailed Tit *Aegitahlos caudatus*

One of the most delightful of all Irish birds, the long-tailed tit's body is even smaller than that of the goldcrest, but it can't qualify as a smallest bird because the tail brings it up to quite a respectable overall length. They travel far and wide in small parties, working over the twigs of small and large trees in search of insects. Like the goldcrest, they are therefore easy to see and, equally, rather uncommon in the inner city. A group spent some time in College Park in winter 1991–92, finding it a big enough place to allow them to wander. The Grand Canal banks, with their variety of trees, are another haunt, and they visit Stephen's Green quite regularly.

## Coal Tit *Parus ater*

The coal tit usually nests in conifers and visits the inner city outside the breeding season, particularly in early spring when natural supplies of food have been reduced and the birds are forced to wander. They can be seen in any of the larger parks and come readily to feeders.

## Blue Tit *Parus caerulea*

The blue tit is amongst the top ten successful city birds. Not only can it be seen easily as it hunts for insects on branches and sometimes on walls, but it is seldom silent, and the high-pitched churring call can be heard almost anywhere there are trees. They live in all the well-established parks and most of the surviving back-gardens. Insects caught amongst the branches are their staple food, but they are very adaptable birds and in winter feed happily on crumbs, seeds and animal fat.

The most serious constraint on their numbers is the availability of nesting holes. They will not build in the open and, in the wild, depend on old trees with hollows and on rough masonry. The young trees and well-maintained walls of the more desirable city squares present them with a problem. One solution is to provide nest-boxes, and these have been a great success in Stephen's Green, where they were set up by the South Dublin Branch of the Irish Wildbird Conservancy. Those placed in the open were used, while the tits showed little interest in boxes hidden amongst the shrubs. A nest-box high on the bare trunk of a tall tree is as near to cat-proof as can be.

## Great Tit *Parus major*

The great tit is not a common city bird, which is very puzzling. It has no problem in making a living in suburban gardens where nesting boxes often attract them. I did see a pair nesting in a hole in a wall in Trinity College in the 1950s, but nowadays they are described as only occasionally seen, mainly in autumn and winter. Ever since I carelessly listed them as birds of Stephen's Green and was told that they are never seen there, I had been looking and listening in vain for years, so confirming their extreme rarity. However, on 20 February 1996, a mild but snowy day, I actually saw a great tit in the Green, which looks like an ideal habitat, as do Merrion Square and College Park. Like the other tits, it is an easy bird to spot and, in almost every month of the year, draws attention to itself by its loud, high-pitched song, rendered 'teacher teacher teacher sir sir sir'.

## Treecreeper *Certhia familiaris*

An unobtrusive, mouse-like brown bird, the treecreeper climbs up the trunks of old trees, searching the crevices in the bark for insects. Suitable old trees are relatively few in Dublin, which may explain the fact that there is only one treecreeper on record for the inner city — it was seen by Tom Cooney in Stephen's Green in January 1996.

## Magpie *Pica pica*

The magpie has earned an evil reputation on account of its persistent breaking of the Eleventh Commandment — 'thou

shalt not be found out'. They rob the nests of other birds and eat the young fledglings. Their mistake is to do it in daytime, while cats, which are probably much more serious and effective predators, hunt at night or very early in the morning. The magpie's other mistake is to be common. Peregrine falcons, which eat many more birds, are rare and loved.

It is a very interesting bird and a relative newcomer to Ireland. Their arrival in 1676 was actually witnessed and recorded, when a storm-driven party came to land in Co. Wexford. Since then, they have spread to most parts of the country. Their greatest problems were in the west where there were few tall trees for them to nest in. Magpies have been true city birds, breeding in College Park among other places, since 1852, but were never especially plentiful until the second half of the present century when an unexplained population explosion occurred.

The nests are large and untidy-looking but very well-built structures of twigs, often with a domed roof. Unoccupied ones can last for years but the resident magpies usually start work on repairs or building in January. This may be as much a social ritual as a necessary undertaking, since the eggs will not be laid until April. Magpie nests can be seen nearly everywhere there are trees: several in O'Connell Street and along the quays, a fine one in St Michan's churchyard, and a great many in the parks. Where suitable trees are scarce, cranes, electricity poles and other structures are acceptable nesting places. There are limits, however, and each nesting pair maintains a large territory, so that there are seldom more than two in College Park, and those on the quays, canal banks and elsewhere are well spaced out.

Between 1980 and 1983 Brendan Kavanagh made a study of breeding magpies in Dublin and found that the numbers had been increasing by about 12 per cent per year since 1970 when Clive Hutchinson had made a nest count. In 1983 there were 28.6 nests per square kilometre, making a total of about 350 pairs in the inner city. If the increase had continued at that rate, there would now be 1,812 pairs — but that is unlikely.

Whether the magpie explosion has had any effect on the population of thrushes and other birds remains unknown because no comparable census of the others has been undertaken. With the exception of the very recent decline of the song thrush, the songbird population gives the impression of being as

healthy now as it was in the 1950s and 1960s. The essential fact is that Irish songbirds have been living with magpies since the eighteenth century, and that would be plenty of time for them to adapt to their depredations. A key factor in the survival of the eggs and young of songbirds is the amount of cover available for them. Provided that there are plenty of hawthorns and other dense shrubs in which blackbirds and others can build secure nests, they have little to fear. None of this makes the sight of a magpie eating a young bird any less distressing — but the only effective remedy would be to kill the magpies. Not only would that be prohibitively expensive, but it would rid the city of one of its most entertaining and beautiful birds.

## Jackdaw *Corvus monedula*

Jackdaws are charming birds which lead exemplary lives, going through a dignified courtship and remaining together as long as they live. As common birds of farmyards and suburban gardens, with no objections to human populations, they are surprisingly scarce in the inner city. The availability of nesting holes may be one of the major constraints. Having numerous redundant chimneys in which they can nest, Mountjoy Jail is one of their strongholds. The Kevin Street area, where there are many old houses and gardens, is another. They can be seen in the parks, by the canal banks and in dockland, but, with the exception of the few nesting places, seldom with any regularity.

## Rook *Corvus frugilegus*

Rooks and jackdaws often feed and fly from place to place together. They separate in the breeding season because the jackdaw always needs a hole to nest in and so cannot breed colonially, while the rooks, in the treetops, are always sociable. They are far more plentiful than jackdaws in the inner city, though not as numerous as the seagulls. However, their habits are similar, flying hither and thither in search of scraps of food or gathering on the lawns to probe for burrowing creatures.

The nearest large rookery is at the Islandbridge gate of Phoenix Park. For a number of years, a few pairs nested in trees on the King's Inns lawn but they left in the early 1990s. About the same time, a few pairs established residence in three plane trees at the south end of O'Connell Street, beginning in 1989. There

were seven nests in 1993, and three in 1995. In 1996 they had deserted Daniel O'Connell's trees and were back in the King's Inns again. Early in March one pair was nest-building near the top of a tall plane tree, and two other pairs were present nearby.

## Hooded Crow *Corvus corone*

Hooded crow, grey crow or scald crow have lived in Trinity College since the 1950s and are possibly extending their range in the inner city. Others inhabit the canals, the quays and dock-land, and in the spring of 1996 there were signs of nesting activity on Leinster Lawn — but the foliage of the holm oak into which the birds were flying was so dense that nothing could be seen within. The crow is typically a bird of the seaside and wide open spaces, where its primary food is carrion and, in the breeding season, the eggs or young of ground-nesting birds. However, like other crows, it is an omnivore and very adapt-able. The main constraint on its population is a need for very large territories, so that it is unlikely that more than about ten pairs will be able to live in Dublin.

When they are not resting in tall trees, the city crows are usually to be seen on playing fields or lawns where they must be hunting for soil organisms rather than carrion. In the country they generally keep safely out of range of people and, in spite of the move to the city centre, they remain fairly unapproachable.

## Raven *Corvus corax*

Ravens nest on Howth and Bray Head, and forage regularly on the shores of Dublin Bay. The raven's deep-throated croak is loud and very distinctive, so it seldom goes unnoticed. One visiting the inner city was seen by Tom Cooney flying over Trinity College in February 1996. He also met two on the wasteland off the quays near Hanover Street early in the same year. The fact that none of the dedicated band of city bird-watchers seems ever to have noticed them before is interesting and implies that, at least until 1996, they were extremely rare.

## Starling *Sturnus vulgaris*

The starling was probably once the most plentiful bird in the inner city. In winter a number of huge flocks used to gather at

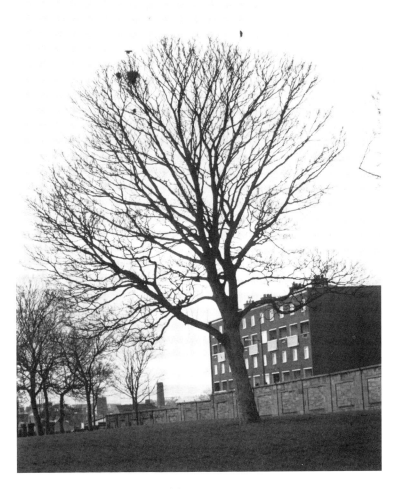

Rook's nest in King's Inns Fields.

dusk. First they would perch on the guy wires of television masts and other vantage points, then hundreds at a time would take off and fly hither and thither. Finally, the flocks would break up, and the birds would find roosting places on the cornices of buildings, in the plane trees and elsewhere. Very interesting though they were, their numbers went beyond tolerable limits, especially because their droppings actually

damaged the stonework, and steps were taken to control them.

The numbers are smaller now, but they can still be seen in most parts of the city summer and winter. Starlings are very sociable birds and have a strong tendency to gather in flocks. Their success comes in part from their ability to eat almost anything, animal or vegetable. Soil organisms make a large part of the diet but scraps are equally acceptable. The flocks break up in the breeding season because the nest must be built in a hole, and suitable sites are widely scattered. When the young have been fledged, the birds rejoin the community. In winter the numbers are greatly increased by migrants from the continent which stay until March or early April.

## Sparrow *Passer domesticus*

The most remarkable thing about Dublin's sparrows is that they are by no means common. In many European cities they have adapted to urban life to such an extent that some are believed to feed only on cooked food and to live under cover, in such places as railway stations, throughout their lives. Sparrows are tolerant of humans, rather than tame. While robins and other species will learn to feed from the hand, sparrows are nearly always wary.

They are regulars in Trinity College where there are plenty of nesting crevices in the older buildings, in Stephen's Green where crumbs are always to be had, and in the Fruit and Vegetable Market where there are old buildings and abundant scraps. Elsewhere in the city, they seem to be closely associated with privet hedges. If you hear the chirping of sparrows in any street, the chances are high that there will be a garden with a hedge, however small, within sight.

## Chaffinch *Fringilla coelebs*

One of the commonest birds in the country, chaffinches in the city seldom wander outside the larger parks and gardens. They need hedges or shrubs for nesting and for shelter, and in winter they hunt for seeds on the ground. These are scarce enough in a well-swept city, but breadcrumbs and discarded sandwiches make an excellent substitute. So chaffinches are always on the watch in places such as Stephen's Green where citizens are willing to provide for them. In winter, especially in harsh weather, the numbers increase from time to time, and flocks of

100 and more have been seen in College Park where they forage on the playing fields. The song of the male is loud and distinctive — a slightly imperfect descending cadence, it is one of the most typical sounds of Stephen's Green, Merrion Square and Trinity in spring. Equally noticeable is the call-note, a single, deep-pitched 'cheep', often used by the chaffinch to draw human attention to itself and increase the possibility of a crumb.

### Brambling *Fringilla montifringilla*

The brambling is a finch that breeds in northern Europe and comes to Ireland in small numbers for the winter, often joining up with flocks of chaffinches. A male brambling stayed in Trinity College for about a week in February 1995 where it was seen by Lynn Mitchell.

### Greenfinch *Fringilla chloris*

The greenfinch is a slightly uncommon bird in the inner city, although small parties may be seen now and again in any park during the winter. Two regular haunts, winter and summer, are the Royal Canal at Crossguns Bridge, where a large currant hedge may be the vital factor, and Merrion Square with its abundance of flowering shrubs. They share with the tits the ability to eat peanuts in feeders, and have a special liking for sunflower seeds. The call-note of the greenfinch, a series of trills, often draws attention to them.

### Goldfinch *Carduelis carduelis*

The goldfinch is a rarity, which is not surprising as it needs a source of very small seeds such as it finds in thistle heads. Thistles are scarce in the city except on derelict building sites, and the only goldfinches I have seen within the area were close to the biggest of them, in Albert Terrace, near Charlemont Street one day in August 1994. They are rare visitors to Trinity College in winter and have been seen by the Blessington Street Basin.

### Linnet *Carduelis cannabina*

The specific name of the linnet denotes a liking for small seeds, rather than an addiction. The *linn* of its English name has the same derivation as linseed and linen, from the Latin name for

flax. It is a regular visitor in winter to College Park, often in flocks numbering between twenty and forty, and once, in February 1992, 180 were counted. The linnet is also on the list for Blessington Street Basin and can be seen now and again in Stephen's Green, Merrion Square and by the canals. In summer, linnets are birds of the open country, rough pastures with gorse being especially favoured. In winter, they join up in flocks and travel widely, but seldom stay long in any one place.

### Redpoll *Carduelis flammea*

Like the linnet, redpolls move around in winter in small flocks and may be seen anywhere there are birch or willow trees. That gives them a good deal of scope in the inner city where they are known as fairly regular visitors to Trinity College and are likely to be seen from time to time in Stephen's Green, Merrion Square and by the Grand Canal.

### Siskin *Carduelis spinus*

The siskin is a rather uncommon bird anywhere in Ireland, a bright green-and-yellow finch, which lives in coniferous woods. In winter, migrant siskins hunt amongst alders and sometimes enter the suburbs and help themselves to peanuts where these are on offer. They are seen in most winters in Trinity College, as many as fifty in 1995–96 when they foraged in the alder trees. Siskin have been recorded in the Blessington Street Basin and are likely to visit the other parks.

### Bullfinch *Pyrrhula pyrrhula*

Bullfinches live in Merrion Square and irritate the gardeners because their principal food is the small buds of flowering bushes. Beautiful birds, the male with a pink breast and velvet black cap, they live in couples and are usually too few to cause serious damage. They are rare visitors to Trinity College, the Blessington Street Basin and Stephen's Green.

# 11
# Wild Flowers

This chapter is a very personal selection of wild flowers and ferns that attracted me for one reason or another, whether for their size and beauty, their incongruity, herb-lore or history, or their ability to thrive in difficult places.

Peter Wyse Jackson and Micheline Sheehy Skeffington began their field work for *Flora of Inner Dublin* in 1979, and by 1984 had observed no fewer than 345 species. These are given, with details on where they can be found, and the book is essential reading for serious urban botanists. It is referred to here simply as the *Flora*. Since it was published, the tall reed *Phragmites* has made its way into the inner city in the Grand Canal and the bulrush *Typha* has extended its range from a single water tank to a more comfortable habitat in the canal. Otherwise there have been few changes. Some of the authors' favourite derelict building sites have been duly built on, but new ones come on the scene from time to time.

Eighty years earlier, in 1904, Nathaniel Colgan published his distinguished and delightful *Flora of the County Dublin*. Not only is it a meticulous species by species catalogue of the flowers and ferns of the county, but it is elegantly written and includes an important supplement giving local plant names collected by Colgan himself from 'the Dublin country folk'. Field Club members have been working on a revision of Colgan's *Flora* and it was nearly ready for publication in 1997.

A number of earlier botanists studied the wild flowers of Dublin, the father figure being Caleb Threlkeld, a doctor of medicine and a dissenting minister of religion. He was born in Cumberland but settled in Dublin, dying in 1728 at the age of 52. Happily, a year before his death, he had published a little book entitled *Synopsis Stirpium Hibernicarum*, of which the title page tells all that needs to be known of its purposes:

Synopsis Stirpium Hibernicarum Alphabetice Dispositarum, sive Commentatio de Plantis Indigenis praesertim Dublinensibus

instituta, being a Short Treatise of Native Plants, especially such as grow spontaneously in the vicinity of Dublin; with their Latin, English and Irish names; And an Abridgement of their Vertues. With several new Discoverys.

The Irish names came from a manuscript by Richard Heaton dating, Threlkeld believed, from before the civil war of 1641. Threlkeld was a true inner-city man, living in Mark's Alley off Francis Street and he gives exact locations within our area for many of the 268 species of wild flowers which he catalogued.

## Field Horsetail *Equisetum arvense.*

The horsetails are 'living fossils' in that they are modern representatives of a class of plants which, with the ferns, were dominant in the Triassic era, some two hundred million years ago. The flowering plants have long since asserted themselves over most of the Earth, but the horsetails do survive, mostly in places that are either too dry or too damp for most species of the higher plants. The inner-city horsetails are confined around about the Royal Canal and Cabra, and they abound on a dry bank a little way upstream of the locks at Crossguns Bridge.

## Bracken *Pteridium aquilinum*

One of the relatively few ferns that can thrive on dry, sandy soil and which normally belongs to moorland, bracken is surprisingly common in the inner city. It grows on walls and sometimes on the edges of pavements where lime mortar may be an essential substrate for it. Compared to the luxuriant plants of the hillsides, city bracken is a puny, almost unrecognisable thing but one to be admired for its tenacity of life far from its usual haunts. Like other ferns, it develops from microscopic spores which can be carried for many miles on the wind.

## Maidenhair Spleenwort *Asplenium trichomancs*
## Wall Rue *Asplenium ruta-muraria*
## Hart's Tongue *Phyllitis scolopendrium*

These three ferns, all members of the family Aspleniaceae, are effectively at home in the city. In the wild they grow in limestone rock crevices or on the ground at the bases of cliffs. Walls

built of limestone masonry or of granite with lime mortar make a perfect substitute. Maidenhair spleenwort has pale, yellow-green fronds, which lie flat on vertical stones. Wall rue is dark green and grows in little tufts, again on walls. Hart's tongue is bigger, with narrow, pointed fronds which don't look very like a typical fern — and are faintly reminiscent of the shape of a deer's tongue. Small specimens grow in crevices, while large ones root in the dirt on the pavement and grow up the walls. Hart's tongue can be found in the meanest of streets, on the walls of derelict places, in grimy dockland, and even in clean, upmarket sites, giving a little flash of colour to grey places.

## Male Fern *Dryopteris filix-mas*

The traditional name may have been bestowed to distinguish a strong, masculine-looking fern from the delicate species called lady-fern. Like the other ferns, the leafy stage is asexual and reproduces by spores. It is one of the most common city ferns and thrives outside dark, damp basements because it likes moisture and shade. Like bracken it also grows on walls, especially where broken gutters and down-pipes supply some moisture. In these situations it hardly ever grows to its full size, getting too heavy for its roots and falling off or being blown away. The biggest and best specimens are found in the most neglected basements where nobody bothers to clear them away.

## Mother of Thousands *Soleirolia soleirolii*

Mother of thousands, one of the smallest wild flowering plants in the city, has minute, rounded leaves about 4 millimetres in diameter. What it lacks in size, it makes up in quantity, and it can cover large areas of damp ground. It was introduced to Ireland as a garden plant and thrives in old greenhouses, usually near water tanks. But it has distributed itself far from gardens and grows most luxuriantly in some of the locks of the Grand Canal where it makes a dense covering on the walls, neatly aligned with the spray from the water cascading over the gates.

## Pellitory-of-the-Wall *Parietaria diffusa.*

The adjective *parietarius* simply means 'belonging to walls' and was applied to the plant as early as the fourth century AD.

Pellitory-of-the-wall is a highly specialised member of the nettle family and thrives on old masonry where sufficient gaps between the stones exist for it to root in the decaying mortar. Indeed, there is a story that the emperor Constantine nicknamed Trajan *Herba Parietaria* because he had covered so many walls with his inscriptions. While there may be fewer inscriptions by Trajan nowadays, pellitory is still plentiful on the walls by the Tiber. It is one of the most conspicuous plants in the Grand Canal Basin where it forms big green tufts above the water on the quays. The stems are reddish and the leaves small, about a centimetre long and oval shaped. They have a slightly waxy surface, an adaptation which allows them to resist periods of drought when the meagre soil in the crevices dries up. Just beyond the bounds of the city, Caleb Threlkeld in 1727 made the first record of pellitory in Dublin 'upon Island-bridge'.

## Knotgrass *Polygonum aviculare* and *Polygonum arenastrum*

The native knotgrasses are unprepossessing plants — small and straggly with pale green, oval leaves and tiny, inconspicuous flowers. The two named are worthy of comment because they are among the most successful of the inner-city plants, found nearly everywhere. *P. aviculare* stands erect, though seldom more than 30 centimetres tall, while *P. arenastrum* has a mass of matted stems, spreading over the ground. Both are annuals, over-wintering as seeds. This makes them especially well suited for colonising open waste ground and such unwelcoming habitats as the dirt between pavements and kerbstones. The seeds and entire flowers were eaten by people in Viking Dublin.

## Amphibious Bistort *Polygonum amphibium*

The English name bistort is known to few, but has a respectable antiquity going back to the sixteenth century. When it lives on land, the plant requires damp soil and therefore in the city is almost confined to the canal margins, although it actually survived for many years in the filled-in Grand Canal Harbour. In the canals it shows its remarkable ability for thriving as a purely aquatic plant. The oval leaves, with square, cut-off bases,

spread out on the surface, and the finger-like spikes of tiny pink flowers stand above the water. It is a perennial, growing up from buried roots.

## Japanese Knotweed *Reynoutria japonica*

Knotweed is an unfortunate name, the sort that gets bestowed by botanists who are more interested in the evolution of a plant than in how it strikes the beholder. It is closely related to the knotgrasses, having similar flower structures, but there the resemblance ends. Japanese knotweed is a substantial bush, with big, pale green leaves, characteristically cut off square at the base. When introduced in the nineteenth century, it became a popular garden shrub and was planted with enthusiasm. When the gardeners discovered that it was more difficult to curtail than to grow, interest flagged, but by that time the knotweed had escaped from the gardens and was growing wild in many places. One of the most widely distributed wild shrubs in the inner city, Japanese knotweed thrives in the wasteland and is probably still expanding its range. There is an especially fine clump by the Grand Canal at Lower Mount Street.

## Fat Hen, Goosefoot, Lamb's Quarters *Chenopdium album*

The pleasing variety of vernacular names indicates a plant well known to the plain people rather than simply to botanists. An annual, with dark green, mealy leaves it grows in most parts of the city in freshly disturbed waste ground. And it has been abundant since Viking times when the seeds were eaten. Frank Mitchell considered that it had actually been cultivated and that the seeds were used in gruel. The name 'fat hen' refers to its subsequent use as poultry fodder.

## Common Chickweed *Stellaria media*

Like knotgrass, chickweed is one of most successful wild plants of the inner city. It is more pleasing to look at, having bright green leaves and growing in healthy-looking clusters rather than straggling over the pavement. It is another of the plants that thrive in the traces of soil that accumulate between pavement and kerb or on the old stone steps of Georgian houses

where there are many crevices. In healthier places, where there is good soil, the chickweed grows luxuriantly. The name suggests that this was another wild plant used by poultry, and there was evidence from the Viking excavations that it was eaten by people, too.

Richard Mabey in *Food for Free* extols the chickweed, recommending that it be simmered for ten minutes with a knob of butter but no water. However, his recommendation to add herbs, lemon and onion suggests that its flavour is not especially exciting. John Gerard recommended it for 'little birdes in cadges'.

### Procumbent Pearlwort *Sagina procumbens*

Its alliterative name alone would justify including the procumbent pearlwort. But it has other claims to fame, including being one more of the species that seem to thrive underfoot, growing amongst the paving stones. It is also one of the smallest of the city's flowering plants, with tiny, pointed leaves and minute white petals.

### Yellow Water Lily *Nuphar lutea*

This is one of two native water lilies. The white one favours slightly acid conditions, and the water of Dublin has too much lime for its liking. The yellow water lily grows here and there on the canals, one of the biggest and best patches being at Wilton Place. It dies away in winter and grows up in spring from roots buried in the mud. The earlier leaves are entirely submerged and, as the year goes on, some reach the surface and spread out, and the bright, globular flowers bloom amongst them in June and July.

### Hornwort *Ceratophyllum demersum*

The dominant submerged weed growing in the Grand Canal Basin and parts of the canal, hornwort is one of the most remarkable of the city's wild flowers. An uncommon species in Ireland, with a very uneven distribution, it is a newcomer to Dublin, and very rare elsewhere in the county. It has no roots but grows beneath the surface in dense masses of pale green feathery leaves. The stems are long and trailing, and the feathery

appearance comes from the structure: the individual leaves, hair-like and forked, grow in whorls at intervals along the stem, giving an overall appearance of a bottle brush. The name refers to the harsh feel of the plant. The flowers are small, coloured green or purple, but the fruit, an oval nut appearing in late summer, is relatively large, about 8 millimetres long.

Hornwort is an aggressive plant which suppresses other water weeds, including microscopic algae. Excessive growth of the algae makes nutrient-rich waters cloudy, and the hornwort can be thanked for keeping the Grand Canal Basin so beautifully clear, in spite of being mildly polluted.

### Traveller's Joy, Old Man's Beard *Clematis vitalba*

Traveller's joy is a rare plant in the inner city, but has to be included partly because I found some myself in a place unknown to my friends, the authors of the *Flora*, and partly because the seventeenth-century herbalist Gerard was so enthusiastic about it. The *Flora* records it around Fitzwilliam Square and in Cabra. It grows now by the Grand Canal on the Wilton Road stretch near Leeson Street Bridge, on the bank in a little clearing between the reed beds, where it must have arrived by chance since 1984 when the *Flora* appeared. Gerard is almost lyrical in his description of its form:

> ...whose long wooddy and viny branches extend themselves very far, and into infinite numbers, decking with his clasping tendrels and white starre-like floures (being very sweet) all the bushes, hedges, and shrubs that are neere unto it ... leaves are broad like those of Ivy, but not cornered at all: among which come forth clusters of white floures, and after them great tufts of flat seeds, each seed having a fine white plume like a feather fastened to it, which maketh in the Winter a goodly shew, covering the hedges white all over with his feather-like tops.

His enthusiasm for the plant was based entirely on its beauty because he noted that it had no use in physicke. And he gave it a lovely name as a final mark of approval:

> The first is commonly called *Viorna, quasi vias ornans*, of decking and adorning waies and hedges, where people travel; and thereupon I have named it the Travellers-Joy.

## Eastern Rocket *Sisymbrium orientale*

One of several small mustards with deeply divided leaves and yellow flowers, it is distinguished by the seed pods, which are extremely long and narrow. Eastern rocket generally grows in the dirt of dingy footpaths and in waste places. Its claim to fame is that it was unknown in Ireland until the end of the nineteenth century and may well have made a first appearance in the Dublin docks, the seeds brought in amongst cargoes of grain. It remains a common flower of the docklands and arrived in Belfast about the same time as in Dublin. It has become well established on the east coast but is still rather uncommon elsewhere.

## Bramble *Rubus fruticosus*

Blackberries abound in the wasteland and make slightly unexpected appearances in parks and gardens. Thriving wherever they are free from being cut or trampled on, they grow into huge clumps in the older wastelands — but as they take several years to attain such dimensions, the short-stay building sites are relatively free from their entanglements. The rougher ground by the Royal Canal above Crossguns is an excellent blackberry-spot. Not surprisingly, their seeds were plentiful in the Viking excavations.

## Clovers *Trifolium repens* and *Trifolium pratense*

These two clovers, with white and purple flowers respectively, are amongst the commonest wild flowers in the inner city. They thrive in lawns, even though gardeners do not particularly want them. More importantly, their ability to use atmospheric nitrogen, rather than having to depend on nitrogen compounds in the soil, allows them to colonise bare patches of very poor ground. The clovers act as pioneer plants, growing in barren soil and making it suitable for grasses to establish themselves on later.

## Shamrock *Medicago lupulina* and *Trifolium dubium*

Black medick and almost any clover with small leaves are used as shamrock — but the yellow flowered varieties have been

found to be the most popular. All good traditionalists know perfectly well which species is true shamrock and which is merely 'clover', but botanists have a much more difficult time. Those, including Robert Lloyd Praeger and Charles Nelson, who have actually studied the subject have found that many species have been declared as undoubtedly the one and only authentic form. Of course, the botanists always get it wrong because they identify shamrock by letting it grow and flower and everybody knows that the true shamrock doesn't have a flower.

## Rosebay Willow Herb *Epilobium angustifolium*

Rosebay willow herb or Fireweed is one of the finest wild flowers of the wasteland. Tall and leafy, with big, pink flowers, it is believed to have come to the city as a garden plant and subsequently escaped by the agency of its seeds, which are attached to long plumes and carried far and wide by the wind. It is an aggressive colonist, capable of suppressing many other invaders of derelict sites, and so it can be seen in large and colourful clumps in all parts of the city where it has had a few years to assert itself.

Colgan's reference to the rosebay indicates that it was a rare plant in his time. He relegated it to an Appendix of Excluded Species comprising 'Errors, Casuals and Aliens not fully Naturalised'. Here he states that James Townsend Mackay observed it in the Scalp in 1825 but that it no longer grows there. There were undoubtedly many derelict sites in the city at the turn of the century but it seems that the rosebay was not to be seen growing in them. As recently as 1967, David Webb could describe it as no more than 'occasional as an introduction by bog margins' — which suggests that it has adapted itself to city life in the course of the latter half of the twentieth century.

Rosebay willow herb.

### Great Willow Herb *Epilobium hirsutum*

This is another large and conspicuous willow herb, which grows in many parts of the inner city. Soft, pale green and hairy leaves distinguish it from the rosebay. First recorded by Threlkeld in 1727, it is considered a fully wild species. Having a preference for damp ground, it grows by the canals and in badly drained wasteland. Several smaller and less conspicuous species of willow herb are also found in the inner city.

### Ivy *Hedera helix*

The most surprising thing about ivy in the inner city is that the writers of the *Flora* failed to find it in two of their fourteen sub-divisions. It was missing from the regions around Mountjoy Square and the south quays. The absence of such a common plant often makes as interesting a study as the presence of a rare one. Nonetheless, ivy is very widely distributed. It carpets the ground amongst the shrubs on the outer edges of most of the larger gardens and, wherever it is left in peace, climbs their stone walls to add a great splash of colour, winter and summer. The small, yellow flowers attract many species of insect in autumn, and the black berries provide good food for wood pigeons and other birds.

Many good botanists and gardeners spurn the ivy, and it certainly can damage the old walls that it loves to climb. The harm it is supposed to do to trees remains uncertain. Possibly a heavy growth shortens the life of an old tree — but it is arguable that the tree needed to be weak and approaching the end of its natural life before the ivy could do any damage. Ivy's habit of climbing trees and walls is commonplace in Ireland but unusual elsewhere in Europe. Frequent frost in other countries prevents it from growing out from well-sheltered spots.

### Alexanders *Smyrnium olusatrum*

With its bright green, shiny leaves and yellowish flowers blooming in spring, Alexanders is a striking plant, particularly when it stands out on its own beside walls or on waste places. In the inner city it is rather scarce, except by the canals. The eighteenth-century naturalists were familiar with it, and Threlkeld, in 1727, told of the use of its young leaves as a salad

and recorded it just outside our area: 'It grows under our Hedges in the Ditches, and particularly on a small Bushy Hillock near *Crumlin* Church'. John Rutty, fifty years later told how it 'was formerly blanched in our gardens and eaten with oil, salt, and pepper, but of late has given way to Cellery'.

It seems to have been introduced to Ireland as a garden vegetable in the seventeenth or early eighteenth century and to have established itself as a wild plant following its fall from favour on the arrival of celery. Abundant around hedges and ditches in Dublin and Wicklow, and the coast, it is quite rare inland and possibly thrives on salt-laden air.

### Buddleia *Buddleja davidii*

As recently as 1967, David Webb left the buddleia out of *An Irish Flora*, presumably on the grounds that it wasn't a properly wild flower or shrub. For the 1977 edition he relented and included it — but even then he described it as common around Cork and only occasional elsewhere, though tending to increase. There seems to be no record of precisely when the buddleia population exploded. But it changed in the course of twenty years or so between the 1950s and 1970s from a deservedly popular garden bush into the most successful coloniser of the wasteland of inner Dublin. The first European to record setting eyes on this Chinese species was the nineteenth-century French missionary, Père David. The great Irish plant collector, Augustine Henry, discovered it independently.

Buddleia, also called 'butterfly bush' because its purple flowers have an irresistible attraction for butterflies and other insects, grows everywhere in the city, distributed on windborne seeds. The best garden books say that it needs a good garden soil. Perhaps it did and perhaps some subtle change in its genetic make-up took place, because nowadays buddleia is not content with invading the ground of neglected building sites. It springs up anywhere a seed lands on something that bears a faint resemblance to soil. So it grows in crevices in walls, in gutters, on chimney tops and roofs, in dank basements and on bright canal banks. The lawn-mower and the assiduous gardener are its sole conquerors. In effect, the soil of good gardens is the only medium in the city in which it is rarely found.

## Ivy-leaved Toadflax *Cymbalaria muralis*

This delightful plant makes bright patches of colour on lime-stone walls; its little, dark green, ivy-shaped leaves on reddish, trailing stems often grow into large clumps. Although related to snapdragons rather than violets, the flowers slightly resemble the latter, coloured mauve with pale yellow upper lip. It was introduced as a rock plant from southern Europe in the nine-teenth century or earlier and was first recorded as a wild flower in Ireland by Kathleen Sophia Baily in her book *The Irish Flora,* published anonymously in 1833. Seventy years later, Colgan found it growing luxuriantly at the Broadstone, and generally distributed throughout the county. Its popularity as a garden plant has long passed, but it has established itself firmly as a true Dubliner.

## Red Valerian *Centranthus ruber*

Red valerian is another of the once popular garden plants which have gone out of fashion but survived in the wild. Its presence in Dublin was recorded by Walter Wade in 1794 and it was widely distributed throughout the county by Colgan's time a hundred years later. Nowadays it is one of the most attractive and most abundant inhabitants of old walls where it roots in the mortar. The stonework of both the canals, of the railway lines in the north city, the western quays and bridges of the Liffey and crumbling walls or neglected pavements in many parts are all brightened by its presence. The most surprising feature of the valerian's occupation of the inner city is that it does not occur everywhere. The authors of the *Flora* failed to find it anywhere in a broad band extending south-westwards across the city from Mountjoy Square to Dolphin's Barn. It may have extended its range since their time, including establishing itself on the walls of Victoria Quay.

## Teasel *Dipsacus fullonum*

Teasel is a rarity, but an interesting one, its Latin name taking it back to Pliny. Members of the Dublin Naturalists' Field Club found it growing in Mountjoy Square in 1981, but that one may have perished since in the course of redevelopment. I found a well-established clump in 1994 in an equally insecure piece of

wasteland, the closed road of Misery Hill in the territory of abandoned gasworks. With its big flower heads and their persistence after the flowers have faded, it is a popular plant in borders and for dried arrangements, but in the eighteenth century a variety of teasel was an important industrial crop. The prickly flower heads were used in carding wool, and John Rutty, whose *Natural History* includes a catalogue of 'useful' plants, says that the clothiers of Dublin were supplied from Lusk and Balrothery. In Colgan's time it grew only north of the Liffey. Whether the Misery Hill clump blew in from the north or was transplanted from a park or garden in a heap of rubbish remains a mystery.

## Daisy *Bellis perennis*

One of the commonest of Irish wild flowers, it finds the inner city particularly to its liking — though its choice is not appreciated by groundsmen. The flat rosette of leaves allows the daisy to survive grazing animals in the wild and, in urban areas, the most aggressive of lawn-mowers. The flowers, which grow up quickly and bloom in nearly every month, are able to produce seed in the intervals between mowing.

## Feverfew *Tanacetum parthenium*

Having been unwise enough to plant feverfew in my own garden, I am not surprised to see it described as one of the commonest wild flowers around the city. In gardens and out of them, it spreads endlessly and appears in open soil, ready to establish itself and take the garden over. The pale green leaves and white flowers with yellow centres make a very attractive plant. As Gerard said, 'it joyeth to grow among rubbish'. It is a plant of many virtues:

> Feverfew dried and made into pouder, and two drams of it taken with hony or sweet wine, purgeth by siege melancholy and flegme; wherefore it is very good for them that are giddie in the head.... Also it is good for such as be melancholike, sad, pensive, and without speech.

## Coltsfoot *Tussilago farfara*

The Latin name for this plant has a very respectable history, having been used by Pliny. *Tussis* means 'a cough', and Gerard

describes how to make a cough-mixture from the leaves and roots. So it has enjoyed fame for 2,000 years and, besides that, is a particularly interesting species. The flowers are among the first to appear in spring, little tufts of yellow florets growing close to the ground on extraordinary pale green stalks. Early in March they bloom in waste places in all parts of the city and make a fine show along the canal banks. They wither in April, and the odd thing is that the flowers have disappeared before the leaves develop. They are flat, green, angular leaves without any very close resemblance to the hoofprint of a little horse. Coltsfoot thrives mainly on damp, bare ground, or occasionally on stone walls, so that the leaves are very conspicuous.

## Winter Heliotrope *Petasites fragrans*

A Mediterranean plant, winter heliotrope was a very popular garden species in the nineteenth century because it blooms in midwinter, though the smallish, pale mauve flowers are far from stunning in appearance. It began to spread beyond the gardens in the latter half of the century and, by Colgan's time, was well established as a wild flower. Liking shady and moist places, it grows well by the banks of the Grand Canal.

## Mugwort *Artemisia vulgaris.*

The English name is an ancient one, with no apparent explanation. *Artemisia* was the name for the species in classical times and was given in honour of Artemisia, Queene of Halicarnassus, who, according to Gerard, adopted it for her own herb. Travellers who carry mugwort feel no weariness. It also protects the bearer from poisons and is used by sorcerers. Otherwise, it is a slightly unimpressive plant, but interesting as one of the commonest of the wasteland species of the inner city. Mugwort is a tall herb, growing to more than a metre in height. The leaves are its most noticeable feature, deeply dissected and dark green on their upper surface, almost white below.

## Oxford Ragwort *Senecio squalidus*

This is a plant with an interesting history. A native of southern Europe, its first appearance in the English-speaking world was

in Oxford in 1794. It made its way to Cork in 1800. When the railways came, Oxford ragwort was carried northwards from Cork and reached Inchicore about 1890. As recently as 1961, it was relatively rare in Dublin, but then it expanded rapidly and has distributed itself throughout the inner city to become every bit as common as the native ragwort. Both are abundant in wasteland but grow also on roadsides and on walls. The Oxford ragwort resembles the native, but has bigger and brighter flower heads, with spreading yellow rays.

## Dandelion *Taraxcum officinale*

Dandelions are deceptive plants. Everybody can recognise them — with the notable exception of botanists. Dandelions can set seed without pollination, and this means that clones of numerous varieties are established. Many of these have been identified and named, but only advanced dandelion specialists are able to distinguish them with certainty. The dandelion, in its loose sense, is numbered amongst the really successful wild flowers of the inner city. It grows nearly everywhere, in the best parks and gardens and by the dingiest dockland gutters, on walls and in wasteland. Generally disliked by gardeners simply because of its vigour, it is a handsome flower, bringing bright colour to many grey places.

Perhaps surprisingly, since it is passable as a salad plant, Gerard has nothing to say of the dandelion's virtues. But he makes a neat description of its seed dispersal, describing a flower 'of colour yellow, and sweet in smell, which is turned into a round downy blowbal that is carried away with the wind'.

## Pondweeds *Potamogeton obtusifolius, P. crispus* and *Groenlandia densa*

These pondweeds belong to the family Potamogetonaceae. They, and other members of the family, grow in still or slow-flowing water, rooted in the mud. Some grow entirely under water, except for the flowers which reach above the surface. *P. obtusifolius*, blunt-leaved pondweed, comes and goes on the Grand Canal in the inner city. It was found in 1972, apparently disappeared soon afterwards, and was back again in the 1990s. Curled pondweed, *P. crispus*, is the commonest and grows in both canals. Threlkeld recorded it just outside our area in 1727 near the Tolka, 'Above

*Ballybaugh-bridge* in some stinking Water near the River'.

However, the prize goes to the opposite-leaved pondweed, *Groenlandia densa*, the only inner-city plant to be rare and threatened enough to have a place in the Red Data Book. It grows near Huband Bridge. The leaves are small by pondweed standards, not more than 5 centimetres long, and they grow in pairs, clasping the stem. Colgan noted that in Co. Dublin it grew only in the Grand Canal but was plentiful in his time all the way to 'Ringsend Harbour'. It lived a hazardous life in the days of heavy traffic on the canal and frequent clearing of the weeds:

> This species varies greatly in abundance according to the length of time the canal has been left undisturbed by cleansing or dredging. In some reaches of the canal near the city its dense masses almost monopolised the waterway in 1903, crowding out even the aggressive Canadian Water-weed (*Elodea*).

## Yellow Flag *Iris pseudacorus*

Iris was the goddess of the rainbow, and her name for this beautiful plant was used by Pliny. The yellow flag is one of the finest of all the inner-city flowers — and quite a rare one. It grows by the water's edge in both canals but only in isolated clumps, and in June its bright yellow blooms add vivid patches of contrasting colour to the green background. The reed grasses, however, seem to make a more successful bid for the same space.

## Grasses *family Gramineae*

No fewer than thirty-eight species of grasses were recorded in the *Flora*. Besides the reeds, a small number of them are both easy to identify and very typical plants of the inner city. **Perennial rye grass** *Lolium perenne* is one of the most abundantly used as a lawn grass but its seeds get scattered widely and it is one of the two or three species which often appears in little tufts in road gutters, by walls and in waste places. Its flowering spike is flattened, the individual flowers growing in pairs with a faint resemblance to herring bone. **Annual meadow grass** *Poa annua* grows up quickly from seed and can go through its life cycle in a matter of months. This makes it one of the commonest of the grasses of the smaller waste places, such as the little heaps of dirt that accumulate beside kerbs, on stone steps and in the

crevices between paving stones. It
also grows on more salubrious
waste places, but needs bare soil to
get established. Generally a very
small grass, it grows in little tufts a
few inches tall. **Wall barley** *Hordeum murinum* grows nearly everywhere, not only on the ground,
where it can form a sward, but in
crevices in walls and in many other
unlikely places. Outside Dublin it is
surprisingly rare, unknown in many
counties. It has a typical barley-
flower, cylindrical and hairy.

Wall barley.

## Common Reed *Phragmites australis*

In Colgan's time these magnificent reeds, the plants justly
celebrated by Yeats and many other poets, were confined to the
river estuaries of Co. Dublin. Abundant in the shallows of many
lakes they were, amazingly, still absent from the inner city when
the *Flora* was published in 1984. By 1994 there was a well-
established stand of them on the Grand Canal at Leeson Street
Bridge, and they appear to be spreading, with several small
clumps visible in 1997 on Charlemont Mall, and goodly beds on
Canal Road and Grove Road. They have probably been carried
gradually downstream from the midlands, but in 1997 had not
travelled farther than Leeson Street.

Although the main feeder of the canal is Lough Owel, and
reeds are abundant in places by its shore, they have yet to make
their appearance by the Royal Canal margins in the city. A
possible explanation of their late arrival is the fact that, since
commercial traffic on the canal ceased, dredging and clearing of
the banks has been scaled down. This enables the silt to stabilise
and may provide a more amenable habitat.

The stems of the reeds continue to stand tall through the
winter, their flowers taking on a fluffy appearance as the fruits
develop fine hairs which carry the seeds far and wide. Below
the mud, the reed spreads by underground roots from which
shoots spring up, so that an extensive reed patch may develop
from a single fertile seed.

## Reed Grasses *Glyceria maxima* and *Phalaris arundinacea*

Two more species of reed grow at the margins of both canals and were there long before *Phragmites* made its appearance. Both have such English names as 'reed grass' or simply 'reed'. *Glyceria* is also called 'reed sweet grass', probably because cattle like to eat it, while *Phalaris* is 'reed canary-grass', being closely related to the species that yields canary seed, and which grows in waste places in the inner city. But the English terms are clumsy, and both the Latin ones have a beautiful sound, making it much easier to use them as common names.

Glyceria was a Greek personal name and a very well-known one, too. One was a celebrated courtesan of Athens and mistress to the poet Menander while, in Rome, another was mistress to Horace. The name, however, was first applied to a smaller species of grass and may not have been inspired by the feminine grace of the slender reeds. *Phalaris* was the classical Latin name for canary grass while *arundinacea* simply means reed-like.

*Glyceria* leaves appear below the surface of the water in spring and grow rapidly, reaching a height of 2 metres and more. The flowers appear in June and remain until autumn, when the reeds die down to grow up again from submerged roots in spring. *Phalaris* grows in much the same way — its flowers are densely packed in contrast to those of *Glyceria*, which are borne on long, slender stalks.

On the one hand, the reeds protect the canal banks from erosion, but, on the other, they entrap silt so that, if left to themselves, they would extend the shallows and ultimately take over the entire canal. Periodic cutting or the use of weedkiller keeps them in check. The beds provide a safe refuge for moorhens and mallard, both of which nest amongst them. A handsome sparrow-like bird, the reed bunting, inhabits reed beds in many parts of the country, but I have yet to see one in the city. It may be that the beds are a little too small to provide the living space they need — but they may make an appearance some time in the future.

## Duckweed *Lemna minor*

This is a most unusual plant, being completely free-floating. Each individual consists of a little oval or circular frond, a

Reed bed in the canal by Grand Parade.

combined leaf and stem, with a single, transparent root which dangles in the water. Duckweed rarely flowers, but reproduces by budding at a great rate so that it can cover an entire pond in a short time. Wind and water currents are its enemies, since it needs to stay in one place and spread out on the surface, and it dies quickly when the wind piles the whole population up on the margin of its pond.

## Bulrush *Typha latifolia*

When the *Flora* was written, the bulrush was known from one site only, and that a very unlikely one. It inhabited a disused water tank in Pearse Station. In the summer of 1995 I found some in very much more attractive surroundings, in the Grand Canal just downstream from Portobello Bridge beside the right bank. A very handsome plant, the flower heads of the bulrush grow on stout stems, 2 metres or more in height. They are dark brown and resemble sausages.

## Orchids *family Orchidaceae*

Orchids conjure up images of exotic blooms in expensive places — but the Irish species, though beautiful, have small or even inconspicuous flowers. Nonetheless, there is something special

about them, and most of the species are very colourful. They are sensitive to disturbance and generally grow in stable places free from grazing, grass cutting and trampling — which makes the inner city an unsuitable place. The fact that three species have been recorded is remarkable, but they may have departed from our area since they were last seen in the early 1980s. However, orchids lead irregular lives and may spring up unexpectedly in places where they have not been seen for some years. The three Dubliners are **Fragrant orchid** *Gymnadenia conopsea,* **Common spotted orchid** *Dactylorhiza fuchsii* and **Pyramidal orchid** *Anacamptis pyramidalis.* They all need a well-limed soil and therefore they grow near the canal to the west of Crossguns Bridge where limestone is plentiful in the glacial till.

# 12

# The Trees

There is an element of street furniture in the trees of the inner city, since most of them grow where they were planted and many have been pruned to make room for traffic. But they are, equally, an essential part of the natural history, since the majority, once planted, take care of themselves and also provide food or resting places or both for many birds and countless insects. Dr Christy Boylan was employed for many years in the Corporation's Parks Department and was one of the pioneers in the present generation of planting and caring for the city's trees. His papers on the subject are the main source material for this chapter.

When St Stephen's Green was developed in 1663 the lessees of the building lots were required to plant a total of 540 sycamores around the square. This is the first historical record of tree-planting in the city. Because the great majority of the streets of the old city were narrow, trees were confined to parks and gardens. While their descendants are many, neither the sycamores of the Green nor any of their contemporaries are now known to survive.

The eighteenth century witnessed a proliferation of parks, and the exertions of the Commissioners for making Wide and Convenient Streets, established in 1757, led over many years to the creation of streets with a possibility of space for roadside trees. The earliest surviving street trees are London Planes planted in Gardiner's Mall, now the middle pavement of Upper O'Connell Street. Estimated to be 200 years old, they are smaller than their contemporaries in the parks. Frequent, and often ill-judged, pruning seriously curtailed their growth. The magnificent planes of the King's Inns, Stephen's Green and Merrion Square are probably also eighteenth-century plantings. Large beeches in Merrion and Fitzwilliam Squares may well be of the same vintage.

Trees are not immortal and, even in the best conditions, few

live for more than 200 years in Ireland. Cities do not provide the best conditions or anything approaching them. Soot and sulphur from the coal fires, which had fouled Dublin's atmosphere for the greater part of two centuries, weaken all trees and actually kill many. The great trees of the parks therefore, in the main, are likely to have been nineteenth rather than eighteenth-century plantings. While the London plane has long been known to have exceptional powers of withstanding the urban environment, other species were less fortunate. The sycamores around Stephen's Green were replaced with wych elm and they succumbed to Dutch elm disease in the 1970s. Limes are growing there now.

Hugh Lane, whose great vision for embellishing the Liffey was never realised, succeeded in a lesser but important scheme. He provided money for planting trees along the riverside pavements. Planes were used again and had some problems. When poured concrete was used to replace the paving sets on Aston's Quay, it was allowed to go right up to the trunks of the young trees. As they grew, the trunks widened and spread out above the concrete but remained narrow where it surrounded them. This pavement subsided and had to be removed and replaced once more. In one or two cases, the narrow trunks were no longer enough for support and the trees snapped and fell. These were in any case an ill-fated community and probably suffered from spilled diesel oil, when the quay served as a bus station. The most successful of the Liffeyside trees are those on Burgh Quay where the traffic is kept a little way from them by the wide pavement.

Elsewhere in the city, unspecified trees were planted in the eighteenth century along the Circular Line of the Grand Canal expressly for adding to its beauty. In the nineteenth century, most of the roadside trees of Dublin were planted in the new suburbs and relatively few grow in the inner city. Amongst the exceptions are Adelaide Road, the North Circular Road and the centre of Lower Baggot Street where there are lines of well-established planes.

## The Trees of the Vikings

James T. Lang's book on the decorated wood found in the excavations of Viking Dublin includes an appendix by Maura

Scannell on the trees from which the wood came. Ten kinds were identified beyond doubt. Rowan and holly or ivy were listed with question marks, none of the three being of any great significance in the day-to-day life of the early citizens.

Yew, spindle, pine, willow and alder were used in many cases. The other species were ash, birch, hazel, oak and pear. Alder was used in chair-making and was also the wood used for a pulley. Spoons were made from alder, willow and yew. Yew and spindle were very important in tool-making, while bowls, boxes and other common objects were made from nearly all the species found.

The pear is not a native tree and does not grow wild in inner Dublin. The Norse Dubliners may have grown it in their gardens but the wood could equally have been imported. The other trees are natives. Most of them still grow in the inner city and they were much more plentiful when the city was so much smaller and river banks and swamps lay close at hand. Spindle is a rather uncommon small tree which usually grows by water. It is likely to have been more common in Viking times. But, as the name implies, it provides wood that is particularly suitable for working and may have been deliberately sought at some distance from the city. Like yew it is tough, has a fine texture and is easily carved.

## The Greening of the Corporation

In the twentieth century few trees, if any, were planted outside the parks prior to 1939 when the Corporation established its Parks Department. This Department's good intentions were frustrated by individuals in the Engineer's Department who were strongly opposed to tree-planting on the pavements and whose permission was required to effect it. After some discussion, the Engineers graciously permitted planting on footpaths which were more than 1.7 metres wide. The Parks people measured many pavements and found that none but Victoria Quay fulfilled the conditions. They moved in quickly there and elsewhere bided their time until a more enlightened view would prevail.

Not only do the latter day Engineers of the Corporation actively support tree planting, but they used their expertise to solve one of the problems facing trees in pavements. On the one

hand, the soil beneath the pavements must be compacted to prevent subsidence while, on the other, the trees need fairly loose soil to allow their roots to breathe. The solution was to provide a pit of topsoil 1.3 metres square and 1 metre deep. This is surrounded by a concrete platform on which rests an iron frame, with a detachable inner section. The tree is planted in the pit and paving slabs laid on top of the frame, leaving a 50 cm square of open topsoil around the trunk of the sapling. When the tree has grown big enough, the detachable frame is removed to provide the happy medium of soil wide enough for the tree but narrow enough to save the citizenry from muddy feet.

There were lessons for the arboriculturists to learn in planting trees and caring for them. About 200 species were available — but only a relatively small proportion of these are really suitable for inner Dublin. The ideal street-side tree has an upright rather than a spreading habit. The plane, by this standard, is not one of the best and it has had its problems, of which at least one was human. The gardeners, not surprisingly, had been trained by horticulturists. Their expertise in tree-pruning lay in apples, and the ideal apple is encouraged to grow outwards rather than upwards. So there was a period in which the planes were induced to spread out, and corrective measures then had to be applied. Beside Grattan's statue in College Green, each plane tree has a more or less pronounced S-bend marking the point in its history when attempts to suppress the main stem were abandoned.

The tree planters still face frustration from time to time. Even though the pavements may be wide enough and positively demand trees at their edges, service pipes and cables frequently run too close to the surface to allow any planting. Dorset Street had so many of these obstructions that the only space to be found there was the traffic island opposite Gardiner Street. Many of the buildings of Westmoreland Street had coal cellars extending beneath the footpath. In some cases, the owners agreed to having them filled in to provide soil. The same street, at the Bank of Ireland portico, has a double line of trees. The first followed the outer edge of the existing pavement, and when the pavement was extended, the second row was planted.

The prohibition of car parking in O'Connell Street, after the Abbey Street bomb outrage, allowed a broad pavement to be

made between O'Connell and the GPO. Previously there had been a single line of trees, and the new promenade allowed planting of a double row. The older tree just north of Jim Larkin had been out of line with the others and was transplanted at the same time.

The S-bend plane trees by Grattan's statue.

## The Top Trees

A full inventory of the 200 or so species of trees in Dublin would belong to the field of arboriculture rather than natural history. This selection gives an outline of the commonest planted trees, together with the few which have seeded themselves and may be considered as truly wild specimens. Native Irish trees are relatively few and the majority of familiar species are known to have been introduced. Pollen grains of trees survive intact for thousands of years in peat bogs or in lake sediments. They can be identified to the species, and the history of the rise and fall of forests since the ice age has been traced in great detail. The absence from this fossil record of pollen of such species as the beech allows for some confidence in deciding on whether they are native or introduced.

## Ash *Fraxinus excelsior*

The ash is one of the very few native trees planted in the city. A small number of tall and beautiful specimens grow in the parks including Stephen's Green and the Iveagh Gardens, and there are two on the east side of Parnell Square which originally lived inside the gardens. The fruits, 'ash keys', grow in green bunches in summer, turning brown as they ripen in autumn before they drop off and are carried away in the wind. They germinate freely and, although deliberately planted ones may be few, self-sown ash are plentiful, particularly on the banks of both canals. The seedlings can't live with lawn-mowers but they grow up in inaccessible places in the corners between canal and bridge or on the steep bank just out of reach of the blades.

The weeping ash was a very popular variety and there are many both in the parks and within the bounds of such government offices as the Custom House and Marlborough House. Stephen's Green has a fine row of them on its north side. The ancestral weeping ash was discovered in England in Cambridgeshire in the middle of the eighteenth century and, with its umbrella shape, became very popular. It is grown from cuttings grafted on to a stem of common ash and can be conveniently tailor-made at whatever height is wanted because it rises very little above the point of attachment.

Ash in Stephen's Green.

## Alder *Alnus glutinosa*

The alder is a common native tree in damp places but, Dublin being generally well drained, is quite a rarity in the inner city. A few may be found by the canals but the most remarkable specimen is a small one growing just above the Liffey in a crevice on the wall of Victoria Quay. Alders are plentiful just

upstream of our area, below Cunningham Road, and it seems likely that a seed floated downstream on a flood and lodged safely in the wall. Bronze-age shields of alder wood can be seen in the National Museum and the wood was used as late as the middle of the twentieth century to make clogs.

## Beech *Fagus sylvatica*

Beech is so common on dry soils, and generally is such a familiar species that it is seldom looked on as an exotic. The date of introduction is unknown and may go back as far as Anglo-Norman times. Beech was extremely popular in the demesnes of the eighteenth century when landlords planted and cared for countless specimens to form a border within the walls. They provided shelter for horses and cattle, valuable timber for furniture and construction, logs for burning — to say nothing of incomparable beauty, winter and summer. Merrion and Fitzwilliam Squares both have fine beeches, mainly at the corners. They may have been planted all the way around the parks, as in the country demesnes. But the beech has a relatively short life, seldom more than 150 years, and it is possible that those still standing are remnants of long rows of trees in the past.

## Birch *Betula alba*

With its beautiful silver bark, slender habit and small leaves which cast only a light shade, the birch is a very popular park and garden tree and was widely planted. It is a long-established native which appeared after the last glaciation and was the dominant forest tree of Ireland until the oaks took over seven or eight thousand years ago. Birch develop fairly easily from seeds, and a number of self-sown ones grow by the Grand Canal on the Grand Parade reach, not far from a little group planted on the green beside Charlemont Place.

## Elder *Sambucus nigra*

The black fruits of the elder are eaten by blackbirds, thrushes and other birds, which scatter the undigested seeds far and wide. Elders, therefore, though rarely if ever planted, are common bushes in the city. They invade old hedges, notably in Shandon Park, and appear in shrubberies and old gardens. One

specimen makes a welcome patch of greenery in a particularly dingy corner of Gardiner Street to the north of the railway bridge. Elder flowers have a strong scent and can be added in very small quantities to enhance the flavour of gooseberry jam. The juice of the fruits ferments to make a delicious wine, and Dr Rutty in the eighteenth century recommended their use to give 'an elegant redness to Brandy'.

Weeping ash in Stephen's Green.

## Hawthorn, Whitethorn *Crataegus monogyna*

The white flowers of hawthorn make it one of the most beautiful of all Irish native bushes, and in autumn the red berries provide abundant food for thrushes and other birds. In the breeding season, the dense, thorny growth makes an ideal nesting place, secure from cats and magpies. The planners of parks are fond of hawthorn, both because of its beauty and because, as a native species, it grows well without any special care. Blackbirds, which benefit so much from its hospitality, return the favour by distributing the hawthorn seeds far and wide. The seeds within the berries are indigestible, pass through the bird's digestive tract and germinate wherever they are dropped. Shandon Park is surrounded by a hedge, which seems originally to have been planted entirely with hawthorn. Many of them survive, but other species have established themselves in between.

## Holly *Ilex aquifolium*

Holly was planted widely in the parks and formal gardens and, in such places as the Iveagh Gardens, grew into quite substantial trees when left untended. In the primeval oak forests, it grew as an 'under-storey', the dark-coloured leaves absorbing enough light for growth even when shaded by the canopy of the oaks. In many parts of Ireland, where the oak has long since disappeared, holly grows as a remnant of the forest. In the inner city, it has seeded itself in Merrion Square and elsewhere and grows well just inside the railings. One of the best specimens, which may have been planted deliberately or may have seeded itself and been allowed to grow, stands in the Huguenot Cemetery on Merrion Row.

## Holm Oak *Quercus ilex*

Both the English word *holm* and the Latin *ilex* mean holly and refer to the dark green, waxy leaves. The leaves have very little resemblance to a typical oak-leaf, but the acorns, though tiny, are undoubted oak fruits. A Mediterranean tree, it became very popular in parks and gardens in the nineteenth century, and there are fine specimens in Merrion Square, on Leinster Lawn and in Stephen's Green. The holm oak's greatest claim to fame

is that it keeps its leaves through the winter, one of the biggest broad-leaved evergreens that can grow in Ireland.

## Horse Chestnut *Aesculus hippocastanum*

Considered by many to be the most beautiful tree in the world, the horse chestnut with its generous spreading boughs, its white, candle-like flowers and hard, shiny 'conkers' has been planted in nearly all the parks. Some specimens may be self-sown as the seeds germinate easily. It is a native of a very restricted area of south-eastern Europe, was introduced to England early in the seventeenth century, and may have been brought to Ireland shortly afterwards. Horse chestnuts have relatively short lives: none are reckoned to be more than 150 years old, and many weaken and get blown down at less than 100 years.

## Lime *Tilia cordata* and *Tilia platyphyllos*

Two species of lime are planted. Their big, pale green leaves give a pleasant shade and, although the fact is of little enough importance in the city, their flowers provide abundant food for honey bees early in the year.

## Lombardy Poplar *Populus nigra var italica*

This is an ideal city tree, resistant to air pollution and having an upright growth so that it can be planted on footpaths without spreading to interfere with traffic. There are two particularly fine rows: one in College Park, along Nassau Street, and one on Mespil Road by the Grand Canal.

## London Plane *Platanus acerifolia*

*Platanus* is the classical Latin name for one of the parents of this hybrid tree which was greatly admired by the Greeks and Romans for its cool shade. *Acerifolia* means 'sycamore-leaved'. The other parent is believed to be an American species, but their misalliance is discreetly shrouded in the distant past. Augustine Henry considered that the London Plane originated in Oxford late in the seventeenth century.

The earliest known Dublin specimens form the row to the south of Parnell, planted in the eighteenth century to decorate a

mall between the houses of Upper O'Connell Street, which was planned as a park rather than a thoroughfare. Two features led to the plane's becoming extremely popular for city planting. It is very resistant to smoke pollution and to vigorous pruning. Its only serious sensitivity is to cold, wet weather, and the Dublin trees suffered in the late 1980s, but recovered when mild conditions prevailed for some years.

Planes were planted in nearly all the great parks. There they have the space they need because the plane is a spreading tree and not ideal for footpaths where they need to be pruned frequently. The King's Inns Fields and Stephen's Green have many truly magnificent specimens, some of the finest trees anywhere in the city. In spite of their street-side position, however, the planes of the east end of the North Circular Road are thriving and make a claim to be the best of the footpath trees.

College Park seems to have no London planes but there is a beautiful one within the garden of the Provost's House. The college does have a pair of oriental planes *Platanus orientalis*, the original species of the Mediterranean countries and one of the parents of our hybrid. Slightly odd-looking trees with bottle-shaped trunks, they stand at the north-east corner of New Square.

### Oak *Quercus petraea* and *Quercus robur*

The oaks of the inner city are more dead than alive. The panelling of the Chapel Royal in Dublin Castle, of the Oak Room in the Mansion House, and countless other distinguished buildings testifies to its unrivalled value and popularity in time past. The timber remains to this day one of the most valuable — but as an oak tree demands good soil and takes 120 years to come to maturity, few landowners are prepared to invest in it. The slow growth probably explains why it was not popular in nineteenth-century park planning and is scarce as a city tree.

Oak pollen from 9,000 years ago has been found in peat, and both fossil and historical records show that it was the dominant tree over enormous areas of Ireland until the destruction of the woodlands in the seventeenth century. The wood was of incalculable value, being used to build the earliest known boats, for all kinds of domestic utensils and furniture from cradle to coffin, and for the building of houses and halls of all shapes and sizes. It was a fodder crop, too, providing acorns for pigs.

London plane in Stephen's Green

## Rowan *Sorbus aucuparia*

Rowan is a native, the alternative name of 'mountain ash' testifying to its ability to grow in the uplands, usually as an isolated tree. The red berries are greedily eaten by thrushes, which scatter the seed over great distances. These berries are very bitter, but were nonetheless eaten in the past, and theirs are amongst the seeds found in the Wood Quay excavations. Since

the 1960s many have been planted as roadside trees and in the gardens of Corporation housing schemes. Self-seeded rowans may turn up anywhere, and in 1995 there was a fine wall-top specimen on New Wapping Street. Such trees are insecure, without enough soil available for sustained growth so that they are likely to be blown down before long.

## Scots Pine *Pinus sylvestris*

Conifers, planted far and wide in the country demesnes, were not especially popular amongst the people who developed the parks and gardens of inner Dublin in the nineteenth century. There is a group of Scots pines in the Iveagh Gardens but there are very few anywhere else. It is a tall and beautiful tree, characterised by the bright orange colour of the bark in the higher parts.

Scots pine appeared in Ireland after the ice age and was one of the dominant trees of the primeval forests. Its wood was identified in Viking artefacts, suggesting that there were pine-woods near Dublin, but by the end of the seventeenth century it had become extremely rare in Ireland. Reafforestation in the eighteenth century depended on imported seeds from Scotland.

## Sycamore *Acer pseudoplatanus*

Like the beech, the sycamore is such a familiar tree in Ireland that it is generally taken to be a native. It seems to have been introduced early in the seventeenth century, and by 1663 was sufficiently well known for the City Assembly to ordain that it be planted around Stephen's Green.

There are many fine sycamores in the parks, but the spreading habit makes it unsuitable for pavement planting. Sycamores, however, share with the buddleia an ability to grow vigorously just about anywhere and they are plentiful everywhere that there are little pockets of soil beyond the reach of lawn mowers and gardeners. The propeller-like fruits are carried by the wind, and germinate readily so that the seedlings may appear anywhere. Their subsequent welfare depends on how much soil there is to allow firm rooting.

Those that grow in the mud of roof gutters seldom survive more than a year or two, by which time they are liable to be blown over by a strong wind. The same fate awaits the

occasional seed that germinates in the crotch of a tree where there may be enough dust and moisture to provide a living space for a while. Old walls are often more hospitable, and sycamores in places live for many years, rooting in the mortar. Several grow above the Liffey on the wall of Victoria Quay, in the unlikely company of alders and other trees. The most successful of all are those that establish themselves in neglected parts of parks and gardens, in fenced-off portions of canal banks, or in abandoned sites.

## Willow

Four species — Sally, Eared willow, Goat willow and osier — are listed in the *Flora*. The first three grow in waste ground in various parts of the city, and the osier is known only from the Grand Canal bank at Dolphin's Barn. Goat willow, which has broadly oval leaves, is the commonest and grows on the banks of both canals. The finest willows in the city grow beside the ponds in Stephen's Green. Weeping willows have been planted on the canal bank by Charlemont Place.

## Wych Elm *Ulmus glabra* and English Elm *Ulmus procera*

Wych elm is a native species, known from early post-glacial times and once an abundant forest tree on the lime-rich soils of the midlands. The population collapsed 5,000 years ago and, again, in the period beginning in the 1970s. The current damage is known to have been caused by Dutch elm disease, a fungus transmitted by a bark beetle. Many botanists believe that the same may have happened in prehistoric times. Elms were planted along the canals — in the eighteenth century specifically to be grown for use as water mains until the introduction of metal pipes in 1802. Bored elm pipes are dug up now and again, and some have been preserved by the Corporation's Waterworks Department.

They were also popular as park trees, and one fine specimen has survived on the east side of Stephen's Green. Young elms are too small to attract the infecting beetle, and therefore small saplings can be found.

English elm has been planted widely in Ireland but it, too, was devastated by the disease. It produces suckers, and these

can survive and spring up when the mature trees are killed. There is a thriving little elm clump on the Grand Canal bank by Mespil Road near Baggot Street Bridge.

## Yew *Taxus baccata*

Yew woods survive in Killarney, but the species was very much more plentiful in historic times. The name of the Dublin suburb Terenure translates as 'land of the yew tree', and the Irish word *iubhar* exists in many place names. Yew grows slowly and produces a beautiful dark, hard wood, which the Dublin Vikings used and which remains very popular amongst craft workers. Two forms have been planted in some of the parks: the 'common' yew has spreading branches and grows from seed. The popular upright 'Irish' yew can be propagated only from cuttings from the descendants of two specimens found in the eighteenth century growing in Co. Fermanagh in Florencecourt demesne.

# 13
# Furry Creatures, Fish, Insects and Others

The inner city has a wealth of wild creatures other than birds and humans. The mammals include seals, foxes, badgers and bats, as well as rats and mice. The Liffey and the canals support a variety of fish. Butterflies, bumble bees, wasps and hover flies abound. And when one includes insects, spiders, earthworms, eelworms and quite literally countless others, the volume of wildlife increases both in numbers and in the variety of species. The problem with all of these smaller creatures is that they can be identified only by specialists, and such experts have but rarely been concerned with the fauna of inner Dublin as an entity in its own right.

This chapter therefore catalogues a small number of the biggest and best-known animals, and makes a selection of the others, based more on their curiosity value than on any scientific criteria.

## The Mammals

### Badger

The badger is a rarity, though not unknown. One of the few definite records was that published by Penelope and Eoin Fannin in *The Irish Naturalists' Journal*, referring to one that they saw in Baggot Street at 2 a.m. on 30 April 1983. They live within the Corporation's boundary in the Dodder valley. Badgers need quite large feeding ranges of open pasture or lawn, together with undisturbed ground in which to establish their setts. They are unlikely ever to become as common as the urban foxes.

### Bats

Brian Keeley of the Dublin Bat Group has records of three species of bat within our area. He has identified Pipistrelle and Daubenton's bat at the Blessington Street Basin. Its water and

Bat.

the nearby canal provide the necessary breeding ground for the large numbers of flying insects that they need. He has also seen Leisler's bat over the Grand Parade reach of the Grand Canal and, in May 1996, made the acquaintance of a female Leisler's captured in the Stephen's Green shopping centre — it was returned to the wild in good order. Bats have been seen from time to time in Trinity College, and it seems likely that Stephen's Green and other large open areas have bat populations. But the parks are closed before dusk and the population of bat-observers walking the canals of Dublin is small, so that the situation of no records would not necessarily mean no bats.

## Fox

Foxes have been familiar animals to nocturnal citizens at least since the 1950s, when I saw my first ones, and probably for a great deal longer. It is possible, however, that they are relatively recent arrivals because earlier naturalists don't seem to have noted their presence. Robert Lloyd Praeger lived in Fitzwilliam Square for thirty years from 1922 and would have been likely to publish any observations he had made. J.P. Brunker, another naturalist who made a point of publishing unusual happenings, worked from time to time on night shifts in Guinness's in the 1930s and 1940s and never mentioned them to me.

There is food and safety for foxes in the city. Traffic would tend to discourage horses and hounds, and deliberate poisoning, though not unknown, is unusual and not applied by the authorities. Food is abundant since foxes, although primarily carnivores, will eat most things that humans enjoy and many that they don't.

In 1995 and 1996 David Wall, in collaboration with John

Rochford of Trinity College Zoology Department, studied urban and suburban foxes of the south city and suburbs, and very kindly gave me an outline of their discoveries. Wall examined twenty-three dead foxes, most of them killed by traffic, though some had contracted mange. Their food was surprising — mainly earthworms and beetles, with the contents of dustbins of secondary importance, and rats and mice even further down the scale. Urban foxes trot hither and thither over lawns and playing fields, snuffling for worms.

Inner-city foxes have an earth in Merrion Square — where there are sufficient bushes to give the necessary cover — and another in wasteland off Barrow Street. In general, the well-tended parks are too open to make an attractive site for an earth. The grounds of St Brendan's Hospital are a possibility, as are the banks of the Royal Canal near Crossguns. Non-breeding foxes may make long foraging journeys and will also sleep on the ground amongst bushes and, for this purpose, many of the patches of wasteland could suit them. To the east of our area, there are earths at Poolbeg and in Ringsend Park, and they are almost plentiful in the suburbs where the gardens generally are bigger.

## Grey Seal

The biggest organism of inner Dublin's wildlife is the grey seal. In most summers an occasional seal travels the Liffey as far upstream as Islandbridge on a rising tide, and goes back to the sea again on the ebb. Salmon anglers are convinced that the seals move upriver to catch the salmon they have so carefully preserved, and there is some evidence that seal arrivals have coincided with good salmon runs. There was one definite record of a seal being spotted *in flagrante* with a salmon in its possession. But mullet are more plentiful than salmon in the inner city in summer, and flounder live there, too.

As a rule the seals remain in the tidal water, but one intrepid individual in 1990 made its way over Islandbridge weir and reached Chapelizod, while another stayed for an unacceptably long time at Islandbridge. This was too much for the fisherfolk, and the staff of the Eastern Regional Fisheries Board attempted to catch it in a net. They failed, but their activities conveyed an important message to the animal and it departed before long.

Grey seals breed on Lambay Island in November and are regular visitors to Dublin Bay.

## Otter

Otters visit the inner city, perhaps regularly. J.P. Brunker from time to time heard otters off Victoria Quay in the 1940s. Spraints, the characteristic black cones of faeces deposited by them on streamside stones, were recorded at Heuston Bridge as recently as 1994 by Ruth Lunnon, and at the eastern end of our area on steps where the Dodder meets the Liffey at Ringsend.

## The Native Fish

The fish of the tidal Liffey are representatives of the few species able to live both in salt and fresh water. This requires a specialised physiology because high and low salinities respectively have different effects on the body of a fish.

## Salmon

Even in the worst years of water pollution, the salmon continued to swim the Liffey. They are very sensitive to the quality of water and many of the great rivers of Europe lost their salmon populations completely as a result of pollution. In its lifetime the salmon has to make at least two journeys through the city: the first as a two-year-old 'smolt' on its way to the sea from nursery grounds farther upstream; the second as a mature fish making its way back to breed. The Liffey is an exceptionally early river, with adult salmon beginning their return journey in December. The fishing season opens on New Year's Day. The early salmon, those returning between December and May, are big ones that have been living and growing in the sea for two summers. Many of them have travelled as far as Greenland. The summer salmon are smaller and more plentiful, having spent just over one year at sea. Before the quays were built, capture of salmon by net was relatively easy and they provided an important source of good, fresh food.

## Eel

Eels are plentiful in the Liffey and the canals. Thousands or millions of needle-shaped young 'elvers' travel up the river having completed their crossing of the Atlantic from the

Sargasso Sea. They are seldom seen, as they prefer to travel at night, using the rising tide to carry them. Elvers have a very impressive ability to climb vertical walls, provided that there is a trickle of water and some plant life for support. Thanks to this, they are able to surmount the canal locks.

Many of them are content to stay in the city. Others make their way farther and farther upstream. Sooner or later, they settle down and grow for some years, sometimes moving on again. Ultimately, ten or fifteen years after their arrival in the river, it is time to make the long journey back to their ocean birthplace where they will spawn and die. Spawning takes place only at the end of a long lifetime, and the adult eels never return to the waters in which they grew up.

In June 1985, with Julian Reynolds and Russell Poole of Trinity College Zoology Department, I undertook an exploratory fishing expedition beneath Butt Bridge to estimate the eel population. We made a good catch of 119 eels in five eel nets. They ranged in length from 25 to 76 centimetres, with an average of 41 centimetres. Twenty of them were longer than 50 centimetres, which means that they must have been females, as males never grow to such a size. Most of the remainder were less than 40 centimetres, and probably males. The only other fish were two flounder and a mullet, but that was to be expected as the nets are specially made for eels and catch very few other species.

## Flounder

Flounder or fluke are flat fish which breed in offshore waters but move into river estuaries when very young. Many stay in salt or brackish water but considerable numbers travel on into rivers and lakes. They have problems in climbing over waterfalls, and in the Liffey can go no farther than Islandbridge Weir.

## Mullet

The presence of most species of fish in the inner city is known more by inference than by observation since they seldom make themselves visible. The grey mullet is a notable exception. When the tide is rising on a summer's day the mullet make themselves so conspicuous that even uninitiated passers-by stop and gaze at them. About the size of small salmon, they

swim in the shallows, nosing for food on the bottom. Unlike any other fish in Ireland, mullet are herbivores, feeding mainly on microscopic algae, the diatoms, which rest on the surface of the mud. Urban mullet can learn to vary their diet with bread crumbs and other scraps. They usually swim hither and thither lazily, often close to the surface and in quite large shoals. Now and again they indulge in bursts of frenzied activity, breaking the surface or making swirls just below it.

## Stickleback

The three-spined stickleback rears its young in fresh water, in barrel-shaped nests built by the male. Many of them drop downstream in the Liffey to live in the salt water. Although the river is tidal as far as Islandbridge, the water at the top of the tide is free from salt, and the inner-city stickleback are able to make their way back there in summer to breed. As they can live their entire lives in fresh water without any problem, there are resident populations in both canals.

## The Alien Fish

That observant Welshman, Giraldus Cambrensis, in the twelfth century noted that all the species of fish in Irish inland waters are those that can live in salt water. The purely freshwater fish were unable to reach Ireland after the last glaciation, and all have been introduced by man in the course of the past seven or eight hundred years. The pike had arrived by the sixteenth century, and the perch may have come at the same time. Carp and tench were brought in in the seventeenth century, bream and rudd probably later. The introduction of the roach to the Munster Blackwater at the end of the nineteenth century is well-chronicled, and to it they were confined until the 1950s when coarse fishermen began to distribute them liberally throughout the country.

The Office of Public Works commissioned the Central Fisheries Board to study the fish of both canals and draw up a programme for their development. Their report, dated March 1995, was prepared by Joseph Caffrey and his colleagues, and, while it is generally much more concerned with the canals in the country and their potential for recreational fishing, it gives some helpful information on the fish of the 'Circular Line' of the

Grand Canal, which forms our southern boundary. They did not survey the inner-city section of the Royal Canal.

## Bream

Bream are plentiful in the Grand Canal west of Robertstown, but are rare to the east. Stragglers may exist within the inner city but they are certainly not established members of the fish stock.

## Rudd

With their small, silvery bodies and red fins, rudd resemble the next species, the roach, in many ways, and none but specialists in fisheries ever bother to distinguish them. They were distributed in many parts of Ireland long before the true roach was released but were generally called 'roach' anyway. It seems that they have little chance of competing with the roach and may disappear from the Dublin ichthyofauna, if they haven't done so already. Their only hope of survival now is in isolated quarry ponds

## Roach

Roach were abundant in the inner city in 1987/88: their biomass was calculated as 216 kilograms per hectare along Clanwilliam Place, and nearly twice that at 528 kilograms per hectare by Herbert Place. Many of these fish were caught and transferred to Clondalkin to save them during maintenance work.

## Perch

Perch live in shoals, grow quickly and breed prolifically, so that they colonise new waters very quickly. They certainly used to live in the Grand Canal within the city, where I saw some in the summer of 1985. While they may have been disturbed a few years later, they are unlikely to have stayed away and are probably safely back again. From time to time they swim near the surface, and can be recognised by the series of vertical dark bands on their flanks.

## Insects and Others

### Bumble Bees

At least two kinds of bumble bee live in the inner city — a big white-tailed and a smaller red-tailed. As there are several

species of each, only an expert can tell what the total score is. I have seen red-tailed bees on the Royal Canal at Crossguns, and white-tailed in Merrion Square and Stephen's Green. The queens emerge in spring when they visit big flowers to collect nectar. They then make burrows in the ground in which to rear a number of generations of workers. Towards the end of the summer, the next generation of fertile males and females appears on the wing. After mating, the males die and, before retiring to hibernate, the females feed for long enough to last them for the winter. They are inoffensive creatures, content with a diet of nectar, and do not even need to attack soft fruit.

## Butterflies and Moths

Tom Cooney has listed nine species within the city limits. Pride of place went to a humming-bird hawk-moth, a rare and remarkable creature, which, like a humming bird, drinks nectar while hovering in front of a flower. The regulars on the butterfly list included large, small and green-veined whites, speckled wood and meadow brown. The clouded yellow was represented by one individual in 1994.

Black wings, with scarlet and white patches, make the red admiral the most splendid of the insects of the inner city. The name has nothing to do with naval officers, but is a corruption of 'admirable'. They are seen mostly in late summer, visiting flowers, so the parks with the best flower-beds are their usual haunt. Merrion Square seems to be particularly favoured. The Irish population of the species is maintained by migrants arriving from southern Europe in spring. They are few in number but they lay many eggs, giving rise to the more numerous autumn brood.

The painted lady can be seen in late summer in most years. Like the red admiral, it is a migrant, unable to survive the Irish winter, though remaining on the wing until well into the autumn. In 1995, a particularly good year for the species, I saw one in the car park of the National Concert Hall as late as 22 October.

The small tortoiseshell is another colourful species, mainly orange coloured, but its finest points are visible only at close quarters — borders of brilliant blue dots on the wings. One brood emerges in autumn and retires indoors to hibernate.

Warm spells in winter sometimes deceive them into a fatal flight, but the majority wait until spring when they mate and lay the eggs that ultimately give rise to the autumn brood. Buddleia is a favourite plant and, for whatever reason, the butterflies seem to be especially plentiful by the Liffey quays.

## Shore Crab

The small, greenish-coloured shore crabs are extremely hardy creatures, capable of living in salt and brackish water and of surviving for quite long periods if they happen to be thrown up on the shore. We caught two beneath Butt Bridge during the eel fishing study (p. 201). Since they are easily caught in eel nets, the small number implies that they are relatively scarce in the city, though likely to be more plentiful farther down the estuary.

However, these are far from being the only city crabs. Jim O'Connor and Mark Holmes have placed on record a quite extraordinary invasion of a house off Manor Street by the species in the autumn of 1991. Two specimens sent to the Museum measured 7 centimetres across the carapace, and by no stretch of the imagination were they the sort of creature an elderly lady would expect to find crawling about on her kitchen floor. The house was about 700 metres uphill from the Liffey and it seems that the crabs must have made their way up one of the underground rivers. The two identified were neither the first nor the only ones found emerging from drains in the area.

## Frog

Robert Lloyd Praeger in *The Way that I Went* devotes some pages to the frog in Ireland, including a reasonable argument against its presence in the country until the seventeenth century. The earliest record of its introduction refers to an inner-city population of the species. The story goes that one Dr Gwithers, a Fellow of Trinity College, was commissioned to make a survey of the quadrupeds of Ireland. On discovering that there were no frogs, he imported some frogspawn and placed it in a ditch in College Park — whence arose, perhaps, the entire population of the species in Ireland.

Frogs possibly live in the small, permanent pond in Stephen's Green, and there was a report of their presence there some years ago. It is one of few favourable haunts in the inner

city. The frog has a problem: it must have a pool of water in which to spawn in February or March, and the water mustn't dry up until June or July when the baby frogs can take permanently to dry land. But if the pool is big enough to be quite safe from drying up in summer, it is likely to have a population of fish ready to eat all the tadpoles. The problem lies in finding a permanent pool, isolated from larger bodies of water. The canals and the Blessington Street Basin have fish and few frogs or none. In the city, there is the added difficulty of travelling safely to whatever spawning pools there may be. There was no shortage of pasture, swamps, pools and ditches in seventeenth-century Dublin, so that frogs could have multiplied there and migrated outwards without any difficulty.

## The O'Connor Chronicle

Dr Jim O'Connor, acting Keeper of Natural History in the National Museum, is the foremost expert on unusual insects of the inner city and has generously provided a collection of his observations. Some owe their discovery to his sharp entomological eye, others were sent to the museum for identification by concerned citizens. Many of the exotics recorded by him were supplied by agricultural inspectors who spotted them on cargo vessels, especially those bringing in consignments of timber, at the Dublin docks. As they failed to enter the inner city of their own free will, they have been excluded from this chapter. On the other hand, several interesting creatures discovered nestling amongst bananas and other tropical fruits in the Fruit and Vegetable Market make a fair claim to temporary citizenship.

### Pub Flies

The most unsavoury and most famous of O'Connor's discoveries was the first *Drosophila repleta* recorded in Ireland. This small fruit fly feeds on almost any kind of fruit — fresh or rotting, before or after digestion by humans or other animals. Most appropriately, he and a fellow-entomologist, Paddy Ashe, observed a small swarm of the flies while they were engaged in writing an insect book. The place of discovery was the WC in a highly respectable south-city pub. *Drosophila repleta* is believed to be of tropical origin but has travelled the world, reaching London in 1942 and Dublin in 1991. Now extinct in its original

location, it may be observed in other Dublin hostelries.

A copy of a report in the *Entomologist's Monthly Magazine* has been framed by Pat Brogan, the proprietor of Kennedy's at the corner of Westland Row, and is displayed proudly on the wall of a snug. Few serious contributions to entomology have ever been so honoured. It concerns the observation by the same distinguished observers, O'Connor and Ashe, of two yellow-coloured flies. Six specimens were captured from a group of the insects found crawling on the inside of the window in July 1992. Five proved to be *Chryomya oppidana* and the sixth was *Chryomya flava*. Both are extremely rare in Ireland, and *C. oppidana* had not been collected since the days of A.H. Haliday 160 years previously. These insects are harmless creatures associated with woodlands and may have been attracted by the scent of wood varnish in use at the time in Kennedy's.

## Booklice

Books about insects are usually regarded as food for the human mind rather than for the insect body. But exceptions occur. The National Museum in 1985 received a consignment of second-hand books from Great Britain. One of them was inhabited by *Badonnelia titei*, an extremely rare booklouse, which was duly dispatched and added to the Museum's collection. Booklice are not lice, strictly speaking, and feed on the paste used in bookbinding. Some species are common but this one had been seen only once before in Ireland, in the library of University College, Dublin, five years earlier.

## Plant Gall-producers

Many species of insects and mites induce plants to grow abnormally and form galls. The gall both protects the developing insect from predators and provides it with all the food it needs. The oak apple is one of the most familiar.

O'Connor has discovered a number of species new to Ireland within the inner city. The fact that such locations as Merrion Square are a convenient lunch-time habitat for a museum worker may influence this pattern of distribution. This newly discovered fauna of Merrion Square comprises no fewer than three species — *Aceria exilis*, a mite, and *Contarinia tiliarum* were found on lime trees. Another inhabitant is the cauliflower ash

gall, *Eriophyes fraxinivorus.* The gall is caused by a mite and forms a brownish, lumpy mass on the flowering stems of the ash tree. Although plentiful in the square, it is something of a rarity throughout Ireland, recorded to date in only seven counties.

In 1996, the first Irish specimens of a gall bug *Trioza alacris,* which causes the leaves of bay laurel to curl up and die, was observed in gardens in Essex Road and Pembroke Road. The same year, an aphid, *Pemphigus spyrothecae,* which forms green or red spiral galls on poplar leaves, appeared in College Park.

## Viking Insects

During the Wood Quay excavations, on 13 April 1978, Mr T. Murphy found the remains of two large, black beetles, which he sent to the museum for identification. They proved to be a remarkable pair, named *Blaps lethifera,* which have never been seen alive in Ireland and, indeed, which may not have visited the country since. One of the specimens had a damaged wing case, which suggested the possibility that a Viking housewife had stamped on it. The species is most abundant in countries around the Mediterranean, and from time to time is discovered on cargo ships. The most likely explanation of their presence in eleventh-century Dublin is that they had been carried there by a Viking trading vessel.

At least seventeen species of insects were found in the Wood Quay remains. Besides the big black beetle, they included the common house fly *Musca domestica,* the human flea *Pulex irritans,* hover flies, blow flies, other beetles, and caddis flies

## Museum Arrivals

O'Connor and a number of colleagues in 1990 published a catalogue of insects that had 'recently caused public concern' during the previous seven years. Thirty-nine of these came from the city of Dublin. Most were harmless creatures but had appeared in such alarming places as bars of chocolate, beds or imported food. Outstanding creatures in the list included the giant wood wasp, *Urocercus gigas,* and a bird parasite, *Crataerina pallida.*

The wood wasp is one of the most handsome of Irish insects and one with a rather alarming appearance. It is large, coloured black and orange, and the female has a formidable, needle-like

tail. Fortunately this is not a sting, but an ovipositor, with which she bores a deep hole in soft wood to deposit her eggs. *Crataerina* is parasitic on swifts and swallows, and the specimen, which was found in a bed in an apartment, was traced to a ventilation opening in which swifts were nesting.

The Corporation's Fruit and Vegetable Market, and the premises of private fruit importers are fertile ground for exotic insects. The Egyptian grasshopper, *Anacridium aegyptium*, made its first recorded appearance in the inner city in June 1982 in a consignment of Italian potatoes. Long before that, in 1906, a specimen had been sent to the museum from Waterford where it walked out of a basket of cauliflowers. This is one of the better-known exotic insects and has even been found under the bonnet of a car imported from Italy. Attaining a length of 66 millimetres, and thus very much bigger than any of our native species, it makes a delightful pet, feeding on lettuce and given to flying around the room. Other species of grasshopper turn up from time to time. Spectaculars from the market have included the firebug, *Pyrrhocoris apterus*, a red and black plant bug, and a splendid South American scarabid beetle, *Strategus aloeus.* A less spectacular but very remarkable insect was a golden bupestrid beetle *Buprestris aurulenta.* It is a North American timber-boring insect, which normally takes about twenty-five years to develop and may live for as long as fifty-one years in a tree stump or in sawn timber. The specimen that appeared in the market is believed to have hatched out of a wooden fruit crate.

Parasitic insects, though rarer than formerly, are not unknown. Bed-bugs, head-lice and human fleas have all been sent to the museum from time to time. Perhaps the most distinguished of these were a population of cat fleas, which invaded a government department and caused serious consternation by biting many respected public servants.

# 14
# Museums and Exhibitions

Dubliners make their first close acquaintance with living nature in Stephen's Green when they meet the ducks. Equally — and largely without hearing the word — they have for nearly 150 years been introduced to biodiversity down the road in the Natural History Museum. Direct observation of living creatures is one of the essentials in understanding the miracle of creation. Another is the ability to know exactly what you are looking at, to identify the species.

The concept of a species has been reasonably well understood since Adam was given the task of naming the birds and beasts. The study took its greatest leap forward in the eighteenth century in Sweden, when Carl Linné, otherwise Carolus Linnaeus, developed and perfected a wonderfully simple system of naming every species of plant and animal by a combination of just two words. He classified many thousands himself, and his names and, above all, his system, remain in use to this day. The classification enabled Darwin to develop his theory of evolution.

## The Natural History Museum

At the same time as Linné, in Uppsala, was describing specimens sent to him from all parts of the world, the Dublin Society had begun to make a natural history collection. In 1792, the chemist Richard Kirwan purchased on its behalf the great collection of minerals and insects made by N.G. Leske in Marburg. This was exhibited to the public in the Society's rooms in Hawkins Street in 1795, and was subsequently enlarged and broadened in scope. When, in 1815, the Society moved to Leinster House, the natural history collection occupied four rooms on the first floor.

Its subsequent growth led to the need for an entire building, and in 1850 the Royal Dublin Society, as it had become in 1820, arranged a lease for land adjoining Leinster Lawn, for the building of the Natural History Museum. The design appears to have

been largely the work of a Board of Works architect, Frederick Villiers Clarendon. The foundation stone of the present building was laid in March 1856 by the Lord Lieutenant, and the museum was opened in August the following year, the celebrations including a lecture by David Livingstone on his African journeys.

In 1863 government support allowed the museum to increase its staff, and in 1877 it was taken over completely by the state. In the early years, the entrance to the museum was at its west end, and led into a spacious hall with a winding staircase, long since closed to the public in the interests of security. The approach now is from Merrion Street, passing beneath a fine plane tree, which, with its companions on Leinster Lawn, may be older than the museum. T.H. Parke, whose statue stands within the gate, was an army surgeon and African explorer from Co. Leitrim. The relief sculpture on the plinth of the statue shows him sucking the venom of a poisoned arrow from the body of a wounded comrade — thereby saving his life.

The three recesses on the wall of the upper storey were designed to take statues of eminent naturalists — but these were never commissioned. The only decoration is above them, in three shallow rectangles, below a leaf scroll motif on the cornice. The left-hand panel has a serpent, the centre a deity flanked by dolphins, and the right a crocodile.

## The Cabinet

*The Origin of the Species* was published in 1859, two years after the present museum was opened. The concept of lower and higher organisms was well established by that time, as were the essential outlines of classification. But Darwin's theory gave an added impetus to the excitement of studying natural history. In the eyes of the Christian establishment, it challenged the authority of the Bible, by putting forward a carefully reasoned but radically different interpretation of the mechanism of Creation itself. A major influence in developing the new theory was the observation of the ranks of preserved animals displayed in the great museums. So a natural history collection came to be more than a wonderland of exotic creatures — it was the basis of a profound challenge to ideas that had been accepted for some thousands of years.

The second half of the nineteenth century was a time when science in all its forms became an object of worship. The temples

were the museums. Trinity College had just built its magnificent Museum Building, with spacious halls in which to display geological and other treasures. The college would also build a huge zoological museum. The upper storey of the natural history museum follows a well-established pattern of a large open floor space to accommodate mammals of nearly all shapes and sizes. Above this are two galleries, in which birds, fish and the invertebrates are displayed. An orderly arrangement beginning with the mammals, the newest and 'highest' forms of life, and moving upwards to the older and simpler creatures, was begun in 1881 under the direction of Alexander Goodman More.

The ground floor was used for special displays, and housed a selection of animals to illustrate the essentials of evolution and of geographical distribution. This is described in detail by George H. Carpenter, Assistant Naturalist, in a paper presented to the Fifth Annual General Meeting of the Museums Association, which was held in Dublin in 1894. In the following year a radical reorganisation took place in which all Irish specimens were brought to the ground floor, while the world collection was arranged on the first floor and in the galleries. A special display, illustrating the geographical variation between animal groups, occupied a third of the ground floor. The Irish collection, beginning with the vertebrates — mainly birds and fish — was the first display to meet the visitor who entered at that time from the west end. The skeletons of the great Irish deer, unearthed in Rathconnor in Co. Limerick in 1824, welcome and impress the visitor.

The Irish collection increased in size and ultimately took over the entire ground floor, and, in 1907, the first floor and higher galleries took on their present-day appearance. After 1922, when the new State acquired Leinster House for the Dáil, and the RDS made its headquarters on its showground site at Ballsbridge, the western hall was closed to the public and the east door on Merrion Street became the only entrance. The collection was rearranged and the positions of cases and cabinets have not been materially altered since.

The birds, fish and mammals are big and more or less beautiful, the insects and other small creatures extremely interesting. The collection contains many of the 'reconstructions' beloved of the Victorians, realistically mounted stuffed birds and mammals, representing the pinnacle of the art of the

The galleries of the Natural History Museum.

taxidermist — and objects of real value before the days of colour photography and videos. Possibly the most precious of all the museum's possessions are the glass animals created by Leopold

and Rudolph Blaschka in Germany between the years 1878 and 1886. The Blaschkas subsequently worked exclusively for the museums of Harvard University. Their models, in coloured glass, are of either microscopic creatures or visible animals such as the sea anemones and jellyfish which cannot be preserved to give anything approaching a life-like appearance. The work is of almost photographic accuracy and extraordinary beauty.

For sixty years, the natural history museum was just about maintained with the employment of a staff too small to give proper attention to the specialist scientific collections, let alone modernise the public display.

This was not a commendable situation — but it has had a completely unforeseen and remarkable result. More affluent museums of the same period retained their basic fabric but modernised their displays, generally doing away with the serried ranks of stuffed birds and beasts, and replacing them with beautiful multimedia exhibits. There can be no question that these museums provide their visitors with a wealth of information and that such developments by and large have been a change for the better.

However, it was accompanied by the inevitable loss of the historical aspect of the nineteenth-century 'cabinet' museum. Dublin's failure to modernise has led to its becoming unique — not just one of many excellent natural history museums, but an actual specimen of an entity from the dawn of contemporary views on evolution. When, at last, funds became available for refurbishment in 1988, the aim was very clear: clean and polish the wooden-framed cases, paint the walls, put the quarry tiles in order, but at all costs preserve the atmosphere of a triumph of nineteenth-century thought. In 1996, the museum looks as bright as it did when newly built nearly a century and a half ago.

Perhaps the most exciting fact of its old-world existence is its popularity. The natural history museum is second only to the Book of Kells as a place to visit — about a quarter of a million people cross its threshold in a year. It has a wonderful atmosphere on a Sunday afternoon — far from quiet and studious, it is vibrant with parents, excited children, and people of all ages who, in spite of being exposed to excellent natural history on television, find a thrill in close contact with the physical animals, even though most of them have been dead for a hundred years.

In spite of the outward appearance of the display, the curator, Jim O'Connor, and his assistants have been able to make important, though subtle, changes in the exhibits. In particular, they have thinned and rearranged many of the displays of insects and other small creatures which, not so very long ago, were stultifying to the general public and of no value to the specialists. Geological specimens have replaced endless birds' eggs, but the essence of the early twentieth-century appearance remains intact.

## The Civic Museum

Natural history is not an expected subject for a civic museum. Two of its permanent exhibits, however, are of considerable interest. Charles Brooking's map and panorama of 1728 show the reclaimed areas of the Liffey, on Custom House and Sir John Rogerson's Quays, still as large stretches of water, with Ringsend as a completely separate village. And the Poddle can be seen above ground through Blackpitts, nearly as far as St Patrick's Cathedral.

The excellent set of Malton prints, even though conceived to celebrate buildings rather than geography, gives some impressions of Dublin as a small, compact city with agricultural land on all sides, and with the Liffey still an estuary with few bridges, so that sailing ships can go as far upstream as Essex Quay. A drover is attempting to control two cows in the middle of the road in front of St Patrick's where the nearby street is named Cross Poddle. Stephen's Green is shown in its original layout, with a broad, tree-lined walk on all sides, and an open pasture within with horses relaxing. Lord Charlemont's house shows well-grown trees at the corner of the Rotunda gardens.

## The Geological Survey

The Survey's offices are at Beggar's Bush, just beyond the Grand Canal, but its museum is of such great interest to inner-city nature that it merits inclusion. The display is very beautifully presented and includes such appropriate exhibits as the geological history of Ireland, minerals, mining, water supply and so forth.

The special interest for Dubliners is the exhibition of building stones, their origin and their particular qualities. Specimens

of granite are used to demonstrate the range and variety of stone dressings. Examples of most of the popular building stones are on show, together with information on their places of origin and geological history. The work of quarrymen, stone masons and stone restorers is explained with the help of specimens and photographs, ancient and modern.

## Marsh's Library

The library of Archbishop Narcissus Marsh did not set out to be part of the natural history of Dublin, nor did it plan to be a museum. The good archbishop's aim was to make great books freely available to 'all graduates and gentlemen'. It was the first public library in Ireland and has continued to serve the people since it was founded in 1701. While later libraries were built and rebuilt and expanded, Marsh's scarcely changed, and its books and buildings remain very much as the architect Sir William Robinson and the archbishop planned. The oak bookcases are the originals. The clasps and chains have been removed from many of the books, and the cages, in which readers were said to be locked to prevent their removing the books, are no longer used seriously.

It is possibly unfair even to describe Marsh's as a museum. Under the direction of its Keeper, Muriel McCarthy, it is a modern working library — with the distinctions that only a minority of its books are less than 250 years old and most of them remain in the places where the eighteenth-century librarians put them. Special exhibitions are mounted regularly, and their subjects have included monsters and botanical works. The catalogues of these exhibitions are themselves collectors' items. The books range over every subject and therefore include many of the great European works on natural history: Conrad Gesner, Olaus Magnus, early printings of Pliny, the herbal of Gerard, and a host of others.

The library includes a residence and garden for the Keeper. There are flower-beds on either side of the entrance steps, and you can glimpse, from between the book stacks, the private garden within the complex — one of very few to survive the pressures for space in the modern city.

# References

Baily, K.S. (1833): *Irish Flora.*

Clarke, P. (1992): *The Royal Canal: The Complete Story,* Dublin: Elo Publications.

Colgan, N. (1904): *Flora of the County Dublin*, Dublin: Hodges Figgis.

Collins, R. and Whelan, J. (1990): 'The Mute Swan in Dublin', *Irish Birds*, 4: 181–202.

Collins, R. and Whelan, J. (1994): 'Mortality in an Irish Mute Swan Population', *Irish Birds*, 5: 183–88.

Craig, A. (1980): *Saint Stephen's Green, 1880–1980,* Dublin: National Parks and Monuments Service.

Craig, M. (1952): *Dublin 1660–1860*, London: Cresset Press.

Crowley, J. (1994): *Basin at the Broad-Stone*, Dublin: Broadstone Press.

Delany, R. (1995): *The Grand Canal of Ireland*, 2nd ed. Dublin: Lilliput Press/Office of Public Works.

Fannon, P. and E. (1983): 'Badger in the Inner City of Dublin', *Irish Naturalists' Journal*, 21: 137.

Gilligan, H. A. (1988): *A History of the Port of Dublin*, Dublin: Gill and Macmillan.

Jeffrey, D. (ed.) (1993): *Trees of Trinity College, Dublin*, Dublin: Trinity College Dublin Press.

Lang, J.T. (1988): *Viking Age Decorated Wood*, Dublin: Royal Irish Academy.

Little, G.A. (1957): *Dublin before the Vikings,* Dublin: M.H. Gill & Son.

Mabey, R. *Food for Free*, London: Collins.

Madden, B., Mitchell, L. and Cooney, T. (1993): *Birds of Trinity College, Dublin*, Dublin: Trinity College Dublin Press.

Mitchell, G.F. (1987): 'Archaeology and Environment in Early Dublin', *Medieval Dublin Excavations 1962–1981*, Series C: 1.

Moffat, C.B. (1931): 'A Remarkable Wagtail Roost', *Irish Naturalists' Journal*, 3: 206–208. This is the main reference for the 1930s, Moffat published several notes subsequently in the *Journal.*

O'Connor, J. The source material is filed in the Natural History Museum and details may be obtained from Dr O'Connor.

O'Mahony, E. (1935): 'Herring Gull Eating Earthworms', *Irish Naturalists' Journal*, 5: 309.

Praeger, R. Ll. (1937): *The Way that I Went*, Dublin: Hodges Figgis.

Rutty, J. (1772): *An essay towards a natural history of the county of Dublin*, Dublin: W. Sleater.

Simpson, L. (1995): *Excavations at Essex Street West, Dublin*, Dublin: Temple Bar Properties.

Smiles, S. (1874): *Lives of the Engineers*, London.

Sweeney, C.L. (1991): *The Rivers of Dublin*, Dublin Corporation.

Threlkeld, C. (1727): *Synopsis Stirpium Hibernicarum*, Dublin.

Wallace, P.F. (1982): 'The Origins of Dublin' in B.G. Scott (ed.) *Studies on Early Ireland: Essays in honour of M.V. Duignan.*

Webb, D. (1967): *An Irish Flora*, Dundalk: Tempest.

Wilkinson, G. (1845): *The Practical Geology and Ancient Architecture of Ireland*, London: John Murray.

Williams, W.J. (1908): 'Seagulls in the City of Dublin', *Irish Naturalist*: 78–80.

Williams, W.J. (1930): 'Strange Roosting of Wagtails in Dublin', *Irish Naturalists' Journal*: 3: 20.

Woodward, M. (1971): *Gerard's Herball*, London: Minerva Press.

Wyse Jackson, P. (1993): *The Building Stones of Dublin*, Dublin: Town House and Country House.

Wyse Jackson, P. and Sheehy Skeffington, M. 1984: *The Flora of Inner Dublin*, Dublin: Royal Dublin Society.

The maps of Brooking, de Gomme, Rocque and Speed are reproduced in Noel Kissane's *Historic Dublin Maps*, published by the National Library of Ireland.

A modern 'solid' geological map was published in 1994 by the Geological Survey under the title *Geology of Kildare-Wicklow.*

Glacial drift is shown on 6-inch sheets which may be seen by arrangement at the Geological Survey headquarters, Beggar's Bush.

# Index